Project Management for the Design Professional

By David Burstein, PE and
Frank Stasiowski, AIA

WHITNEY LIBRARY OF DESIGN
an imprint of Watson-Guptill Publications/New York
The Architectural Press Ltd./London

This book is dedicated to the spouses and children of all design firm project managers, especially Zenaide and Anita, who must continually endure long hours of work and separation from their husbands as they pursue the endless struggle to satisfy clients, principals, agencies, and others who demand their share of time.

Edited by Stephen A. Kliment and Susan Davis
Designed by Bob Fillie
Graphic production by Hector Campbell
Set in 10 point Aster

First published 1982 in New York by Whitney Library of Design,
an imprint of Watson-Guptill Publications,
a division of Billboard Publications, Inc.,
1515 Broadway, New York, N.Y. 10036

Library of Congress Cataloging in Publication Data
Burstein, David, 1947–
 Project management for the design professional.
 Bibliography: p.
 Includes index.
 1. Architectural practice—Management. 2. Engineering
—Management. 3. Interior decoration—Management.
I. Stasiowski, Frank, 1948– II. Title.
NA1996.B84 1982 720'.68 82-13692
ISBN 0-8230-7434-X

Published in Great Britain by The Architectural Press Ltd.,
9 Queen Anne's Gate, London SW1H 9BY
ISBN 0 85139 959 2

Manufactured in U.S.A.

First Printing, 1982

5 6 7 8 9/89 88

Page 103: G.A. Pogany, "A Positive Approach to the Negative Thinker,"
used by special permission from CHEMICAL ENGINEERING, July 27,
1981. Copyright © 1981, by McGraw-Hill, Inc., New York, N.Y. 10020.

Acknowledgment

This publication is indebted to the input and effort of Michael R. Hough, PE, Publisher of *The Professional Services Management Journal*. Starting in 1974, Hough began to educate the design professions on many of the topics covered in this text. Since 1978, much of the enclosed material has been enhanced and presented by Frank Stasiowski to over 3,000 design professionals who have attended PSMJ Seminars. Were it not for the initial step by Mike Hough, and his continuing work to improve project management techniques throughout the profession, none of this would have been possible.

In addition, thanks must also be given to the management of Engineering-Science, Inc., of Arcadia, California, and Atlanta, Georgia, for their assistance and patience during work on this book by David Burstein, PE, who was allowed the freedom to develop new and innovative approaches to project management based on sound fundamentals learned while at the firm.

CONTENTS

FOREWORD

THE BIGGEST INDUSTRY IN AMERICA is the construction industry, and it is an industry of projects. Virtually every building ever built is seen by its designers and builders as a distinct and unique task with a beginning and with an end. The process of getting that project designed and built is project management.

If one is involved in architecture, engineering, building construction or any one of hundreds of related fields, then one must be concerned with project management. Those of us in the design professions can think of our practices as composed of subunits—the projects that are flowing through our office at any given time. I know that much attention is being directed at the design office these days. But we must bear in mind that the design office exists only so that projects can be acquired, executed, and completed, all in an efficient and profitable manner. In other words, the project is what it's all about.

Project management is also about more than management. Project management, if I'm correct in my view that design practices are simply aggregations of numerous projects, is the means by which we achieve all our personal and company objectives. Great architecture rarely happens (at least not in the long run) if excellence in project management does not reside within the firm. Quality engineering is unlikely in a context in which projects are improperly managed. And of course if projects all lose money, then our firms will lose money as well, and we won't be practicing anything for very long.

But what is the big mystery about project management? Why should we concern ourselves about it, let alone read a book on the subject? Isn't it, after all, just a simple manifestation of the old management maxims: plan, organize, direct, and control? Sure, project management is concerned with all the basic management functions. A project manager must certainly plan the project. An unplanned project is doomed from the outset. The project manager also must bring them to a proper level of organization so that the myriad tasks will be carried out effectively. Then the efforts of many, many participants must be directed in order to be certain that each is following the preordained plan. And finally a system of controls and feedback must be established to ensure the final objectives.

Yet there is much more to it than that. There are subtle nuances to project management that are very difficult to capture. They have to do with things like quality, accountability, integrity, professionalism—all those matters that we are so concerned about as professional people but that are essentially philosophical issues. Whether or not success is achieved in bringing all these factors together to a happy conclusion is largely a burden on the back of the project manager.

Once again, why so difficult? In my view the reason is that the project manager is required to bring together diverse individual human efforts from many different disciplines; the project manager must manage many different technologies ranging from computer sciences to building sciences; the project manager must extract from all levels within the firm and other firms the best efforts of many individuals; and yet the project manager is almost always in the position of having to do this without possessing adequate authority to *require* it to be done.

In other words, the project manager is the quintessential integrator: a person who must be intelligent and skilled, creative and sensitive, and above all, blessed with the ability to negotiate. The project manager must be willing to take on a highly rigorous task and assume the responsibility for its successful accomplishment often without the clear authority to make it all happen. And yet this person's success will determine the success of the whole organization.

It is obvious that I think project managers are more than just important. They are critical to our firms. They need every bit of help they can get to accomplish their most difficult task. This book by David Burstein and Frank Stasiowski is a very important, very direct, nuts-and-bolts guideline to what project management is all about, and it carefully and thoroughly delineates a proven approach to the

task. It includes a large number of specific techniques that are extremely helpful to the practitioner at all stages of development.

I've known Frank Stasiowski for years. In all that time he's been hard pressed to talk about anything other than management in professional design firms. He's practiced it himself at all levels as a registered architect. He's listened to the views of probably 10,000 other practitioners in all segments of the building design professions as they have expressed their views on management-related subjects. He's lectured many, many times all over the country with great acceptance. He's written provocative articles. And now he's a practicing consultant dealing with management problems in all kinds of building industry-related organizations.

David Burstein is a practicing environmental and civil engineer who has written and lectured widely on project management. He and Frank have often collaborated in the past, and this time they have effectively pooled their diverse project management experiences to produce this important resource for project managers in all areas of the building sciences.

The authors of this book know what they're talking about, and they are talking about a subject of tremendous relevance to all of us.

W. Ennis Parker, Jr., AIA
President, Heery International, Inc.

INTRODUCTION

MUCH HAS BEEN WRITTEN on the subject of project management. However, the vast majority of the literature deals with general principles of managing various kinds of projects. The management of projects in professional design firms is a highly specialized topic for which the available literature is much less complete.

This book minimizes discussions of theoretical management concepts and concentrates instead on "nuts and bolts" ideas that will help the project manager in professional architecture, engineering, planning, and interior design firms do a better job. The book deals with subjects that are important for design professionals to help them become well-rounded project managers. It concentrates on the planning, organizing, directing, and controlling functions that are the activities at which project managers spend most of their time. In keeping with the nuts and bolts approach, this book provides numerous checklists, forms, examples—even a proprietary method. Copying any of these documents is encouraged so long as the materials are not used for resale or other commercial purposes.

This book was written by David Burstein, a professional engineer, and Frank A. Stasiowski, a registered architect. Each author has had years of experience as a project manager, as well as a supervisor of other project managers. However, the information presented here is not merely a compilation of the knowledge of the two authors. It is also based on scores of articles published in the *Professional Service Management Journal* (edited by Frank Stasiowski and published by MRH Associates in Newington, CT.) over the past ten years, as well as feedback from over 100 seminars presented by the authors to some 3,000 project managers and principals in architecture, engineering, planning, and interior design firms in the United States, Canada, and Australia. The audiences intended for this book are project managers, supervisors of project managers, and design professionals who are aspiring to become project managers.

The authors' major objective is to help you avoid the trap of concentrating solely on the performance of a particular project to the exclusion of seeing the "big picture," that is, how management of a given project fits within the overall objectives of the firm. We hope that this book can, by exposing project managers to the broader concepts, contribute to their professional advancement and increase their contributions to their firms.

Subjects presented in this text apply to a wide variety of project and firm types and sizes. As you read the material, relate its content to your firm. Whether your projects are small or large, the concepts within each chapter work. They have been tested by your peers from firms of all sizes on all types of study and design projects.

Project Management for the Design Professional

The Strong Project Manager

1. What are my roles as a strong project manager?

2. What are my key responsibilities to the firm and the client?

3. Why is it essential to make a profit on *every* project?

4. How can I ensure proper supervision of the project team?

5. What is the fairest way for my supervisor to evaluate my performance?

6. What are the right and wrong ways to secure authority on a project, in line with my responsibility for it?

I

N RECENT YEARS there has been a trend for many design firms to convert to a "strong project manager" (SPM) organization. While the objectives of this trend have been generally laudable, there has been considerable misunderstanding of this form of organization and its proper application in most consulting firms.

The Strong Project Manager Organization

The SPM organization originated with the realization that revenue produced in design firms comes primarily from projects that involve several people, in contrast with general consulting involving only one or two professionals, such as in a law practice. This means that the proper management of the project team is a key ingredient to long-term profitability.

In its purest form, the SPM organization is a "matrix" system in which the project manager has no permanent staff, but rather is assigned an interdisciplinary project team for assistance in performing a specific project. When the project is completed, the team is disbanded, and each team member is reassigned to another project.

A typical organization chart for a SPM system in a small single-discipline firm is presented in Figure 1.1. It can be seen that a group of project managers has been selected from among the principals and architects in the firm. In this type of organization it is possible for any employee (including principals) to report to the designated project manager for a specific project. However, each individual also has a permanent supervisor (who in this example is a principal in the firm). Each time a project is begun, the principal-in-charge decides which of the three designated project managers should be assigned the project. Then the principal-in-charge and project manager jointly determine which other staff members should be assigned to the project team and what their involvement should be. The principal-in-charge must then delegate day-to-day supervision of the project to the project manager, while maintaining sufficient control to recognize and respond to major problems. Figure 1.1 also shows a typical SPM organization chart for a multidisciplinary firm. As in the case of the single-discipline firm, a group of project managers is selected from all the firm's employees. In the multidisciplinary firm, however, department managers are also involved in the selection of the project manager and project team on a project-by-project basis, as well as responsible for quality control for the work done by personnel in their department.

While the SPM organization has many benefits, it is by no means a panacea for all project management problems. It works best on major projects where each team member can be assigned to the project on a long-term, full-time basis. In this ideal situation, the project manager can concentrate his or her efforts on coordinating the input of each team member to best accomplish the project objectives. (An example of this is the major international project in which most or all of the project's team is physically located in the client's country.)

Unfortunately, most design projects are not of sufficient size or duration to permit personnel to be assigned on a long-term, full-time basis. More commonly, several project managers are forced to share the available time of a single technical person. This situation often results in competition by several project managers vying for limited available manpower and requires the principals and/or department managers to spend much of their time trying to meet these demands.

Most firms in this situation find that only through regular manpower planning meetings between department heads and project managers can they solve the recurrent problems of over- or underutilization of staff. Constant communication becomes key.

Another problem often arises when the principal-in-charge is not experienced in the important technical aspects of the project, reducing his or her ability to monitor the overall project status and increasing the likelihood of substandard quality work. One way to overcome this problem is to designate a technical director for

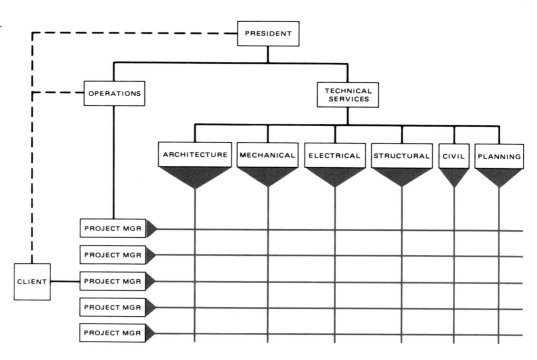

TYPICAL MATRIX ORGANIZATION

the project. The technical director selected should be the individual who is most proficient in the key technical aspects of the job. His or her responsibilities do not include budget or schedule control, but only the assurance that the work is done in accordance with the firm's technical standards. For projects requiring a broad variety of technical expertise, the technical director can also obtain consultation and review from anyone in the firm or from outside consultants.

The key to success for the SPM organization is for the principal-in-charge to permit the project mananger to manage projects on a day-to-day basis while still maintaining sufficient control to prevent minor problems from becoming major disasters. It requires considerable skill, flexibility, and self-control for a principal to handle this situation properly. Also, the project manager and department head must share equal authority for perfoming project activities, no matter what their positions are in the firm's employment structure.

Specific Roles of the Strong Project Manager

A project manager in an SPM organization has seven basic roles:

technical supervision
planning
organizing
directing
controlling
financial management
marketing assistance

Each of these roles is described below.

Technical Supervision. The technical role of the project manager is listed first because most design firms' existence depends on technical expertise in a particular field. So it is important for the project manager to be technically competent and directly involved in the technical aspects of the project. Clients will not respect a project manager who cannot respond to technical questions without first consulting the project team to obtain correct answers. Ask yourself if you would rather deal with product salespeople who can respond to your inquiries imme-

diately or those who always have to consult the factory. Clients feel the same way about project managers who are not technically proficient. In addition, several studies have shown that technical competence is the single most important factor in determining how project team members rate project managers. This factor can dramatically affect the project manager's ability to motivate the team.

Planning. The purpose of planning is to divide the overall project requirements into elements that can be effectively managed. Effective planning avoids unnecessary crises and anticipates unavoidable crises, making them easier to control. Some common problems that can be overcome by proper planning include:

inadequate definition of requirements by clients
unwillingness to specify objectives
undefined end point of the project
poor communications about project requirements and changes

Organizing. In a SPM organization, the project manager should be involved in the selection of the project team. The project manager also has a responsibility to provide feedback on each project team member's performance on a project. This feedback should go not only to department heads and principals, but also to the individual members themselves.

Directing. After the project is planned and organized, the project manager must spend considerable effort directing the activities of everyone involved in the project. This effort includes the coordination of project team members, principals, outside consultants, clients, and third-party review agencies. This role is basically one of effective communication, making sure that project work is done efficiently and that nothing falls through the cracks.

Controlling. The project manager's control functions can generally be divided into four categories:

technical quality
budget
schedule
client satisfaction

The control function can be successfully accomplished through use of various control techniques, such as design reviews, formal progress reports, and informal milestone reviews. The ability of the project manager to delegate work to other team members also calls for adequate control measures.

Financial Management. Another role of the project manager in an SPM organization that is not recognized in more traditional design firms is participation in financial management. The project manager is the individual who is most familiar with the project and the client. Having this in-depth knowledge assures that job costs are properly accounted, that invoices are prepared quickly and accurately, and that accounts are paid promptly.

Marketing Assistance. Of all the roles of a project manager, one of the most important is to assist in the firm's marketing effort. The project manager's marketing role with existing clients is to sell additional work by virtue of doing a good job. His or her role in securing projects with new clients is (1) to establish a program for a potential project that meets the client's needs and (2) to help sell it to the client. The project manager's ability to sell ideas can be the single most important factor in the final selection process.

Position Description for the Strong Project Manager

The position description for a project manager in an SPM organization can take on a variety of forms. A good example of such a description is presented in Figure 1.2. Use it as a starting point for developing a project manager position description within your firm by examining each duty and responsibility carefully with your management team.

POSITION: Project Manager

ACCOUNTABLE TO: Project Director

RESPONSIBLE FOR: Communication with client's representative and team members

Major Responsibility

Directs the project throughout its various phases by continuing and timely communication with client's representative and the team members.

Additional Minimum Duties

1. Assists during promotional phase as required.

2. Assists in organization of project providing input to the project director.

3. Works with all involved disciplines; prepares estimated manpower requirements, schedules, and other pertinent data; participates with project director in preparing fee proposals, conducting fee negotiations, preparing contractual agreements; and is sufficiently familiar with all agreements between firm and client to effectively manage the project in a professional and economic manner.

4. Ascertains that code checks are made and zoning status is acceptable and coordinates with proper building officials.

5. Arranges for timely submission of documents to Quality Control Board for in-house and client milestone progress reviews. Submittal documents should be dated and initialed by project manager signifying his or her review and the coordination of all disciplines.

6. Coordinates and conducts reviews of the project with discipline directors or their assigned representatives on a timely basis to ensure proper coordination and beneficial input from team members.

7. Interviews and contracts with required consultants, subject to review and approval of the project director.

8. Obtains approvals and decisions from client in a timely manner that allows the project to flow smoothly and quickly through the office and alerts project director to any changes of scope, lack of information, or decisions from client that affect schedule or production costs. Negotiates or assists in negotiations with client to account for such changes.

9. Mediates disagreements between disciplines and makes decisions always in regard to the best interests of the project and the firm.

10. Participates in periodic reviews of the project with respect to schedule, construction cost, and profit plan; prepares progress report for biweekly job status meeting.

11. At the closeout of the project, prepares project history data, for example, construction cost analysis, special design features, and problem feedback for future jobs.

12. Turns all documents over to librarian for entry into the firm's record storage, including project files, accounting files, and original construction documents.

Description

This is a 100-employee firm in the south offering architectural, structural, civil, electrical, mechanical, and interior design services.

General Responsibility

A project manager is an experienced analyst who can define a project, develop a set of tasks to accomplish the project, coordinate and monitor the work involved in the tasks, and deliver a final product on time and within prescribed cost constraints.

Project managers are designated by the president upon the initiating recommendation of the group manager and approving recommendation of the department manager. This designation, while resulting from specific qualifications the individual has attained, will always contain some amount of subjective judgment. To be designated as a project manager, an analyst should generally possess the qualities of maturity, judgment, leadership, experience, and project success.

Guidelines

The following guidelines should be used as an aid in selecting individuals for designation as project managers. They can also be used by junior and midlevel analysts as a qualification *guide* to achieving the project manager position. These guidelines are *not* intended to be rigid requirements that must be met without fail.

1. Experience in work field: at least 3 years.

2. Experience of at least 1 year in the company.

3. Experience coordinating technical efforts of others.

4. Project management experience: manage from conception to completion at least one significant project, that is, of more than 6 months in duration and dollar value exceeding $30,000, specifically.

5. Ability to work on and manage a variety of technical tasks.

6. Ability to make formal presentations to company management and customers.

7. Ability to estimate costs associated with technical tasks.

8. Sales success.

Specific Responsibilities

1. Defining the scope of individual projects.

2. Developing integrated tasks to accomplish individual projects.

3. Coordinating/monitoring the technical work of each task.

4. Assigning personnel within own group.

5. Recommending salaries for group personnel for higher authority approval.

6. Reviewing (for group manager approval) all reports prepared for each project.

7. Monitoring progress toward deliverable schedules.

8. Working closely with finance and contracts personnel to ensure fulfillment of contract requirements.

Personnel

1. Planning/evaluating staffing requirements for each project.

2. Coordinating technical efforts of all project members.

Marketing

1. Developing and maintaining trust and confidence of customers.

2. Seeking follow-on business for each project.

3. Making formal presentations to company management and customers.

1.2 Here is a good example of the position description for a project manager in a strong project manager organization.

Responsibilities of the Strong Project Manager

20 Excuses For Poor Project Performance

1. I had too many other things to do.

2. I didn't have enough time.

3. _____ kept making changes.

4. The budget was unrealistic.

5. I couldn't get enough help.

6. Working for that client is impossible.

7. I couldn't get the information I needed from accounting.

8. The schedule was unrealistic.

9. _____ didn't do the kind of job he or she should have.

10. Everyone kept loading time onto the job.

11. _____ was taken off the job when I needed him or her most.

12. _____ went on vacation at the worst possible time.

13. _____ quit and left me holding the bag.

14. I wasn't given enough authority.

15. The designers wouldn't stop designing.

16. The contractor didn't understand the job.

17. The job was unique.

18. The building department is full of idiots.

19. Principals kept charging time to my job.

20. The consultants wouldn't cooperate.

1.3 Neither these nor any other excuses are a substitute for fulfilling the project's objectives.

The first and foremost responsibility of the project manager is to accomplish rather than excuse. Numerous excuses can be identified for any project that does not go well. (Some commonly used excuses are presented in Figure 1.3.) However, none of these excuses is a satisfactory substitute for performance. The successful project manager views difficulties as challenges and gains the respect of clients, supervisors, and peers by accomplishing the project objectives in spite of problems. It is the ability to overcome external difficulties and still make the project a success that usually leads to rapid professional advancement in a design firm.

The second responsibility of the project manager is to know when to take charge. To be most effective, recognize that the project team is looking to you, the project manager, for guidance and direction. However, each member of the team must be allowed to exercise judgment and creativity within the constraints of the project.

The third responsibility of the strong project manager is to serve the client. The key phrase is "Serve, but don't be servile." This means that you must sometimes tell the client things he or she doesn't want to believe (for instance, that the costs to develop a design concept are more than the budget). The ability to manage client relationships successfully is one of the most important skills that a project manager can develop.

The fourth responsibility of the SPM is to meet the schedule. This means doing everything possible to complete the project within the contractual time frame. Despite one's best efforts and through no fault of the project team, there are times when external forces cause the schedule to slip. The most common delays are caused by the client or third-party review agencies. In such cases, it is essential that the project manager make an effort to (1) inform the client of the consequences of such delays, (2) make up any lost time by stepping up the productivity of the project team, and (3) confirm with the client that the delay was in no way caused by the design firm.

The final responsibility of the strong project manager is to make a profit on *every* job. It is unfortunate that many project managers do not understand the need for design firms to make a profit. Contrary to popular belief, profits are not funneled directly into the pockets of the principals. The following is a partial list of the kinds of things that must come from the profits of a typical design firm:

1. Profits, in the form of retained earnings, provide a cushion that enables the firm to operate through lean times without going out of business or laying off its key staff. The cyclical nature of the consulting business demands that considerable retained earnings be available to assure stability.

2. Profits are the source of investment in new equipment, furniture, and other capital goods that are essential for the continued growth of the firm. In today's environment, the increasing importance of computers, word processing equipment, and computer-aided drafting equipment makes the need for capital investment more important than ever before.

3. A record of consistent profitability is a key measure that all banks use to determine the line of credit available to the firm to finance day-to-day operations. If the borrowing capacity of the firm is insufficient, the firm's ability to grow will be severely impaired.

4. Continued profits provide the money to compensate the firm's best performers with pay increases, improved benefits, bonuses, profit sharing, and stock purchases.

5. The profits earned by a publicly owned design firm must provide the investors with a rate of return greater than one that can be obtained from more secure investments, such as treasury bills, money market funds, and high-quality bonds. If the return falls below one that can be realized from these more secure investments, the sources of needed capital will soon evaporate.

6. Finally, profits are the reward to owners for the tremendous risks of owner-ship, such as financial commitment to the firm and professional liability con-siderations.

The project manager is the person in the firm who most directly affects profits by being able to meet project budgets agreed to in advance.

Performance Reviews in a Strong Project Manager Organization

In most project management organizations, the technical staff reports to the proj-ect manager for specific projects, but to a department head or principal for perfor-mance reviews and salary increases. As a result, the staff may not have sufficient incentive to be responsive to the project manager. This problem can be virtually eliminated by:

1. Establishing a policy by which the project managers take part in performance reviews.

2. Assuring that this policy is clearly understood by the technical staff. Not only will this method assist the project manager in supervising the project team, it will also provide department managers and principals with valuable input from the individuals who are most familiar with the performance of the technical staff.

Another question is how project managers should themselves be evaluated in a strong project manager organization. The traditional approach is to use the same preprinted form as for technical staff, which may include such categories as quality of work, cooperation, and quantity of output. These categories are clearly inadequate to measure the performance of a project manager in an SPM organi-zation. This problem can be overcome by adopting a rating sheet developed specifically to evaluate the performance of project managers, such as the one in Figure 1.4.

Although the categories in Figure 1.4 are appropriate for evaluating project managers, the rating itself tends to be an arbitrary rather than an objective eval-uation of performance. A better way to evaluate performance is to eliminate pre-printed rating sheets altogether. Instead, the project manager and the supervisor should discuss, agree on, and document individual goals that will benefit both the firm and the project manager's personal career development. Specific objectives should then be developed for the next six- to twelve-month period. A typical tabulation of these objectives is shown in Figure 1.5.

The specific objectives should be (1) based on accomplishment and (2) measur-able without having to introduce subjective judgments. At the end of the review period, the project manager and the supervisor can then compare actual perfor-mance with the objectives that both agreed to earlier. The rationale behind this concept is that a different yardstick is used to measure the performance of each individual, with these measures mutually agreed upon in advance.

The Authority/ Responsibility Dilemma

The easiest thing to define is the project manager's *responsibility* in a strong proj-ect manager organization: everything related to the project. If anything goes wrong with the job, it is by definition the project manager's fault. It is much more difficult to define the *authority* of the project manager. Unless he or she is also a principal, the project manager's direct authority is much too limited to handle such broadly defined responsibilities.

The solution to this dilemma lies in the fact that most of the project manager's real authority comes by delegation from the principals. There is a right way and a wrong way for the project manager to apply this delegated authority, as the follow-ing example shows:

The Situation: You have just been assigned to manage a major project with a tight budget, an accelerated schedule, and a difficult scope of work.

The Wrong Way: After reviewing the project requirements, you go into your principal's office and say, "In order to accomplish the project objectives, I must be given the authority to remove anyone from the project team who I think is not performing satisfactorily."

Rating Period: _January 1- June 30_

Function: _Project Manager_	Standards	Rating	Remarks
Company Relationships			
1. Supervisor's office	4	4	
2. Other departments	4	4	
3. Staff offices	4	4	
4. Intracompany organization	4	4	
Project Participation			
1. Project manager	—	—	
2. Project team	4	5	
3. Local liaison	4	3	
Planning			
1. Projects assigned	4	3	
2. Proposals submitted	4	3	
3. Implement company policies	4	4	
Organization			
1. Design and growth	3	3	
2. Delegation of responsibility	4	5	
Control			
1. Project budget	5	4	
2. Participate employee review	4	4	
3. Staff communication	4	5	
4. Monitor projects	4	4	
5. Report operation ot supervisor	4	3	
6. Company policy	3	3	
Climate			
1. Working morale	5	5	_People really_
2. Employee development	5	5	_want to work for him._
Leadership			
1. Enhance corporate image	4	3	
2. Personal example	4	4	

*Please use a rating scale of 1–5 with 5 being the maximum.

1.4 Standard rating sheets such as this one are often used to evaluate the performance of project managers. However, they lack the personal touch.

TYPICAL PERFORMANCE OBJECTIVES FOR PROJECT MANAGER

Overall Goals	Performance Objectives
1. Improve profitability on jobs.	Increase profit budgeting on jobs to 12% of contract value. Reduce budget overruns by 50%.
2. Increase work from existing clients.	Book $100,000 of add-ons to existing contracts. Book 4 new jobs with existing clients.
3. Improve management skills.	Enroll in night course at the university and make an A in the course. Attend 2 seminars. Subscribe to one management journal.
4. Get more involved in marketing.	Establish contacts with 12 potential clients. Get short-listed on 4 projects with new clients. Book one project for a new client. Keep marketing costs below $2,000.
5. Improve professional reputation.	Publish 2 technical articles. Make a presentation at a technical conference. Become an officer in the local AIA chapter.

1.5 Performance goals and objectives can be developed on an individual basis between project manager and supervisor.

The Right Way: After reviewing the project requirements, you go about the business of organizing the project team and beginning work on the job. After the first month, you realize that Tom Smith, the structural engineer, is not performing adequately. You then go into your principal's office and say, "Tom Smith has been working on this project for about a month, and his performance has not been satisfactory. As you know, this project is a difficult one, and I don't think we can accomplish the objective if we continue down the present path. I therefore recommend that we take Tom Smith off the project."

The first approach requested blanket authority to solve a problem that had not yet arisen; the second approach requested specific authority to solve an identified problem. Request for authority without a specific need creates uncertainty in the mind of the principal about the project manager's motives—is he or she trying to do the best possible job or merely seeking power?

To avoid the authority/responsibility dilemma, recognize that authority must be delegated on a case-by-case basis and that you must argue the merits of each case before requesting the authority to take action.

Potential Pitfalls of "Projectitis"

In *The Harvard Business Review*, Paul O. Gaddis defined "projectitis" as "the seeing of all things as though a particular project were the center of the corporate universe." When observed in World War II, this phenomenon was called "theateritis." General Henry H. Arnold, in his autobiography *Global Mission*, remarked that the disease of theateritis—that is, the inability of an Air Force commander to recognize the problems of war in any theater other than his own—caused him great concern and trouble in his personal dealings with his top field commanders. However, General Arnold noted at the same time that he would not have under his command any general who did not suffer from this disease.

The project manager on his own battleground needs a modicum of projectitis to generate the necessary drive and momentum to spark the project to success. These symptoms will be observed by the principals, but they will expect this malady and may themselves suffer outbreaks of it from time to time when they take a personal interest in a particular project.

However, the project manager must learn where to draw the line between project objectives and company objectives. It must be further understood that when this line is crossed, there is no doubt about which objectives will take precedence. Excessive complaining will not alter that outcome, but will only serve to alienate the principal. Furthermore, project managers often use the need to make a sacrifice for the good of the firm as merely another excuse to rationalize poor performance. Like all other excuses, this one will not turn a bad project into a good one.

Even more important, the project manager with excessive projectitis will come to be viewed by management as an excellent project manager, but one whose limited vision will hamper advancement to more responsible positions in the firm.

Conclusion

This chapter has described some of the features of the strong project manager organization and how you, the project manager, can best function within this organization.

The rest of the book presents a variety of concepts and tips to help you do your job better. The next chapter describes how you should plan your projects and how to set each one on its proper course.

Planning the Project

1. How can I set up a project to help me keep track of the budget and schedule?

2. What is the main purpose of a project work plan?

3. What are the four main features of a good work plan?

4. To what level of detail should I define the activities* that make up a project?

5. Is there such a thing as too detailed a task outline?

6. How can I prepare a task outline so as to avoid confusion when the scope changes?

7. What are the three elements a project task must have to be included in the task outline?

8. Why is it wise to identify project management as a separate activity in the task outline?

*The terms "task" and "activity" are used interchangeably in this book.

I T IS IRONIC that most project managers in design firms plan every aspect of a client's project down to the finest level of detail, but spend little time planning their own work on the project. Yet without proper planning it is unlikely that the objectives of the project will be met on time or within budget.

The Importance of Project Planning

The longer and more complex the project, the more time should be spent planning it. This is because of the difficulty in realizing loosely defined objectives that extend over a long period of time.

The major purpose of planning, therefore, is to divide broad contractual goals into manageable tasks that can be performed in relatively short periods of time. Proper planning also provides the project manager with a yardstick to use in measuring progress and controlling the project.

Preparing the Work Plan

A good work plan is *not* a report. It is a compilation of tables and figures (with little or no text) that can be used as a ready reference document throughout the project. The work plan should define:

1. *What* is to be done

2. *when* it is to be done

3. *how much* it will cost

4. *who* will do it

An outline of a typical work plan is presented in Figure 2.1.

The Three Levels of Project Definition

Depending upon its size and complexity, a project may have up to three levels of definition, as briefly outlined below:

Level 1. Proposal definition. Most projects are first defined during proposal preparation. This definition should contain only enough detail to describe how the project will be performed and the basis for the price proposal and schedule.

Level 2. Project control. After the contract is signed it may be necessary to further define the project so the project manager can adequately control the job. On small, simple projects the proposal definition may be quite adequate for project control. For large, complex projects the project manager should elaborate with additional details.

Level 3. Activity control. Once the project control definition is established, it may be desirable to add a further level of detail to define the elements that are required to accomplish each of the various activities. These additional details are not used by the project manager to monitor overall progress; they are tools used to communicate the scope of each activity to the individual(s) responsible for performing them. On large, highly complex projects there may be several layers of activity control definitions, just as there are several layers of task and subtask delegation.

A task outline can be prepared for each of the three levels described above. While all three levels are important, the task outline should deal primarily with Level 2 —project control definitions that the project manager must use on a day-to-day basis to properly control the job.

Preparing the Task Outline

A good task outline consists of a brief summary of the scope of work required for fulfillment of the contract. Because it is the foundation of any system of project control, the project manager should devote considerable attention to preparing the task outline.

Keeping the Task Outline Simple. A good task outline summarizes the contractual scope of work in a brief and simple manner, using the *minimum* number of tasks

2.1 The outline of a typical work plan for a major design project consists of a compilation of tables, graphs, lists, and so on, with little or no text.

and subtasks necessary to describe the work to be done. Excessively detailed task outlines invariably lead to a *loss* of control because project managers in most design firms simply do not have the time required to track numerous minor activities and to continuously update a complex task outline, schedule, and budget. For project control purposes it is better to establish a simple task outline that can be easily tracked and updated than a complex one, which is tedious and time-consuming to maintain.

Maintaining Consistent Task Breakdowns. When preparing a task outline, use the same breakdown of project activities for (1) the scope of services in the contract, (2) the project schedule, and (3) the project budget. This consistency enables you to monitor project progress accurately because each activity in the contract can be measured in terms of progress made, time elapsed, and money spent. Using consistent activity definitions also permits you to assess the impact of changes to the scope of work. In other words, if a scope of work contains twelve major tasks and a total of twenty-four subtasks, then the project schedule and budget should be prepared using an identical activity breakdown.

What Constitutes a Task? In order to be included in the task outline, a task (or activity) must contain three elements:

1. a definable scope of work

2. a duration consisting of at least one start date and at least one finish date (some scheduling methods call for more than one start and finish date)

3. a level of effort required to complete the activity

Any item which does not contain each of the above elements is not a defined task and does not belong in the task outline. For example, a project manager may assign the task of preparing piping specifications for a building to a mechanical engineer. Let us say it was agreed that work would begin on May 4 and be completed by June 3, using a total of 92 man-hours, plus $320 in other direct costs. It can be seen that "prepare piping specifications" meets our criteria and should be included in the task outline.

In further discussions between the project manager and the mechanical engineer, it may be agreed that the following piping specifications are required for the project:

Schedule 40 PVC pipe and fittings
Schedule 80 PVC pipe and fittings
stainless steel pipe and fittings
gate valves
check valves
butterfly valves
pipe hangers and supports

Should these specifications be included in the project manager's task outline? Let us examine these items using our criteria for defining a task.

1. *Does each item have a definable scope of work?* Yes, it is clear what has to be done for each item.

2. *Does each item have a defined duration?* Yes, but it is the same for all of them, since the mechanical engineer will do them essentially simultaneously.

3. *Does each item have a defined level of effort?* Not really. The total budget cannot be meaningfully apportioned among individual items, because they will be performed as a group.

While "prepare piping specifications" belongs in the task outline, the list of individual specifications does not. Does this mean that the project manager should

**CRITERIA
FOR EVALUATING
A TASK OUTLINE**

1. Does the task outline
 contain all the
 deliverables required by
 the contract?

2. Can the same task
 outline be used to
 establish the project
 schedule?

3. Can the same task
 outline be used to
 establish the project
 budget?

4. Does each item meet
 the three criteria
 required for inclusion in
 the task outline (scope,
 duration, and level of
 effort)?

5. Will the task outline
 require revision *only* if
 the contract is modified?

6. Is the task outline
 general enough to
 accommodate routine
 changes in approach
 without being modified?

7. Is project management
 identified as a separate
 task?

2.2 If, when a task outline is evaluated, the answer to any of these questions is "no," more work is needed.

forget about this list and assume that the mechanical engineer will handle the task properly? Not at all. The project manager should keep this breakdown as a checklist to (1) periodically measure the progress of the task and (2) assure that nothing has been omitted when the mechanical engineer presents the completed piping specifications to the project manager. However, this is clearly a lesser level of control than if each of the specification sections were included on the task outline.

After developing the initial task outline, the project manager should evaluate it to be sure that it has been properly prepared. Figure 2.2 presents a list of questions that can be used to make this evaluation. If the answer to any of these questions is no, the task outline requires additional work before it can be considered complete.

The last question on Figure 2.2 implies that project management should be identified as a separate activity in the task outline. Why? First let us put this question to the test of our three criteria for defining a task.

1. *Does it have a definable scope of work?* Yes, project management consists of a number of activities that are not associated with any of the technical tasks, but are essential for successful project completion. Some typical project management activities are listed in Figure 2.3.

2. *Does it have a defined duration?* Yes, it starts when the contract is signed and ends when the job number is closed.

3. *Does it have a defined level of effort?* Yes, the budget required for project management is related to, but independent from, the budgets for technical activities.

From the above criteria, it can be seen that project management should indeed be included in the task outline. This conclusion is supported by the fact that many sophisticated clients, such as the U.S. Army Corps of Engineers, now include project management as a line item in their standard budgeting forms.

Figure 2.4 represents a "first cut" and final task outline for a hypothetical project. Although this project is fictional, it is based on an actual project conducted for the U.S. Department of Energy (DOE) from 1979 through 1982. The objective of the project was to evaluate the impact of newly promulgated solid waste disposal regulations on the DOE's goal of promoting greater use of coal.

Figure 2.5 represents a typical task outline for a small architectural project [a 12,000-square-foot (1,100-square-meter) rural office building].

Compare the first cut and final outlines, and try to identify the methods that were used to simplify the task outline. Evaluate each activity using the criteria in Figure 2.2. You will see that this kind of critical analysis can greatly simplify the task outline, thus reducing the amount of time required to monitor and control the project.

Conclusion

This chapter has described some ways you can improve your project plans, with emphasis on proper definition of the project, preparation of a work plan, and development of a task outline.

The next chapter describes how the task outline can be used to establish the project schedule. The chapter also takes up various scheduling methods and shows which ones may be most suitable for your projects.

Although budgeting and scheduling should be done at the same time, the methods of developing a project budget are presented separately for the sake of clarity. Development of project budgets is therefore described in Chapter 4.

TYPICAL PROJECT MANAGEMENT ACTIVITIES

1. Budget and schedule control

2. Client liaison
 a. Meetings
 b. Periodic progress reports
 c. Telephone conferences

3. Liaison with principal-in-charge

4. Maintenance of project record
 a. Files
 b. Calculations
 c. Meeting summaries

5. Coordination of project team activities
 a. Defining manpower requirements
 b. Maximizing productivity

6. Coordination of consultant and subcontractor activities

7. Verification of invoices

8. Technical quality control

2.3 Although they are not generally identified in contracts, these and other project management activities are required to accomplish the objectives of almost all projects.

2.4 This task outline is based on a project conducted between 1979 and 1983 for the U.S. Department of Energy. Its aim was to assess the impact of new solid waste disposal regulations on the department's goal of converting oil-fired power plants to coal. Compare the first cut outline with the simplified final task outline.

TASK OUTLINE FOR AN ENVIRONMENTAL STUDY

First Cut Outline

A. Develop background data
 1. Coal use data
 2. Physical characteristics
 3. Regulatory considerations
 4. Other relevant cost impacts

B. Conduct case studies
 1. Select case study sites
 2. Prepare briefing documents
 3. Develop data management plan
 4. Visit case study sites
 a. Compile engineering information
 b. Identify jurisdictional constraints
 c. Collect and preserve waste samples
 5. Analyze waste samples

C. Estimate disposal costs for case studies
 1. Develop computer cost models
 2. Perform preliminary designs
 3. Estimate costs

D. Evaluate treatment, recovery, reuse
 1. Waste treatment technologies
 2. Direct waste reuse
 3. Potential for waste recovery

E. Assess cost impacts
 1. Regional impacts
 2. National impacts

F. Evaluate cost impact models

G. Project reporting
 1. Topical reports
 a. Background data
 b. Case study site visits
 c. Waste sampling and analyses
 2. Draft report
 3. Final report

H. Project management
 1. Budget and schedule control
 2. Liaison with principal-in-charge
 3. Client liaison
 a. Meetings
 b. Periodic progress reports
 c. Telephone conversations
 4. Maintenance of project records
 a. Files
 b. Calculations
 c. Meeting minutes
 5. Coordination of activities
 a. Defining manpower requirements
 (1) Type of expertise
 (2) Number of man-hours
 (3) Schedule
 b. Maximizing productivity
 6. Technical quality control

Final Outline

A. Develop background data

B1. Select case study sites

B2. Prepare briefing documents

B3. Develop data management plan

B4. Visit case study sites

B5. Analyze waste samples

C1. Develop computer cost models

C2. Perform preliminary case study site designs

C3. Estimate case study disposal costs

D. Evaluate treatment, recovery, reuse

E. Assess cost impacts

F. Evaluate cost impact models

G1a. Prepare background data reports

G1b. Prepare site visit report

G1c. Prepare sampling and analyses report

G2. Prepare draft report

G3. Prepare final report

H. Project management

TASK OUTLINE FOR DESIGN OF A SMALL OFFICE BUILDING

First Cut Outline	Final Outline

First Cut Outline

A. Obtain client data
 1. Site location
 2. Financing availability
 3. Goals for project
 4. Zoning

B. Develop program
 1. Gross space required
 2. Parking
 3. Walking
 4. Mass transit
 5. Environmental
 6. Utilities
 7. Tenant uses

C. Schematic development
 1. Layout plans and elevations
 2. Identify alternate structures
 3. Investigate building materials
 4. Identify outside consultants
 5. Layout "miniset" of drawings
 6. Preliminary cost estimate

D. Design development
 1. Finalize plans
 2. Initiate specifications
 3. Layout all drawings
 4. Code review

E. Drawing production
 1. Updated cost estimate
 2. Coordination of consultant drawings
 3. Final details
 4. Final specifications

F. Bidding

G. Contract administration
 1. Site meetings
 2. Change orders
 3. Punch list

H. Project management
 1. Budgets and schedules
 2. Team selection
 3. Review meetings
 4. Client relations
 5. Financial management
 6. Project records
 7. Quality control
 8. Managing changes

Final Outline

1. Obtain client data
2. Check zoning
3. Develop program
4. Site access plan
5. Schematic development
6. Identify outside consultants
7. Design development
8. Initiate specifications
9. Code review
10. Drawing production
11. Updated cost estimate
12. Final specifications
13. Bidding
14. Contract administration
15. Punch list
16. Project management

2.5 First cut and final task outlines are shown for a small office building. Note that project management is included as a separate task in both outlines.

CHAPTER 3

Establishing the Project Schedule

1. What are the four project scheduling systems most widely used in design firms?

2. What is the best method for scheduling short or simple projects?

3. At what stage of complexity of a project should I switch to a bar chart?

4. What are the main drawbacks of a bar chart?

5. Is there a good, simple method for developing a critical path method diagram?

6. When should I consider using a computerized critical path method system?

7. What is the best scheduling technique for actively involving all members of the project team?

8. What are the most common pitfalls when preparing project schedules?

O<small>VER THE YEARS</small> hundreds of scheduling systems have been devised to control all kinds of projects. All have advantages and disadvantages and each project must be scheduled using a method that is suitable for that particular project's scope and complexity. Attempts to adopt a single scheduling system as a standard for all projects within a firm have almost always failed. However, the types of projects typically performed by design firms share a number of characteristics that can be used to narrow the choice of scheduling method. These characteristics include:

scope of work
number of disciplines involved
number of staff involved
duration of the project
amount of fee
project leadership

Depending on the size and complexity of the project, any one of the following scheduling methods can be used to provide effective project planning and control.

Milestone Charts

Perhaps the simplest scheduling method is the milestone chart. In its most basic form, this method consists of identifying the target completion date for each activity in the task outline. Additional information that can be added to a milestone chart includes the actual completion date and name of the person responsible for performing each task. The major advantages of milestone charts are their ease of preparation and emphasis on target completion dates.

The best applications for milestone charts are short projects with few participants and little interrelationship between activities. Probably the most common

MILESTONE CHART FOR A TYPICAL PROPOSAL

Activity Description	Responsibility	Target Date	Completed
1. Proposal cover	DB	3/16/81	✔
2. Letter of transmittal	AWL	3/27/81	
3. Introduction	AWL	3/27/81	
4. Scope of services	MRH	3/22/81	✔
5. Project schedule	MRH	3/25/81	✔
6. Project budget	MRH	3/25/81	✔
7. Project organization	DB	3/25/81	✔
8. Appendix A. Qualifications	DB	3/24/81	
9. Appendix B. Biographical data	DB	3/26/81	✔
10. Typing and graphics	DB	3/30/81	
11. Final editing	AWL	4/1/81	
12. Printing, binding, and mailing	DB	4/3/81	

3.1 Milestone charts are an excellent way to control the preparation of proposals.

REPORT PREPARATION SCHEDULE

Job Name *Ft. Cannon Warehouse* Date *4/6/81*

Job Number *2264* Project Manager *D. Burstein*

	Date	To be reviewed/ approved by:
1. Complete detailed work plan	*4/15/81*	*MRH*
2. Complete general outline of report	*4/20/81*	*MRH*
3. Complete detailed outline of report with lists of tables and figures	*4/28/81*	*MRH*
4. Interim submittals to client	*5/14/81*	*MRH, AWL*
	6/1/81	*MRH, AWL*
5. Complete first draft of report	*7/1/81*	*MRH, AWL*
6. Complete drafts of figures	*7/1/81*	*MRH, AWL*
7. Complete editing of report	*7/21/81*	*AWL*
8. Complete final draft of report	*7/24/81*	*AWL*
9. Submit draft report to client	*8/1/81*	*AWL*
10. Receive comments from client	*8/15/81*	
11. Submit final report to client	*9/1/81*	*AWL*

Draft typing to be done by *HHH, JW, RNP*

Editing to be done by *LTP*

Final typing to be done by *HHH, JW*

Graphics to be done by *VAJ, VMT*

3.2 A form such as this one may be used to control the logistics of preparing a report.

example of such projects in consulting firms is the preparation of proposals, as in Figure 3.1. Another good application for milestone charts is for summarizing complex schedules containing many tasks. When doing so, list only key activities to avoid excessive detail, which can defeat the purpose of the chart. An example of this type of milestone chart is the report preparation schedule form presented as Figure 3.2.

A major drawback of the milestone chart is that it shows *only* completion dates. For complex projects, this may result in uncertainty about when each activity should begin, as illustrated in the milestone chart in Figure 3.3. Although the tasks are listed in the general order in which they are to be done, there is much overlapping of completion dates. Furthermore, comparing the actual completion dates with the target dates provides only a general indication of the overall schedule status. This project is clearly too complex to be adequately controlled using a milestone chart.

Bar Charts

Some of the drawbacks of milestone charts can be overcome by using a slightly more complex method—the bar chart (also known as the Gantt chart). Probably the most widely used planning tool among design professionals, a bar chart consists of a list of tasks presented along the left side of a page with horizonatal bars along the right side indicating the scheduled start and finish dates for each task. A bar chart for the project shown in Figure 3.3 is presented in Figure 3.4.

The biggest drawbacks of bar charts are that they do not show the interrelationship among various tasks, nor indicate which activities are most crucial for completing the entire project on schedule. As a result, some activities may inadvertently be omitted from the original project schedule, only to be discovered when it is too late. Also, assigning equal importance to each activity (implicit in the bar chart method) may leave the project manager in a quandary when forced to decide which task should be delayed in the event of a manpower shortage. This confusion may result in assigning top priorities to the wrong tasks.

Despite these drawbacks, bar charts remain an effective method of controlling projects with total fees in the $50,000 to $2,000,000 range.

MILESTONE CHART FOR EXAMPLE PROJECT

Project Activity	Responsibility	Target Date	Actual Date
A. Develop background data	PJS	5/1/84	9/12/84
B1. Select case study sites	BEB	4/1/83	3/22/83
B2. Prepare briefing documents	DSF	2/1/83	3/6/83
B3. Develop data management plan	DSF	4/1/83	3/22/83
B4. Visit case study sites	DSF/WEW	10/1/83	9/26/83
B5. Analyze waste samples	WGC	12/1/83	
C1. Develop computer cost models	DSF	4/1/82	6/12/82
C2. Perform preliminary case study designs	FRT	12/1/82	
C3. Estimate case study disposal costs	FRT	1/1/83	
D. Evaluate treatment, recovery, reuse	WEW	6/1/83	
E. Assess cost impacts	JAW	9/1/82	
F. Evaluate cost impact models	DSF/JAW	6/1/82	
G1a. Prepare background data report	PJS	8/1/83	
G1b. Prepare site visit report	DSF	12/1/83	
G1c. Prepare sampling/analysis report	WGC	2/1/84	
G2. Prepare draft report	DB	6/1/84	
G3. Prepare final report	DB	8/1/84	
H. Project management	DB	6/1/82	

3.3 In this milestone chart for the project defined in Figure 2.4, note that the initials of the person responsible for each task are identified along with the target date and the actual completion date.

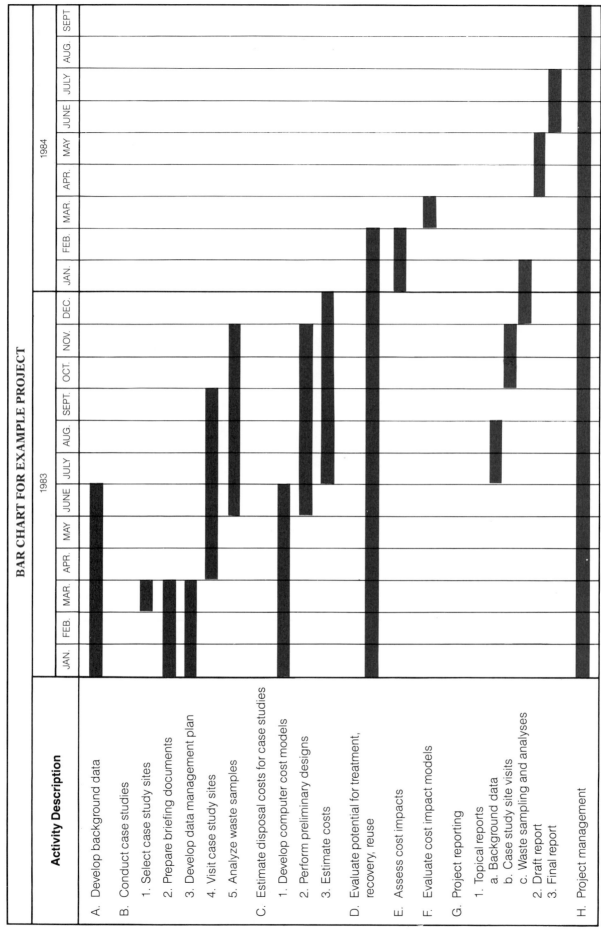

BAR CHART FOR EXAMPLE PROJECT

Activity Description	1983												1984								
	JAN.	FEB.	MAR.	APR.	MAY	JUNE	JULY	AUG.	SEPT.	OCT.	NOV.	DEC.	JAN.	FEB.	MAR.	APR.	MAY	JUNE	JULY	AUG.	SEPT.
A. Develop background data																					
B. Conduct case studies																					
1. Select case study sites																					
2. Prepare briefing documents																					
3. Develop data management plan																					
4. Visit case study sites																					
5. Analyze waste samples																					
C. Estimate disposal costs for case studies																					
1. Develop computer cost models																					
2. Perform preliminary designs																					
3. Estimate costs																					
D. Evaluate potential for treatment, recovery, reuse																					
E. Assess cost impacts																					
F. Evaluate cost impact models																					
G. Project reporting																					
1. Topical reports																					
a. Background data																					
b. Case study site visits																					
c. Waste sampling and analyses																					
2. Draft report																					
3. Final report																					
H. Project management																					

3.4 The bar chart is the scheduling method most commonly used in architectural, engineering, space planning, and interior design firms. This example is for the project defined in Figure 2.4.

The Critical Path Method

One way to overcome some of the shortcomings of bar chart scheduling is to use the critical path method (CPM), a highly mathematical system in which task interrelationships are defined and task schedules analyzed. A number of variations in CPM have been developed during the years since it was first introduced. The following approach describes one such variation, which has been successfully applied in design firms for a variety of study, design, and construction projects.

The method is usually broken down into four steps.

Step 1. Identify Task Interrelationships. The first step in preparing a CPM schedule is to identify systematically all task interrelationships. One way of doing this is to use a task interface diagram, also known as a precedence diagram. This diagram describes each of the three distinctive types of interrelationship graphically as follows:

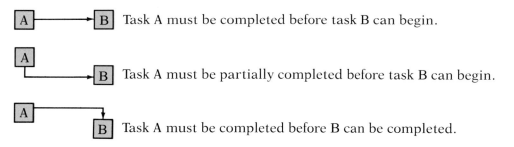

Task A must be completed before task B can begin.

Task A must be partially completed before task B can begin.

Task A must be completed before B can be completed.

An example of the first case would be:

Task A = determine heat loads

Task B = select air conditioning unit

Obviously, the air conditioning unit cannot be selected until the heat loads are known.

An example of the second case would be:

Task A = prepare structural calculations

Task B = prepare structural drawings

Although structural calculations are necessary for the structural drawings, it is not necessary that the calculations for *all* the structures be completed before the drawings of *some* of the structures can be begun. Thus, task B cannot be started until a certain amount of progress has been made on task A.

An example of the third case would be:

Task A = prepare piping drawings

Task B = prepare piping specifications

The specifications for common elements (including pipe supports, installation, and testing) can be begun as soon as the project is reasonably well defined. However, the specifications cannot be completed until all the drawings are completed, so that all piping materials, valve types, and so forth can be selected, identified, and tabulated.

Figure 3.5 shows how these interrelationships can be represented for a complete task outline. Study this diagram to see which of the three types of interrelationships exist between each pair of tasks. Note also that in this example, there is more than one type of interrelationship between two tasks. For example, interrelationship types 2 and 3 exist between tasks C2 and C3. In other words, task C3 (cost estimates) cannot begin until task C2 (preliminary design) is partially completed, and task C3 cannot be completed until task C2 has been completed. In fact, this "double interface" is quite common.

TASK INTERFACE DIAGRAM

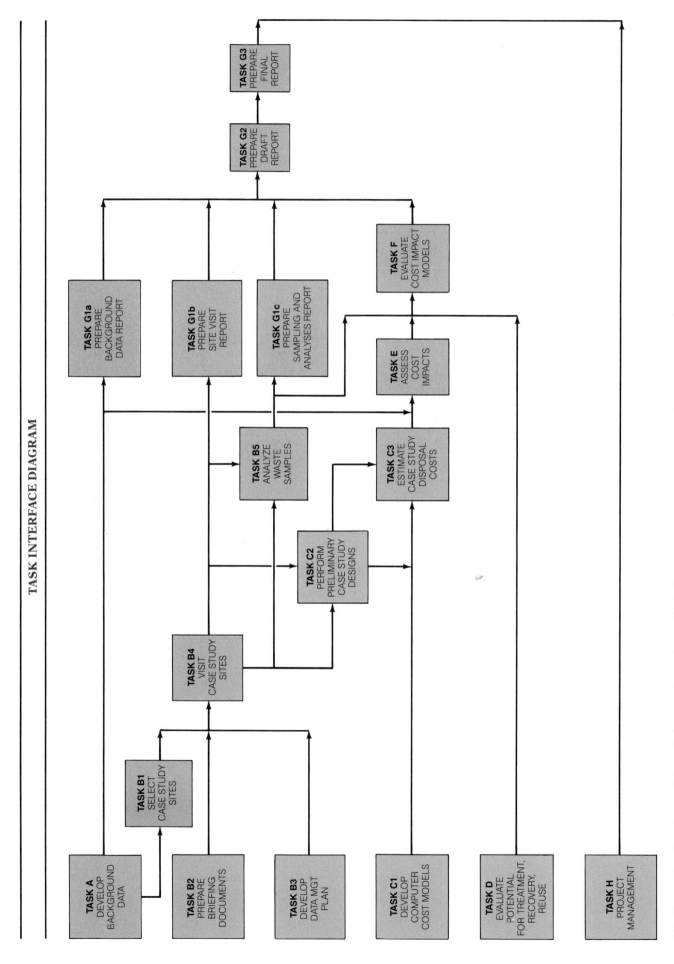

3.5 The task interface diagram (also called a precedence diagram) is the first step in the critical path method. This example refers to the project defined in Figure 2.4.

Step 2. Establish Optimum Task Durations. The next step is to establish the optimum duration for each activity on the task outline. This is the length of time (in calendar days) required for the activity to be completed in the most efficient manner possible assuming that all prerequisite tasks have been completed. A typical tabulation of task durations is presented in Figure 3.6, using the same sample project as in Figure 3.5.

Note that task H, project management, is scheduled to extend sixty days beyond completion of all other tasks. This is typical of most projects performed by design firms. Even if all contractual responsibilities are completed by the contract due date, activities tend to continue beyond that date—such as printing of additional copies of drawings, answering questions from contractors or equipment vendors, organizing project files, or appearing at City Council meetings. Even if all contractual obligations have been met, these residual activities are part of the project management task and should be scheduled as such.

TABULATION OF TASK DURATIONS FOR EXAMPLE PROJECT

Activity description	Calendar days
A. Develop background data	180
B1. Select case study sites	30
B2. Prepare briefing documents	30
B3. Develop data management plan	90
B4. Visit case study sites	180
B5. Analyze waste samples	105
C1. Develop computer cost models	90
C2. Perform preliminary case study site designs	135
C3. Estimate case study disposal costs	30
D. Evaluate treatment, recovery, reuse	90
E. Assess cost impacts	60
F. Evaluate cost impact models	30
G1a. Prepare background data report	60
G1b. Prepare site visit report	60
G1c. Prepare sampling and analysis report	60
G2. Prepare draft report	60
G3. Prepare final report	60
H. Project management	*

*Task H should be completed 60 days after completion of all other activities.

3.6 The duration of each activity should be expressed in calendar days, assuming that all prerequisite tasks have already been completed.

Step 3. Prepare Project Schedule. Having completed the basic task interface diagram (Figure 3.5) and established optimum task durations (Figure 3.6), you may use these results to prepare a project schedule. Do this either in bar chart format (similar to Figure 3.4) or CPM format, in which the schedule is drawn as a network. The network schedule is best explained by using the same examples of simple two-task projects.

Let us say that the first sample project contains the following tasks and durations:

Task A = determine heat loads (five days' duration)

Task B = select air conditioning unit (three days' duration)

The task interface diagram for this project will be:

This interface diagram can be converted to the network schedule shown below, based on the defined task durations.

The vertical arrow in the network schedule serves the same purpose as the horizontal arrow in the interface diagram: to show that task B cannot begin until task A is completed. The arrow for the network schedule must be vertical to show that no time should elapse between completion of task A and start of task B. These vertical arrows are known as "dummy activities."

The second example contains the following tasks and durations:

Task A = prepare structural calculations (five days' duration)

Task B = prepare structural drawings (six days' duration)

The task interface diagram will be as follows:

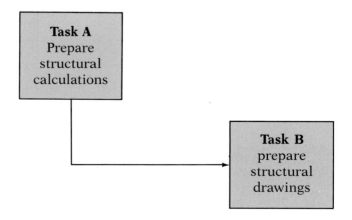

This diagram can be developed into the following network schedule:

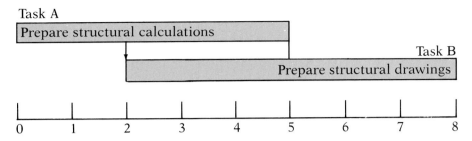

Note that the above schedule presumes that sufficient progress can be made by working on task A for two days in order to permit task B to be started. Again, the vertical arrow in the network schedule identifies the interrelationship between tasks A and B.

The third example defines the tasks and their durations as follows:

> Task A = prepare piping drawings (five days' duration)

> Task B = prepare piping specifications
> (eight days' duration)

The task interface diagram will be as follows:

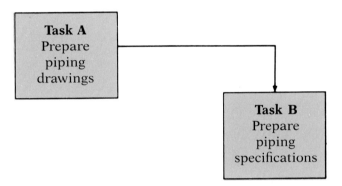

From this interrelationship and durations of tasks, the following network diagram may be drawn:

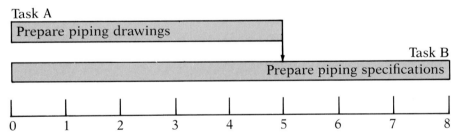

Note that task B can proceed up to a certain point, at which time you will need input from task A. If you had found that only three days of productive work could be done on task B prior to completion of task A, the schedule for the project above would have been:

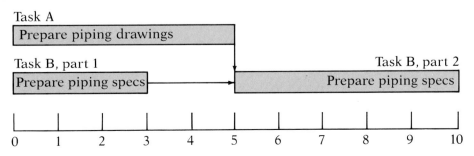

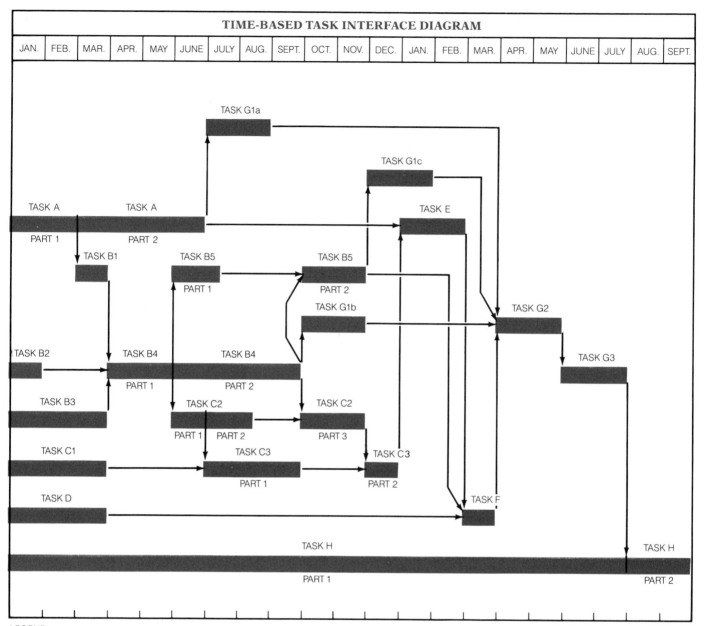

TIME-BASED TASK INTERFACE DIAGRAM

| JAN. | FEB. | MAR. | APR. | MAY | JUNE | JULY | AUG. | SEPT. | OCT. | NOV. | DEC. | JAN. | FEB. | MAR. | APR. | MAY | JUNE | JULY | AUG. | SEPT. |

TASK G1a

TASK G1c

TASK A — PART 1 TASK A — PART 2 TASK E

TASK B1

TASK B5 — PART 1 TASK B5 — PART 2

TASK G1b

TASK B2 TASK B4 — PART 1 TASK B4 — PART 2 TASK G2

TASK G3

TASK B3 TASK C2 — PART 1 PART 2 TASK C2 — PART 3

TASK C1 TASK C3 — PART 1 TASK C3 — PART 2

TASK F

TASK D

TASK H — PART 1 TASK H — PART 2

LEGEND
↑ ↓ DUMMY ACTIVITY
→ FLOAT TIME

3.7 The results of Figures 3.5 and 3.6 may be combined to derive a time-based task interface diagram.

Although the optimum duration of task B had been established as eight days, ten days will actually be required to complete this activity. The additional two days are spent waiting for task A to be completed before the second part of task B can be started. This delay is shown by the horizontal arrow connecting parts 1 and 2 of task B. These horizontal arrows are referred to as "float time."

The methods shown in the above examples may be used to develop a network schedule such as the one shown in Figure 3.7.

Step 4. Determine Critical Paths. The last step in the CPM procedure is to determine which tasks are "critical," that is, which tasks will affect the project completion date if any delay occurs. The critical tasks for each of the four two-task project examples are shown on Figure 3.8. For projects with fewer than 100 tasks, the critical tasks may be determined by graphic inspection, with results such as those shown in Figure 3.9.

CRITICAL TASKS FOR SAMPLE PROJECTS

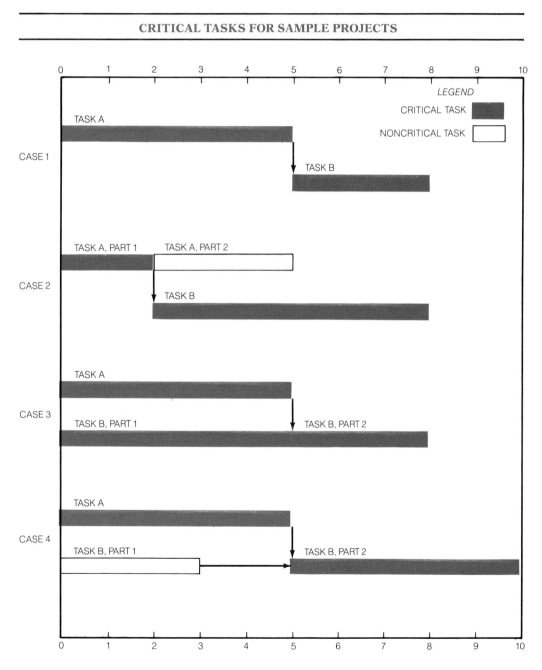

3.8 The mini-projects described on pages 31–39 may be drawn as shown, as a way of highlighting the critical tasks.

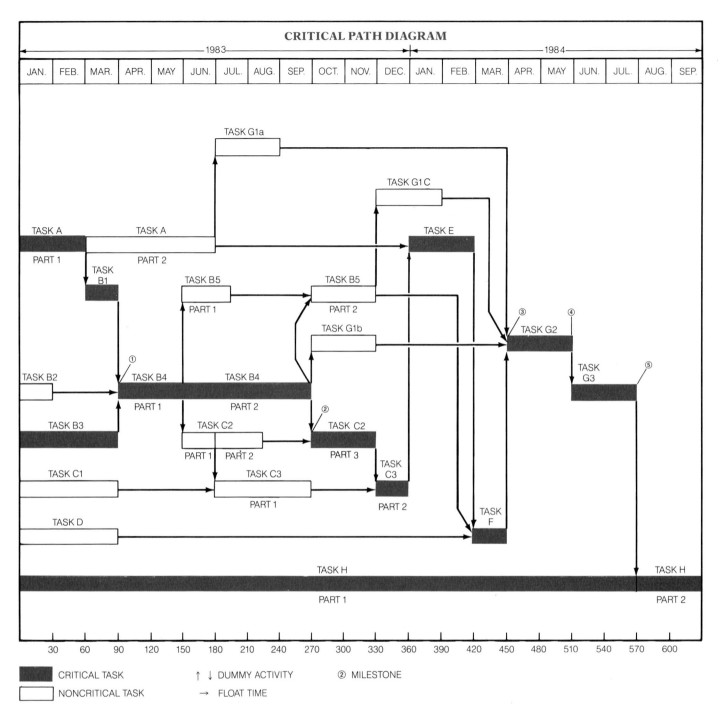

CRITICAL PATH DIAGRAM

1983 | 1984

JAN. | FEB. | MAR. | APR. | MAY | JUN. | JUL. | AUG. | SEP. | OCT. | NOV. | DEC. | JAN. | FEB. | MAR. | APR. | MAY | JUN. | JUL. | AUG. | SEP.

TASK G1a

TASK G1 C

TASK A TASK A

PART 1 PART 2

TASK E

TASK B1

TASK B5 TASK B5

PART 1 PART 2

TASK G1b

① ② ③ ④ ⑤

TASK B2 TASK B4 TASK B4

PART 1 PART 2

TASK G2

TASK G3

TASK B3 TASK C2 TASK C2

PART 1 PART 2 PART 3

TASK C3

TASK C1 TASK C3

PART 1 PART 2

TASK F

TASK D

TASK H TASK H

PART 1 PART 2

30 60 90 120 150 180 210 240 270 300 330 360 390 420 450 480 510 540 570 600

■ CRITICAL TASK ↑ ↓ DUMMY ACTIVITY ② MILESTONE

□ NONCRITICAL TASK → FLOAT TIME

3.9 The main advantage of the critical path diagram as a scheduling method is that it clearly shows relationships between tasks and pinpoints those that could prevent you from meeting project deadlines.

For larger, more complex projects you may need to tabulate the data as in Figure 3.10 to establish which tasks are critical. The identity of critical tasks becomes less obvious as the number of tasks increases, until a trial-and-error approach becomes necessary for projects with several hundred tasks.

You may then illustrate the critical paths by connecting the critical tasks using the task interrelationship arrows. It is a common misconception that every project has only one critical path. In fact, most projects have several. The number of critical paths is a good indicator of the difficulties you are likely to encounter in meeting the schedule.

The principal advantage of the critical path method is that it shows task interrelationships clearly and highlights those activities that could create problems in meeting deadlines. The major disadvantages are that CPM diagrams are difficult to read and time-consuming to prepare and update. The considerable time required to maintain a CPM chart can be a problem for project managers who have numerous responsibilities other than budget and schedule control of a single project. Often, an excellent CPM chart is prepared, but never updated, and the project manager ultimately loses control. To avoid this problem, use the critical path method to prepare the original project schedule, and then convert to a bar chart to monitor the project. You can thus reap the primary benefit of CPM—that of a planning tool—while using a less time-consuming method to monitor progress on a regular basis.

The one major exception is in case of a construction management project. The critical path method is ideal for monitoring the construction process. However, be sure to allocate enough time to keep the CPM diagram updated.

Computerized CPM Systems

The use of computers to perform CPM calculations and plot CPM charts has become increasingly popular in recent years. A number of aerospace firms and computer service bureaus offer a variety of CPM software, all of which operate in much the same way. Examples of input and output from a commonly used CPM program are presented in Figures 3.11 through 3.13.

No CPM program eliminates the need to prepare a task outline, estimate task durations, or determine the task interfaces. The computer simply computes the critical path and prepares the CPM charts and tables. The additional costs involved in computerized CPM methods compared with manual methods cover time required for:

computer processing
plotting
filling out input forms
coding all lines, nodes, and task durations
keypunching data
checking input
correcting data entry errors

The benefits of computerized CPM methods outweigh the costs only for large, complex projects. Interactive microcomputer software is most efficient for 100- to 200-task projects, while main-frame computers are generally required for projects with over 500 tasks.

Definitions

Duration: the length of time required to complete an activity assuming all prerequisites have been completed and sufficient manpower is available.

Early start: the soonest that the necessary prerequisites can be completed for a task to begin.

Early finish: the soonest that a task can be completed.

Late start: the latest that an activity can begin and still not affect the overall project completion date.

Late finish: the latest that an activity can be completed and still not affect the overall project completion date.

Free float: the length of time that a task can be delayed and still not affect the scheduling of other tasks.

Total float: the length of time that a task can be delayed and still not affect the overall project completion date.

Calculations

$(4) = (1) + (2)$

$(6) = (2) + (11)$

$(8) = (1) + (6) = (4) + (11)$

Task Designation	Activity Description
Task A, Part 1	Develop background data
Task A, Part 2	Develop background data
Task B1	Select case study sites
Task B2	Prepare briefing documents
Task B3	Develop data management plan
Task B4, Part 1	Visit case study sites
Task B4, Part 2	Visit case study sites
Task B5, Part 1	Analyze waste samples
Task B5, Part 2	Analyze waste samples
Task C1	Develop computer cost models
Task C2, Part 1	Perform preliminary case study site designs
Task C2, Part 2	Perform preliminary case study site designs
Task C2, Part 3	Perform preliminary case study site designs
Task C3, Part 1	Estimate case study disposal costs
Task C3, Part 2	Estimate case study disposal costs
Task D	Evaluate potential for treatment, recovery, reuse
Task E	Assess cost impacts
Task F	Evaluate cost impact models
Task G1a	Prepare background data report
Task G1b	Prepare site visit report
Task G1c	Prepare sampling and analyses report
Task G2	Prepare draft report
Task G3,	Prepare final report
Task H, Part 1	Project management
Task H, Part 2	Project management

3.10 The critical path diagram may be represented in a tabular format if actual dates and durations must be known precisely.

| (1) | (2) | (3) | (4) | (5) | (6) | (7) | (8) | (9) | (10) | (11) Time (Days) |
| Duration | Early Start | | Early Finish | | Late Start | | Late Finish | | Free float | Total float |
	Days	Date	Days	Date	Days	Date	Days	Date		
60	0	1/1/83	60	3/1/83	0	1/1/83	60	3/1/83	0	0
120	60	3/1/83	180	7/1/83	240	9/1/83	360	1/1/84	0	180
30	60	3/1/83	90	4/1/83	60	3/1/83	90	4/1/83	0	0
30	0	1/1/83	30	2/1/83	60	3/1/83	90	4/1/83	60	60
90	0	1/1/83	90	4/1/83	0	1/1/83	90	4/1/83	0	0
60	90	4/1/83	150	6/1/83	90	4/1/83	150	6/1/83	0	0
120	150	6/1/83	270	10/1/83	150	6/1/83	270	10/1/83	0	0
45	150	6/1/83	195	7/15/83	285	10/16/83	330	12/1/83	75	135
60	270	10/1/83	330	12/1/83	330	12/1/83	390	2/1/84	0	60
90	0	1/1/83	90	4/1/83	150	6/1/83	240	9/1/83	90	150
30	150	6/1/83	180	7/1/83	195	7/15/83	225	8/15/83	0	45
45	180	7/1/83	225	8/15/83	225	8/15/83	270	10/1/83	45	45
60	270	10/1/83	330	12/1/83	270	10/1/83	330	12/1/83	0	0
90	180	7/1/83	270	10/1/83	240	9/1/83	330	12/1/83	60	60
30	330	12/1/83	360	1/1/84	330	12/1/83	360	1/1/84	0	0
90	0	1/1/83	90	4/1/83	330	12/1/83	420	3/1/84	330	330
60	360	1/1/84	420	3/1/84	360	1/1/84	420	3/1/84	0	0
30	420	3/1/84	450	4/1/84	420	3/1/84	450	4/1/84	0	0
60	180	7/1/83	240	9/1/83	390	2/1/84	450	4/1/84	210	210
60	270	10/1/83	330	12/1/83	390	2/1/84	450	4/1/84	120	120
60	330	12/1/83	390	2/1/84	390	2/1/84	450	4/1/84	60	60
60	450	4/1/84	510	6/1/84	450	4/1/84	510	6/1/84	0	0
60	510	6/1/84	570	8/1/84	510	6/1/84	570	8/1/84	0	0
570	0	1/1/83	570	8/1/84	0	1/1/83	570	8/1/84	0	0
60	570	8/1/84	630	10/1/84	570	8/1/84	630	10/1/84	0	0

TASK ID	TASK DESCRIPTION	START NODE (I)	FINISH NODE (J)	DURATION CALENDAR DAYS
IA	STATE/REG BACKGROUND PART 1	1	4	60
IA	STATE/REG BACKGROUND PART 2	4	3	120
IB1	UTILITY SITE SELECTION	4	5	30
IB2	BRIEFING DOCUMENTS	137	5	30
IB3	DATA MGMT PLAN	1	5	90
IB4	UTILITY SITE VISITS PART 1	5	65	60
IB4	UTILITY SITE VISITS PART 2	65	11	120
IB5	DATA MGMT PART 1	10	41	120
IB5	DATA MGMT PART 2	41	12	90
IC1	DEVELOP COMPUTER MODELS	1	6	60
IC2	VERIFY COMPUTER MODELS	6	10	30
IC3	PRELIM DESIGN PART 1	10	13	30
IC3	PRELIM DESIGN PART 2	13	40	90
IC3	PRELIM DESIGN PART 3	40	14	60
IC4	COST ESTIMATE PART 1	13	42	150
IC4	COST ESTIMATE PART 2	42	16	30
ID	TREATMENT, RECOVERY, REUSE	1	18	180
IE1	REG COST IMPACTS	16	17	30
IE2	NATIONAL COST IMPACTS	17	19	30
IE3	IMPACT MODEL EVALUATION PART 1	18	43	30
IE3	IMPACT MODEL EVALUATION PART 2	43	125	30
IF1A	EMERG TECH DATA COLL	1	7	180
IF1B	EMERG TECH SITE VISITS	1	8	180
IF1C	EMERG TECH DATA MGMT	8	120	120
IF1D	EMERG TECH COST IMPACT PART 1	7	44	30
IF1D	EMERG TECH COST IMPACT PART 2	44	124	30
IF2A	REVIEW OTHER REGS	1	9	90
IF2B	POTENTIAL DELAYS	9	126	60
IF2C	ESTIMATE INCREMENTAL COST INCREASE PT 1	126	45	90
IF2C	ESTIMATE INCREMENTAL COST INCREASE PT 2	45	125	30
IG1	BACKGROUND DATA REPORT	3	125	60
IG2	SITE VISIT REPORT	1	125	60

3.11 Recent advances in microcomputer technology have made it economical to utilize computerized scheduling methods for smaller projects. Reproduced courtesy of Omicron Software, Atlanta, Georgia.

WORK ITEM	ACTIVITY DESCRIPTION	ORG DLR	REM CUR DLR	TYPE CUR WORK	CCNTR LCC	START	FINISH	EARLY START	LATE FINISH	REM FLCAT
05/01/75 (13.0)										
STL7517C09	PREFAB METAL BLDG DETAILS	4.0	0.4	GENL EGR	EXT FIN	05/01/75	05/01/75	A04/21/75	05/15/75	9.6
STL7517E12	PAINT CERTIFICATE & SAMPLES	5.0	4.0	PAIN PRO	EXT FIN	05/01/75	05/07/75	A04/22/75	06/02/75	17.0
STL7517C10	PLUMBING MATERIALS, PUMP AND CONTROLS	5.0	2.5	PLMB PRO	INT FIN	05/01/75	05/05/75	A04/23/75	05/15/75	7.5
STL7517B06	FORM & POUR	5.0	2.0	GENL CON	FND FIN	04/30/75	05/02/75	A05/01/75	M05/02/75	0.0
STL7517B07	CURE TIME	8.0	8.0	GENL CON	FND NEW	05/02/75	05/14/75	05/05/75	05/15/75	1.0
05/08/75 (18.0)										
STL7517B07	CURE TIME	8.0	5.0	GENL CON	FND FIN	05/02/75	05/14/75	05/05/75	05/15/75	1.0
05/15/75 (23.0)										
STL7517C14	ERECT STRUCTURAL STEEL	4.0	4.0	GENL CON	EXT FIN	05/14/75	05/20/75	05/15/75	05/21/75	1.0
STL7517C13	SET PUMP & COMPLETE PIFING	7.0	7.0	PLMB CON	INT NEW	05/14/75	05/23/75	05/15/75	06/03/75	6.0
STL7517C15	INSTALL ROOFING & SIDING	5.0	5.0	SIDE CON	EXT NEW	05/20/75	05/28/75	05/21/75	05/29/75	1.0
05/22/75 (28.0)										
STL7517C13	SET PUMP & COMPLETE PIFING	7.0	2.0	PLMB CON	INT FIN	05/14/75	05/23/75	05/15/75	06/03/75	6.0
STL7517C15	INSTALL ROOFING & SIDING	5.0	4.0	SIDE CON	EXT FIN	05/20/75	05/28/75	05/21/75	05/29/75	1.0
STL7517D16	WIRE PUMP	2.0	2.0	ELEC CON	INT FIN	05/23/75	05/28/75	05/27/75	06/05/75	6.0
STL7517D18	INSTALL LIGHTS & PANELS	3.0	3.0	ELEC CON	INT NEW	05/28/75	06/02/75	05/29/75	06/03/75	1.0

3.12 This computerized CPM network report provides essentially the same type of information as was s computed manually in Figure 3.10. computed manually in Figure 3.10. Reproduced courtesy of Omicron Software, Atlanta, Georgia.

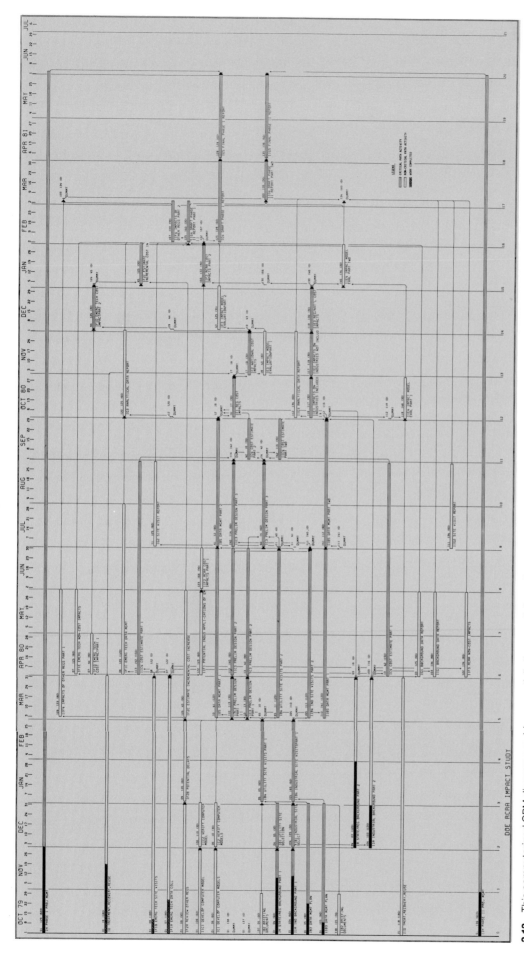

3.13 This computerized CPM diagram provides essentially the same information as was developed manually in Figure 3.8. Reproduced courtesy of Engineering-Science, Inc., Atlanta, Georgia.

Wall Scheduling

In recent years several firms have begun using a technique known as "wall" scheduling. It uses a full wall on which vertical lines are drawn five inches apart, with the space between each pair of lines representing one workweek. Horizontal lines spaced three inches apart are used to separate the key individuals on the project team (see Figure 3.14).

To assemble the full-wall schedule, the project manager must develop a list of project tasks, identify who is primarily responsible for each task, and prepare a preliminary milestone chart. Then each task is written on two 3″ × 5″ index cards. One card is labeled "start" and the other "finish." The cards are then divided into piles—one for each person responsible for performing the various tasks.

After all cards are prepared, the project manager writes the name of each key individual on a 3″ × 5″ card and pins the cards along the left column of the divided wall. The project manager then calls a meeting in the room and asks that all responsible for carrying out the tasks be present (including the client, any third-party agency representatives, and, if possible, the contractor). Each person is handed his or her 3″ × 5″ cards and asked to tack each one onto the vertical division on the wall in the workweek during which each task will be started and finished. Tasks may be divided into subtasks or better defined as required. When all cards are up, additional tasks not anticipated may be added. Others may be modified.

LAYOUT FOR WALL SCHEDULING

Project Team Participants	Week # 1 3/22–3/26	Week #2 3/29–4/2	Week #3 4/5–4/9	Week #4 4/12–4/16	Week #5 4/19–4/23	Week #6 4/26–4/30	Week #7 5/3–5/7

3.14 Note in the layout for wall scheduling that each space is sized to allow standard 3″ x 5″ index cards to be pinned or taped over it.

During the meeting, the project manager should obtain verbal and graphic commitment from all parties that their tasks will be accomplished on schedule. In addition, conflicts should be discussed and solutions resolved with everyone in one room. After the session and before taking the task cards off the wall, the project manager identifies each individual vertically with a letter and each task horizontally with a number. Subsequently, each letter/number combination becomes a designation for a task description, which may then be dictated to the secretarial staff for typing.

After the task list has been dictated, a mini-wall schedule is prepared by listing the work weeks in numerical order across the top of an 8½″ × 11″ page and listing those parties responsible for the tasks down the side of the schedule. The intersecting boxes then contain only the numerical designation of a particular task or tasks that an individual will accomplish during that particular workweek. Copying the one- or two-page schedule and attaching the list of task descriptions provides everyone with a comprehensive yet simple schedule that is completely understood and that everybody has already agreed to. Revisions can be made quickly by phone or, if necessary, by reassembling the team. Primary tasks can be broken down into subtasks and scheduled in a similar manner.

A brief outline summarizing the wall scheduling procedure is shown in Figure 3.15 for easy reference. Output from a completed wall schedule is shown in Figures 3.16 and 3.17. Photographs of an actual wall scheduling room are shown in Figures 3.18 through 3.20.

WALL SCHEDULING PROCEDURE

1. Set up wall schedule

 a. "Time" scale (horizontal)

 b. "Team member" scale (vertical)

2. Project manager prepares preliminary schedule

 a. List start and finish of events on cards

 b. Place critical event cards on schedule board

 c. Arrange other event cards

3. Gather together all key team members

 a. Identify additional events

 b. Rearrange cards on schedule board

 c. All team members commit to schedule

4. Project manager serial numbers each team member's events

5. Convert to 8-1/2″ × 11″ format (see example) and distribute to team members

6. Update schedule as required

7. Follow above steps for scheduling in-house staff

3.15 In this summary of the steps used to prepare wall scheduling, note that step 2 is the one most critical to the success of this approach.

Work Week	#46 Nov. 12 through Nov. 16	#47 Nov. 19 through Nov. 23	#48 Nov. 26 through Nov. 30	#49 Dec. 3 through Dec. 7	#50 Dec. 10 through Dec. 14	#51 Dec. 17 through Dec. 21	#52 Dec. 24 through Dec. 28	#53 Dec. 31 through Jan. 4
OWNR A	7	8 9	10	11	12 13	14 15		
CONT B				1	1	1		
ARCH C	8 9	10 11	12	13 14	15	16 17		
LA D	2	3			4			
IA E	3 4	5	6		7 8			
SE F	4	5 6	7		8			
ME G	4	5			6			
EE H	3 4 5	6			7			
CE J	6 7	8	9		10 11			
DC K						1		
CNTY L			2			3 4		
GC M					1			
PUC N		2						
SHD P	1	2						
CL Q	1							
GT R	1							
IRI S	2			3	3			
MC T				1	1	2 3		
SC U	1 2							
CA W								
FC X	2			3				

WALL PROJECT SCHEDULE

3.16 In this portion of a completed schedule using the wall scheduling method, time milestones are shown across the top and initials and letter symbols of team members in the left column. Key project personnel and task numbers are defined in Figure 3.17.

SCHEDULE OF EVENTS FOR WALL SCHEDULE

A. Owner

A.7 Issue mill construction schedule
A.8 Approve design development
A.9 Approve furnishings program
A.10 Negotiate easements
A.11 Approve piling construction documents
A.12 Approve construction documents
A.13 Approve bidder list
A.14 Approve furnishings design
A.15 Sign piling contract

B. Contractor

B.1 Begin bidding

C. Architects, MUS/PC

C.8 Complete design development
C.9 Review overpass with PUC and Highway Dept.
C.10 Begin construction documents—general construction
C.11 Begin piling construction documents
C.12 Complete piling construction documents
C.13 Prepare bidder list—general construction
C.14 Issue piling construction documents
C.15 Complete construction documents—
 general construction
C.16 Prepare piling contract
C.17 Issue bidding documents for general construction

D. Landscape Architect, MUS/PC

D.2 End landscape design development
D.3 Begin landscape construction documents
D.4 End landscape construction documents

E. Interiors Architect, MUS/PC

E.3 End furnishings program
E.4 End interiors design
E.5 Begin interiors construction documents
E.6 Begin furnishings design
E.7 End interiors construction documents
E.8 End furnishings design

F. Structural Eng., John Herrick

F.4 End structural design
F.5 Begin piling construction documents
F.6 Begin structural construction documents
F.7 Complete piling construction documents
F.8 End structural construction documents

G. Mechanical Eng., Rogers Eng.

G.4 End design
G.5 Begin construction documents
G.6 End construction documents

H. Electrical Eng., Warner Eng.

H.3 Review with telephone co.
H.4 Review with power co.
H.5 End design
H.6 Begin construction documents
H.7 End construction documents

J. Civil Eng., Tri Systems

J.6 Complete storm system design
J.7 End design
J.8 Prepare easements
J.9 Begin construction documents
J.10 End construction documents
J.11 Easement dedication

K. Dept. of Commerce, Bldg. Code Dept.

K.1 Begin plan review

L. Douglas Co., Bldg. Dept.

L.2 Begin piling plan review
L.3 Begin plan review
L.4 Issue piling building permit

M. City of Gardiner Water Dist.

M.1 Review water system design

N. Public Utility Commission

N.2 Approve clearance

3.17 Task assignments for each key individual are agreed upon during the scheduling meeting and then documented as shown.

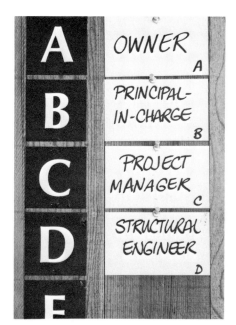

3.18-20 Some firms have constructed "wall scheduling rooms" in their offices. Photographs courtesy of Moreland/Unruh/Smith, PC, Eugene, Oregon.

The key feature of the wall scheduling procedure is the high degree of interaction that takes place during the scheduling meeting. Conflicts are identified early, discussed, and resolved. This process enables the key project team members to make firm commitments to the project manager as to their assigned activities. Furthermore, these commitments are made in front of the entire group, thereby increasing the probability that they will indeed be accomplished on time.

The successful application of the wall system relies on the project manager's skills in planning the project, establishing a preliminary schedule for use by the group, and directing the proceedings during the scheduling meeting. If the project manager does these things well, total meeting time can be cut to a minimum while producing a realistic schedule to meet client needs.

The primary disadvantage of wall scheduling is that it requires all parties to come together for a scheduling meeting. Firms with multiple offices throughout the country could face travel problems. Also, this method of scheduling does not clearly show interrelationships of tasks on a critical path as well as do the CPM methods of scheduling.

As with any scheduling method, wall scheduling should be used only on appropriate projects, based on scope of tasks and numbers of people involved in the schedule. This method works best for projects with more than 30 but fewer than 500 tasks and with anywhere from 3 to 10 people involved in the scheduling session. Many firms are reporting that clients and third-party agency representatives are among the strongest supporters of this method of scheduling.

Selecting the Best Scheduling Method

As mentioned in the beginning of this chapter, no single scheduling method is applicable for all projects. Figure 3.21 summarizes some of the most important criteria for selecting the best scheduling method.

You should review these criteria for each specific project and then select the scheduling method that is best suited to the criteria with the highest priorities.

CRITERIA FOR SELECTING THE PROPER SCHEDULING METHOD

Evaluation Criteria	Milestone	Bar Chart	CPM Diagram	Full Wall Schedule
1. Ease of communication	Good	Good	Poor	Excellent
2. Cost to prepare	Minimal	Minimal	Extensive	Moderate
3. Cost to update	Minimal	Minimal	Extensive	Moderate
4. Degree of control	Fair	Good	Excellent	Good
5. Applicability to large projects	Poor	Fair	Excellent	Good
6. Applicability to small projects	Excellent	Good	Poor	Good
7. Commitment from project team	Fair	Fair	Fair	Excellent
8. Client appeal	Fair	Good	Excellent	Excellent

3.21 Select the best scheduling method by considering which evaluation criteria are most important to you for each specific project.

Avoiding Common Pitfalls in Preparing Project Schedules

Establishing a realistic project schedule is a difficult assignment. The following pitfalls have been commonly observed as a job progresses:

1. Scheduling time for "final reviews" without scheduling time to make the changes that always result. For instance, when you schedule review by a building code plan examiner one week before your bid date, you risk a major code violation that could cause significant changes and a delay in bidding.

2. Failure to anticipate the nontechnical activities that must be performed after all the contractual requirements have been met, such as phone calls from contractors to clarify drawings and meetings with review agencies to obtain the necessary permits.

3. Scheduling a project without properly considering the impact of other projects on the workload of the project team. Many principals are guilty of this omission, which causes teams to lose motivation and overall quality of work to suffer. Promises to clients should be qualified with statements that allow you to check your manpower "loading" before committing yourself.

4. Failure to obtain firm commitments from key project team members, including outside consultants.

5. Failure to provide time for slippage in the schedule. All schedules slip. For instance, if no time is allowed for an architectural designer to miss a deadline, you will create an impossible chain of unmet future deadlines, causing frustration for your project team and client. Slippage time is a necessary ingredient of good scheduling, to allow for reviews or changes that will occur in every project.

All the above problems can be remedied more readily if they are anticipated at the time the project schedule is prepared. If ignored, they will almost always cause difficulties later in the project.

Conclusion

This chapter has shown how a task outline may be used to develop a project schedule. It has also pointed out ways to select the best scheduling methods for various types of projects.

The next chapter describes various ways of developing the project budget, with special emphasis on how to avoid common pitfalls that may result in budget overruns.

CHAPTER 4 Establishing the Project Budget

1. What must I do to convert the project fee into a project budget?

2. What elements of a project budget should I be able to control?

3. When should I use or avoid zero-based budgeting on my project?

4. When can I best apply downward budgeting to a project?

5. What are the main advantages and drawbacks of unit cost budgeting?

6. How do I know I have included all budget items that belong in a project budget?

7. What is the best way to develop a projected expenditure curve?

WHEN YOUR FIRM receives a design fee for a project, that amount is usually divided into five components:

1. Prepare a task outline of contract requirements (see Chapter 2).

2. Overhead—holidays, rent, vehicles, insurance, etc.

3. Other direct costs—consultants' fees, travel costs, printing fees, and other related out-of-pocket expenses required to perform the project.

4. Contingency—a cushion to handle unforeseen problems.

5. Profit—provides the necessary reward and stability that enable the firm to operate through lean times without going out of business.

Fees Are Not Budgets

The project manager has responsibility for establishing and controlling only the first four items. Profit should be removed from the budget as soon as the contract is signed and "put in the bank." It belongs to the principals of the firm, and the project manager has no right to *any* of it. This means that project managers should be judged *not so much on how much profit they have made, but on how closely they have adhered to their budgets.* The only exception to this rule is the contract that is based on a standard fee schedule which includes the profit in the billing rates. In this case, the project manager must monitor total costs (including profit) to be sure that they do not exceed the authorized amount.

Another common source of confusion is how the word "fee" is used in a cost-plus-fixed-fee or cost-plus-percentage-fee type of contract. In this case, the fee is synonymous with profit, assuming that the cost portion truly includes all the first four of the above components. If these components are not included the actual profit is less than the fee. Because of the potential for confusion we will avoid the word "fee" in this chapter and define the "project value" as the total amount of compensation received and the "budget" as the sum of the first four of the above components.

Four Ways to Budget a Project

There are usually four ways that budgets can be computed for any project. The first method is "zero-based" budgeting. You start with a list of tasks and estimate the man-hours and corresponding costs to perform the work. The second is "downward" budgeting, which involves starting with the amount of compensation that can be obtained and breaking out the various cost components to establish the number of man-hours that can be allocated. The third method of budgeting is the "unit cost" budget, or the use of "historical" cost data (other than man-hours) from previous similar projects, such as cost per sheet of drawings. The fourth method is the "staffing level" budget, which considers the number of people assigned to a job for a certain time period.

Each method provides a different perspective, and comparison of results from the four can be most revealing. This chapter describes how each of these methods is best used, its advantages and pitfalls, and finally, how the results of each can be used to establish the project budget.

Zero-Based Budgeting. Zero-based budgeting means that each task must be analyzed so that any cost associated with that task is developed by determining what the particular project requires. Zero-based budgeting typically uses the following approach:

1. Prepare a task outline of contract requirements (see Chapter 2)

2. Estimate man-hours by labor category for each task.

3. Estimate direct labor rates for each labor category.

4. Calculate direct labor cost for each task by multiplying results of steps 2 and 3.

PROJECT ESTIMATING SHEET

Prepared by __DB__
Date __11/26/79__
Project __Example__ Number _____ Client __DOE__

(Category of Personnel / Rate per Hour)

Each direct-labor cell shows hours (top) and dollars (bottom).

Phase/task	A Principal $22/hr	A Proj Mgr $16/hr	A Arch/Eng $13/hr	A Technician $10/hr	A Drafting $8/hr	A Secretary $6/hr	B DIRECT LABOR COSTS	C OVERHEAD (B×1.5)	D OTHER DIRECT COSTS	E EST COST B+C+D	F CONTINGENCIES	G TOTAL BUDGET (E+F)	H PROFIT	I PROJECT VALUE (G+H)
A	20 / $440	20 / 320	200 / 2600	40 / 400	40 / 320	20 / 120	340 hrs / $4200	6,300	2640	13,140	1,314	14,454	1,445	15,899
B1	8 / 176	16 / 256	40 / 520	0 / 0	0 / 0	8 / 48	72 / 1000	1,500	420	2,920	292	3,212	321	3,533
B2	0 / 0	20 / 320	40 / 520	0 / 0	20 / 160	20 / 120	100 / 1120	1,680	160	2,960	296	3,256	326	3,582
B3	12 / 264	40 / 640	120 / 1560	0 / 0	20 / 160	40 / 240	232 / 2864	4,296	490	7,650	765	8,415	842	9,257
B4	20 / 440	60 / 960	400 / 5200	0 / 0	0 / 0	0 / 0	480 / 6600	9,900	3,200	19,700	1,970	21,670	2,167	23,837
B5	0 / 0	20 / 320	40 / 520	400 / 4000	0 / 0	40 / 240	500 / 5080	7,620	4,800	17,500	1,750	19,250	1,925	21,175
C1	8 / 176	20 / 320	120 / 1560	60 / 600	20 / 160	40 / 240	268 / 3056	4,584	420	8,060	806	8,866	887	9,753
C2	20 / 440	40 / 640	160 / 2080	0 / 0	120 / 960	20 / 120	360 / 4240	6,360	260	10,860	1,086	11,946	1,195	13,141
C3	8 / 176	20 / 320	160 / 2080	80 / 800	0 / 0	12 / 72	280 / 3448	5,172	200	8,820	882	9,702	970	10,672
D	8 / 176	12 / 192	80 / 1040	0 / 0	20 / 160	20 / 120	140 / 1688	2,532	200	4,420	442	4,862	486	5,348
E	20 / 440	60 / 960	40 / 520	0 / 0	0 / 0	12 / 72	132 / 1992	2,988	280	5,260	526	5,786	579	6,365
F	20 / 440	40 / 640	80 / 1040	0 / 0	12 / 96	12 / 72	164 / 2288	3,432	520	6,240	624	6,864	686	7,550
G1a	8 / 176	20 / 320	80 / 1040	20 / 200	80 / 640	120 / 720	328 / 3096	4,644	1,200	8,940	894	9,834	983	10,817
G1b	8 / 176	20 / 320	80 / 1040	20 / 200	80 / 640	120 / 720	328 / 3096	4,644	1,200	8,940	894	9,834	983	10,817
G1c	8 / 176	20 / 320	80 / 1040	20 / 200	80 / 640	120 / 720	328 / 3096	4,644	1,200	8,940	894	9,834	983	10,817
G2	20 / 440	80 / 1280	160 / 2080	80 / 800	120 / 960	240 / 1440	700 / 7000	10,500	600	18,100	1,810	19,910	1,991	21,901
G3	8 / 176	40 / 640	40 / 520	20 / 200	20 / 160	60 / 360	188 / 2056	3,084	2,800	7,940	794	8,734	873	9,607
H	60 / 1320	160 / 2560	40 / 520	0 / 0	20 / 160	40 / 240	320 / 4800	7,200	1,400	13,400	1,340	14,740	1,474	16,214
TOTALS	256 hrs / $5632	708 / 11,328	1960 / 25,480	740 / 7400	652 / 5216	944 / 5664	5260 hrs / $60,720	91,080	21,990	173,790	17,379	191,169	19,116	210,285

4.1 Forms such as this project estimating sheet can help you do the computations using the zero-based budgeting method. Letters in left-hand column refer to tasks described in Fig. 2.4.

5. Add overhead costs as a percentage of the direct labor cost determined in step 4.

6. Estimate other direct costs (such as air fare, printing, and subconsultants) for each task.

7. Add the appropriate contingency.

8. Add the desired profit.

Computations can be made more systematic by using an estimating form like the one in Figure 4.1. Examples of worksheets that can be used to derive this budget are shown in Figures 4.2 and 4.3. The major advantages of the zero-based budgeting approach are:

1. It forces the project manager to plan the job.

2. It provides the project manager with baseline information essential for monitoring and controlling the project budget and schedule.

3. It obtains commitments from the individuals involved in estimating the level of effort required for each task.

4. It provides the information needed to calculate manpower requirements.

5. It provides the information that can be valuable during fee negotiations or negotiations for contract modifications.

Despite the above inherent advantages, the zero-based budgeting method also contains two potential pitfalls. The first is that the project manager may tend to pile contingency upon contingency, ultimately overpricing the job and losing the contract. The second pitfall is failing to identify all the subtle costs that must be figured into the typical project.

To illustrate this second potential pitfall, let us define a sample project, which consists of sending a two-person crew to a power plant to collect smokestack samples for a one-month period. The obvious costs of this project are:

> two man-months for the field crew
> travel costs for the field crew to get to the power plant
> two months of living expenses while on-site
> stack sampling equipment rental for one month

However, a more careful analysis of the project requirements would reveal the costs must also be included for such activities as:

> office coordination of activities
> meetings with the client
> mobilization and demobilization of sampling stations
> reduction of stack sampling data
> report preparation and printing
> maintenance of project records

Another example of hidden costs is an interior design firm that is asked to evaluate a client's existing furnishings and to integrate new furniture purchases with older furnishings before a move into a new office building. The obvious costs for such a project are:

> man-hours for a field inventory of furniture
> travel time to and from various client offices
> design time to select appropriate new furnishings
> drawing time to layout old vs. new furnishings

A closer scrutiny of such an interiors project would reveal that these additional costs must be included before budgeting the project:

> tagging of all old furniture for moving and locating in the new facility
> meeting time with client to review specific pieces of furniture you have selected

U. S. ARMY
HUNTSVILLE DIVISION, CORPS OF ENGINEERS

ARCHITECT-ENGINEER COST ESTIMATE	ARCHITECT-ENGINEER FIRM NAME AND ADDRESS	DESIGN STAGE		COST OR PRICING DATA REFERENCE
	ABC Consultants, Inc. 1000 Main Street Anytown, USA	MODIFIED CONCEPT	(OPTION) FINAL	
RFP/CONTR. NUMBER DACA87- 81 - R - 0000		**LOCATION:** Fort Kennedy		
PREPARED BY: David Smith	**PROJ. TITLE:** Industrial Waste Treatment Facility	**PROJ. NO:** 5062.61		
APPROVED BY: A. W. Jones	**DATE:** 11/8/82	**TASK NAME/BUILDING/OTHER:** Intermediate Design	**TASK NO:**	

ITEM "A"-TASK EFFORT BREAKDOWN TASK RECAP: 4,024 MH = $ 133,674

SPECIALITIES	JOB TITLES	MAN-HOURS	RATES $	AMOUNTS $	TOTALS $
PROJECT MANAGEMENT	Supervisor	214	20.50	4,387	
	Typist/Clerical	80	5.89	471	4,858
CIVIL	Supervisor	10	20.50	205	
	Journeyman	30	13.89	417	
	Draftsman	90	8.90	801	
NO. OF DWGS.(3)	Typist	20	5.89	118	1,541
ARCHITECTURAL	Supervisor	14	20.50	287	
	Journeyman	30	13.89	417	
	Designer	48	10.95	526	
NO. OF DWGS.(4)	Typist	12	5.89	71	1,301
STRUCTURAL	Supervisor	34	20.50	697	
	Journeyman	100	13.89	1,389	
	Draftsman	280	8.90	2,492	
NO. OF DWGS.(7)	Typist	24	5.89	141	4,719
MECHANICAL	Supervisor	232	20.50	4,756	
	Journeyman	928	13.89	12,890	
	Designer	996	10.95	10,906	
NO. OF DWGS.(36)	Typist	32	5.89	188	28,740
HV/AC	Supervisor	6	20.50	123	
	Journeyman	20	13.89	278	
	Draftsman	30	8.90	267	
NO. OF DWGS.(2.)	Typist	4	5.89	24	692
ENVIRONMENTAL	Supervisor	25	20.50	513	
	Journeyman	98	13.89	1,361	
	Draftsman	100	8.90	890	
NO. OF DWGS.(13)	Typist	20	5.89	118	2,882
ELECTRICAL	Supervisor	63	20.50	1,292	
	Journeyman	85	13.89	1,181	
	Designer	110	10.95	1,205	
NO. OF DWGS.(11)	Typist	16	5.89	256	3,934
SPECIFICATIONS	Supervisor	28	20.50	574	
	Journeyman	79	13.89	1,097	
	Typist	44	5.89	259	1,930
ESTIMATES	Supervisor	20	20.50	410	
	Journeyman	102	13.89	1,417	1,827
OTHER					

TOTAL DRAWINGS	71	TOTAL MAN-HOURS	4,024	TOTAL DIRECT SALARIES	52,424

ITEM "B" OVERHEAD POOLS

	TITLES	RATES %	BASES $		
1	Total Allowable Overhead	148.3	52,424		77,745
2					
3					

ITEM "C" OTHER COST (CONSULTANTS, TELEPHONE, REPRODUCTION, POSTAGE, ATTACH ESTIMATES AS REQUIRED	1,252
ITEM "D" TRAVEL COST (ATTACH ESTIMATE SHEETS)	2,253
ITEM "E" MATERIAL AND SUPPIES (ATTACH ESTIMATES AS REQUIRED)	

HND FORM 371 14 AUG 1975

4.2 This format (used by the U.S. Army Corps of Engineers) may be used to summarize costs associated with design projects. Note that project management is identified as a major budget item along with civil, architectural, structural, and other disciplines.

ARCHITECT-ENGINEER COST ESTIMATE	PROJECT TITLE: Industrial Wastewater Treatment Facility		AE NAME & ADDRESS: ABC Consultants, Inc. 1000 Main Street Anytown, USA
PREPARED BY: David Smith	PROJECT LOCATION: Fort Kennedy	PROJECT NO. 5062.61	
DATE: 11/8/82	TASK DESCRIPTION: Intermediate Design	TASK NO.	RFP/CONTRACT NO. DACA87- 81 - R - 0000

REPORTING DISCIPLINE:

MECH ___ CIVIL ___ ARCH ___ ESTIMATES _X_

ELECT ___ STRUCT ___ SPECS ___ P.M. ___ OTHER ___

TASK AND DRAWING DESCRIPTION	CONCEPT DWGS NEW	CONCEPT DWGS REV.	CONCEPT MAN-HOURS SUPERVISOR	CONCEPT MAN-HOURS JOURNEYMAN	CONCEPT MAN-HOURS DRAFTSMAN	FINAL DWGS NEW	FINAL DWGS REV.	FINAL MAN-HOURS SUPERVISOR	FINAL MAN-HOURS JOURNEYMAN	FINAL MAN-HOURS DRAFTSMAN
A. Prepare Major Equipment List			8	8						
B. Obtain Quotes for Major Equipment				24						
C. Take off Major Piping				8						
D. Take off Site Work				8						
E. Take off Concrete			4	12						
F. Take off Buildings				10						
G. Obtain Unit Prices (Means, Dodge Guides)				8						
H. Estimate Misc. Other Costs			4	16						
I. Review and Finalize Estimate			4	8						
TOTALS			20	102						

NO. DWGS ___ NO. MHs ___ MHs/DWG ___

HND FORM 426 (REVISED 29 MAR.77) PREVIOUS EDITIONS MAY BE USED PAGE ___ OF ___

4.3 The major budget items in Figure 4.2 may be broken out as shown in this example taken from a project conducted for the U.S. Army Corps of Engineers.

cost of supplies for tagging and inventorying old furnishings
expediting costs involved in the purchase of new furniture
cash flow costs incurred if the firm purchases furnishings on behalf of the client
replacement costs of furniture damaged or lost before or during a move, including your time to evaluate the problem and select another piece of furniture

When requesting proposals, most clients tend to consider only the obvious costs, ignoring the less visible items. It is the project manager's job not only to include all these hidden costs, but also to be able to explain to the client why they are necessary.

Downward Budgeting. The downward budgeting approach arrives at a total fee based on a percentage of construction cost, cost per square foot of building, or some other method not directly related to the level of effort required to perform the work. The desired profit, contingencies, overhead, and other direct costs are subtracted to obtain the dollar amount available for manpower. This amount is then divided by average hourly rates to obtain the total number of hours available for each labor category to perform required tasks. Sample calculations of downward budgets are shown on Figures 4.4 and 4.5.

WORKSHEET FOR DOWNWARD BUDGETING: FIXED FEE OR LUMP SUM PROJECTS

1. Total project value $ _92,000_

2. Desired profit $ _9,200_

3. Total project budget $ _82,800_

4. Direct costs excluding labor $ _4,700_

5. Amount available for direct labor and overhead $ _78,100_ 6. Current nominal overhead rate _150_ %

7. Amount available for direct labor

$$\text{Line 5} \div \left(1 + \frac{\text{line 6}}{100}\right)$$

$ _31,240_

Personnel	Category	Hours	Hourly Rate	Direct Salaries
F. Jones	Principal	40	$ 25.00	$1,000
R. Smith	Senior Engineer	160	18.00	2,880
N. Turner	Senior Architect	160	17.00	2,720
L. Johnson	Junior Engineer	635	12.00	7,620
S. Strom	Senior Designer	480	11.00	5,280
D. Sargent	Draftsman	1,240	8.00	9,920
N. Franklin	Typist	280	6.50	1,820

8. Total direct salaries (should be same as line 7) $ _31,240_

Reproduced courtesy of Engineering–Science, Inc., Arcadia, California.

4.4 The downward budgeting approach begins with a total anticipated fee and serves to determine the number of man-hours that may be used by each member of the project team.

WORKSHEET FOR DOWNWARD BUDGETING: STANDARD FEE SCHEDULE PROJECTS

1. Total project value $ _93,670_ 1a. Nominal overhead rate _150_ %

2. Direct costs excluding labor $ _4,200_

3. Handling charge for expenses $ _420_

4. Total expenses billed $ _4,620_

5. Total labor billed $ _89,050_

Category	Hourly Billing Rate	Hours	Labor Billing	Actual Salary Rate	Direct Salaries
Principal	$ 75	40	$ 3,000	$ 25.00/hr.	$ 1,000
Senior A/E	50	320	16,000	17.50	5,600
Staff A/E	30	1115	33,450	11.50	12,822
Draftsman	25	1240	31,000	8.00	9,920
Clerical	20	280	5,600	6.50	1,820

6. Total labor billed $ _89,050_

7. Total direct salaries $ _31,162_

8. Nominal overhead (line 7 × nominal OH rate) $ _46,743_

9. Total projected budget (sum of lines 2, 7, and 8) $ _82,105_

Reproduced courtesy of Engineering–Science, Inc., Arcadia, California

4.5 When you do not initially know exactly who will work on the project team, downward budgeting may be used to establish the total man-hours for each labor category.

The success of the downward budgeting approach is based on determining the maximum possible compensation for a given project, which requires knowing two important items of information. The first is the market price, or how much your competitors will charge for the same project. The second is the client's budget for the job. Estimating the market price means knowing who your competitors are, the nature of their pricing structure, the level of effort they will probably use for budgeting the job, and how hungry they are for work. Finding out the client's budget involves probing to determine the kinds of guidelines that the client usually uses (for instance, percentage of construction cost or dollars per square foot). In some cases, the client's budget may even be public information that can be obtained for the asking.

The major advantages of downward budgeting are (1) it is based on obtaining the maximum possible compensation and (2) it targets budgets that will (at least theoretically) meet the firm's profit goals. The primary disadvantages are:

1. It does not obtain a high level of commitment from the project team.

2. It does not provide the project manager with essential planning information.

3. It fails to identify jobs that cannot be done within the available financial limitations.

4. The hours left to do the work may not relate to the amount of time required for the various tasks.

Unit Cost Budgeting. Probably the most common use of the unit cost budget is to determine the cost per sheet of design drawings. Other examples of unit cost budgeting tools used in design firms include cost per square foot of design drawings, cost per page for certain types of reports, cost per analysis for laboratory work, and cost per boring for soil investigations.

The main advantage of unit cost budgeting is that it provides an objective estimate based on actual historical costs for similar work. The major disadvantage is that no two projects are exactly alike. Even if they were, the second project would probably cost less because of the experience gained from the first. Also, this method does not account for cost impacts resulting from changes in conditions that have occurred over the years. Examples of such changes include productivity increases resulting from computerization, additional work required by new government regulations, and improvements or reductions in efficiency resulting from staff changes.

Furthermore, the unit cost budgeting approach does not provide the project manager with the quality of planning information that can be obtained from the zero-based budgeting method.

Staffing Level Budgets. The fourth method of budgeting is to estimate the total size of the project team for each phase of the project. The budget is determined by multiplying the number of people by the length of time each will work on the project to obtain the total estimated man-hours.

The man-hours are then multiplied by average hourly rates to obtain direct labor costs. Overhead, other direct costs, contingency, and profit are added in the same manner as previously described for zero-based budgeting.

Staffing level budgeting works well for small projects involving few people for a short period of time. It is also useful as an independent check of the other budgeting methods described above. The major problem with staffing level budgeting is that it doesn't directly relate the costs to the tasks that must be performed.

Developing the Budget for Your Project

Each of the four budgeting methods described in this chapter has distinctive advantages and disadvantages. Used together they provide a sound basis to derive the project budget. Once the project budget has been determined, the result *must* be put into the zero-based budgeting format to permit proper monitoring and control of the project, as will be discussed in Chapter 5.

It is essential that each task have a specific budget and that the sum of the task budgets equals the total budget (excluding contingencies and profit). Also, the task breakdown used for the project budget must be *exactly* the same as the one used for the project schedule.

Avoiding Common Pitfalls

Following is a brief review of some common pitfalls that project managers often overlook when establishing project budgets, along with the suggestions on avoiding these traps.

Budgeting For Project Management. As described in Chapter 2, project management is a task that is required for every project, yet it is seldom identified as a requirement in the contract with the client. If this activity is not budgeted, be prepared to spend evenings and weekends trying to perform the necessary management duties of the project. The best way to avoid this dilemma is to establish project management as a separate task with its own budget. A 1981 study by *The Professional Services Management Journal* indicates that the average budget for project management on design projects is 10 to 15 percent of the total project budget.

Budgeting for Corrections. Most people budget for reviews, but overlook the fact that reviews almost always result in the need to make corrections. Identify review and correction tasks as separate activities in the task outline and budget them individually.

Activities Beyond the Contractual Due Date. As described in Chapter 3, projects never end on the contractual due date, even if all the contract requirements have been met. There are questions from contractors, requests to attend City Council meetings, or requests for extra sets of drawings. The costs for these wrapping-up activities can be budgeted by including an appropriate amount in the project management task budget and planning to spend it after all the other tasks have been completed.

The Dangers of "Lowballing." "Lowballing" is a practice in which a project is taken at a fee lower than the cost of doing the work, in the hope of obtaining a future fee increase. Consider the following example of lowballing on a typical time-and-expense project:

$$\text{Total estimated cost} = \$80,000$$

$$\text{Proposed compensation} = \$50,000$$

$$\text{Estimated loss} = \$80,000 - \$50,000 = \$30,000$$

$$\text{Anticipated additional fees} = \$50,000$$

$$\text{Anticipated profit} = \$50,000 + \$50,000 - \$80,000 = \$20,000$$

Because the practice of lowballing is a gamble, let us evaluate the above example in gambling terms. You have taken a bet that you will be able to *double* the originally negotiated fee. Furthermore, you have laid 3:2 odds that you will succeed! If you really want to gamble, play the stock market; if you want to be profitable, avoid lowballing when budgeting projects.

Developing a Projected Expenditure Curve

Once the project budget has been completed, the next step is to develop a projected expenditure curve that will serve as the basis for projecting manpower requirements and monitoring schedule and budget status throughout the project. The expenditure projection is derived by apportioning each task budget into the scheduled time frame for the corresponding activity, as shown in Figure 4.6. Values can then be totaled for each project period (monthly in the example) and summed up to estimate the cumulative expenditures throughout the project duration (as illustrated in Figure 4.7), which are then plotted to form a curve such as in Figure 4.8.

Remember that this curve represents not only the projected expenditures, but also the estimated rate of progress for the project—a concept that can be displayed graphically by defining the total project budget to equal 100 percent completion and then establishing a progress scale (percent complete) on the right side of the page, as shown in Figure 4.8. The resulting graph will thus serve as the baseline against which the status of the project may be measured periodically.

Conclusion

This chapter described various methods of budgeting a project and concludes the portion of the book that deals with the planning phase of a project (Chapters 2–4).

The next chapter shows how the planning tools described so far may be used as a baseline against which you may monitor the project schedule and budget status at key points throughout the project. Chapter 5 also describes specific procedures to overcome budget and schedule problems once you recognize them.

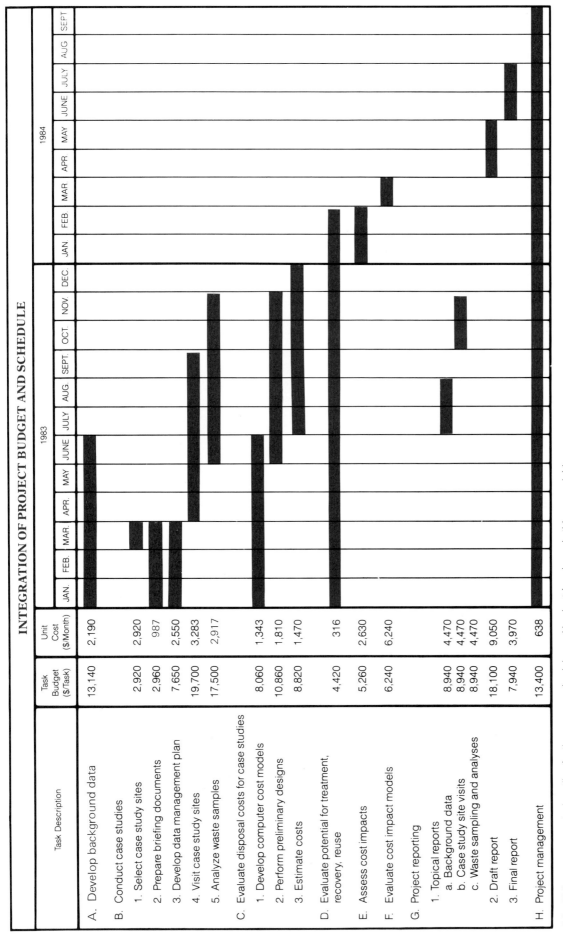

INTEGRATION OF PROJECT BUDGET AND SCHEDULE

Task Description	Task Budget ($/Task)	Unit Cost ($/Month)	1983 JAN.	FEB.	MAR.	APR.	MAY	JUNE	JULY	AUG.	SEPT.	OCT.	NOV.	DEC.	1984 JAN.	FEB.	MAR.	APR.	MAY	JUNE	JULY	AUG.	SEPT	
A. Develop background data	13,140	2,190						■																
B. Conduct case studies																								
1. Select case study sites	2,920	2,920			■																			
2. Prepare briefing documents	2,960	987			■																			
3. Develop data management plan	7,650	2,550			■																			
4. Visit case study sites	19,700	3,283						■			■													
5. Analyze waste samples	17,500	2,917											■											
C. Evaluate disposal costs for case studies																								
1. Develop computer cost models	8,060	1,343						■					■											
2. Perform preliminary designs	10,860	1,810							■															
3. Estimate costs	8,820	1,470												■										
D. Evaluate potential for treatment, recovery, reuse	4,420	316	■													■								
E. Assess cost impacts	5,260	2,630														■								
F. Evaluate cost impact models	6,240	6,240															■							
G. Project reporting																								
1. Topical reports																								
a. Background data	8,940	4,470								■														
b. Case study site visits	8,940	4,470										■												
c. Waste sampling and analyses	8,940	4,470																■						
2. Draft report	18,100	9,050																		■				
3. Final report	7,940	3,970																				■		
H. Project management	13,400	638	■																					■

4.6 Using a common task outline for the scope, schedule, and budget (as shown in this example) is a prerequisite to development of a projected expenditure curve. Determining unit costs often helps in the calculations.

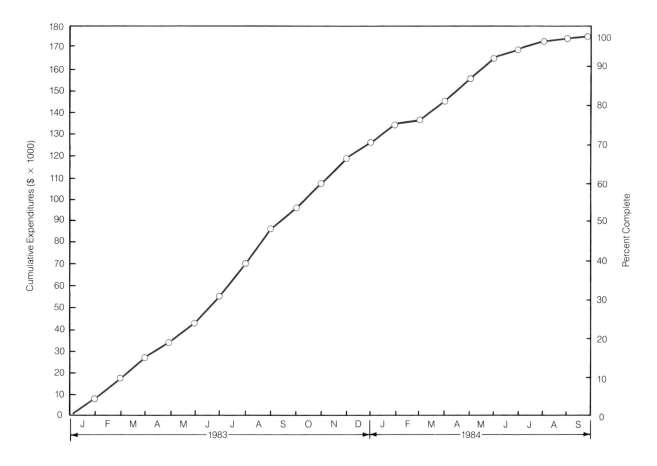

4.8 The cumulative costs calculated in Figure 4.7 on pages 64–65 can be plotted to obtain a projected expenditure curve. Setting the total budget to correspond to 100 percent will enable you to establish the "percent complete" scale on the right side of the graph.

Task Description	Task Budget ($/TASK)	Unit Cost ($/MONTH)	JAN.	FEB.	MAR.	APR.	MAY	JUNE	JULY	
			1983							
A. Develop background data	13,140	2,190	2,190	2,190	2,190	2,190	2,190	2,190		
B. Conduct case studies										
1. Select case study sites	2,920	2,920			2,920					
2. Prepare briefing documents	2,960	987	987	987	987					
3. Develop data management plan	7,650	2,550	2,550	2,550	2,550					
4. Visit case study sites	19,700	3,283				3,283	3,283	3,283	3,283	
5. Analyze waste samples	17,500	2,917						2,917	2,917	
C. Evaluate disposal costs for case studies										
1. Develop computer cost models	8,060	1,343	1,343	1,343	1,343	1,343	1,343	1,343		
2. Perform preliminary designs	10,860	1,810						1,810	1,810	
3. Estimate costs	8,820	1,470							1,470	
D. Evaluate potential for treatment, recovery, reuse	4,420	316	316	316	316	316	316	316	316	
E. Assess cost impacts	5,260	2,630								
F. Evaluate cost impact models	6,240	6,240								
G. Project reporting										
1. Topical reports										
a. Background data	8,940	4,470							4,470	
b. Case study site visits	8.940	4,470								
c. Waste sampling and analyses	8,940	4,470								
2. Draft report	18,100	9,050								
3. Final report	7,940	3,970								
H. Project management	13,400	638	638	638	638	638	638	638	638	
Total Monthly Costs			8,024	8,024	10,944	7,770	7,770	12,497	14,904	
Cumulative costs	173,790		8,024	16,048	26,992	34,762	42,532	55,029	69,933	

4.7 Spreading the task budgets throughout their respective durations will enable you to estimate the total projected cost for each month. These monthly costs will provide you with a projection of cumulative costs throughout the scheduled duration of the project.

					1984								
AUG.	SEPT.	OCT.	NOV.	DEC.	JAN.	FEB.	MAR.	APR.	MAY	JUNE	JULY	AUG.	SEPT.
3,283	3,283												
2,917	2,917	2,917	2,917										
1,810	1,810	1,810	1,810										
1,470	1,470	1,470	1,470	1,470									
316	316	316	316	316	316	316							
					2,630	2,630							
							6,240						
4,470		4,470	4,470										
				4,470	4,470								
								9,050	9,050				
										3,970	3,970		
638	638	638	638	638	638	638	638	638	638	638	638	638	638
14,904	10,434	11,621	11,621	6,894	8,054	3,584	6,878	9,688	9,688	4,608	4,608	638	638
84,837	95,271	106,891	118,512	125,406	133,460	137,044	143,922	153,610	163,298	167,906	172,514	173,152	173,790

CHAPTER 5 # Monitoring and Controlling Schedules and Budgets

1. What basic steps should I follow to obtain an accurate assessment of the status of my project?

2. How can I use the percent completion of each project task as a basis for overall schedule and budget control?

3. When determining overall schedule and budget status, why is it a mistake to compare projected expenditures with actual expenditures?

4. How can I determine which activities are behind schedule?

5. How can I best monitor budget and schedule *trends* and not just the *status* of my project at a point in time?

6. What are common ways to explain a lagging schedule or budget?

7. How can I overcome schedule problems?

8. How can I overcome budget problems?

\mathbf{T}HE FIRST STEP in controlling schedules and budgets is to assess their status accurately throughout the project. One method to accomplish this was developed by David Burstein and is known as "integrated budget and schedule monitoring" (IBSM).

The IBSM Method of Monitoring Schedule and Budget Status

Used successfully at Engineering-Science, a large international engineering firm, the IBSM method determines the overall schedule and budget status and consists of six phases:

1. Estimating the progress of each task

2. Computing total project progress

3. Estimating project expenditures

4. Determining overall schedule and budget status

5. Determining the schedule status of each task

6. Determining the budget status of each task

Each of the phases of the IBSM method will be discussed in detail below.

Estimating the Progress of Each Task. The first step in the IBSM method is to prepare a realistic estimate of the progress on each task in terms of percent completion of that task. "Progress" is defined as work actually accomplished and is independent of either budget expenditures or calendar time spent on the activity. For example, if a task consists of pouring 4,000 cubic yards of concrete and a total of 3,000 have been poured, then that task is 75 percent complete regardless of how much time or money it took to accomplish it.

Estimating the progress of each activity is the single most important step in the IBSM method. This step is nonmathematical, relying solely on the experience and judgment of the project manager and staff involved in the project.

Techniques exist to reduce the potential errors in estimating the progress of each task. One method is to develop measurable milestones for each task in the task outline. For example, a task defined as "prepare architectural woodwork cost estimate" might be divided into the following milestones:

Prepare material take-off	30%
Obtain hardware prices	10%
Determine material unit costs	10%
Estimate labor hours	20%
Determine local wage rates	5%
Calculate extensions	5%
Final review	10%
Final corrections	10%
Total	100%

When the time comes to estimate the progress of this task, each milestone can be objectively reviewed to obtain a reasonably accurate estimate of the progress on the entire task. The use of milestones is most effective when they are (1) established and agreed upon at the outset of the project and (2) defined in terms of measurable performance, so as to reduce subjective judgments.

Another way to monitor progress on design jobs is to use a preliminary list of drawings to measure the progress of each design discipline. Figure 5.1 shows how the technique could be used to estimate the progress of the structural drawings on a small design project.

A third approach to improving the accuracy of projections is to estimate the

PROJECT DRAWING CONTROL SHEET

Project Name _Executive Park Office Bldg._ **Date** _5/7/81_ **Previous Progress** ▮▮▮▮ **80% = Drafting Complete**

Discipline _Structural_ **Job No.** _1367_ **Last Period** ▮▮▮▮ **100% = Ready for Bidding**

Lead Engineer/Architect _H. Hennesey_ **Sheet** _1_ **of** _1_ **Overall Progress = Σ (Budget × Status) ÷ Budget =** _48_ %

DRAWING NO.	DRAWING TITLE	BUDGET (Man-Hrs. or $)	ESTIMATED COMPLETION DATE	STATUS (% Complete)				
				20	40	60	80	100
S-1	Legend	28	6/4/82	▮				
S-2	Foundation plan	73						
S-3	Roof plan	85						
S-4	Foundation sections	85						
S-5	Foundation sections	85						
S-6	Roof sections	85						
S-7	Roof sections and details	85						
S-8	Typical column sections	85						
S-9	Typical beam sections	85						
S-10	Structural details	66						
S-11	Structural details	66						
	Total man-hours	828						

5.1 By tabulating a preliminary list of drawings, you can measure the progress of each design discipline.

effort required to complete a particular task. Progress of the task can then be calculated as follows:

Progress = 1 − [work remaining ÷ original budget]

A format such as the one in Figure 5.2 can be used to make this type of determination on design projects.

Computing Total Project Progress. After the percent of completion has been determined for each task, all percentages are multiplied by the corresponding task budgets as shown in Figure 5.3. The products of each multiplication are then totaled to obtain a value that represents the estimated amount of progress made to date on the total project. Dividing this sum by the total project budget provides an estimate of overall project progress, as follows:

Overall progress = $33,387 ÷ $173,790 = 0.186 = 18.6%

It is emphasized that the progress computation has nothing to do with how much money has been spent on the project.

Estimating Project Expenditures. The next step is to estimate how much money has been spent on the project. The place to start is the accounting department, which should be able to tell you how much has been charged to the job up to the date for which time and expense records are available. Next, you estimate the expenditures incurred during the period for which the data are not yet available and add that to the costs reported from accounting.

68 PROJECT MANAGEMENT FOR THE DESIGN PROFESSIONAL

PROJECT STATUS RECORD

PROJECT Executive Park Office Building DEPARTMENT Structural (Discipline) JOB NO. 1367 PREPARED BY H. Hennesey DATE 5/7/82 Sheet 1 of 1

Drawing No.	Drawing Title (or Task)	Budget Hours			WORK REMAINING TO BE COMPLETED																
					4/16/82		4/23/82		4/30/82		5/7/82		5/14/82		5/21/82		5/28/82		6/4/82		
		A/E	D	Total	A/E	D	A/E	D	A/E	D	A/E	D	A/E	D	A/E	D	A/E	D	A/E	D	
	Supervision & Review	40	24	64	40	24	36	24	30	24	20	24									
	Coordination	40	—	40	36	—	32	—	24	—	16	—									
	Field Investigations	16	32	48	8	16	—	—	—	—	—	—									
	Specifications	40	—	40	40	—	40	—	40	—	32	—									
	Estimating	32	32	64	32	32	32	32	32	32	32	32									
	Final Corrections	24	60	84	24	60	24	60	24	60	24	60									
S-1	Legend	8	16	24	8	16	8	16	8	16	4	16									
S-2	Foundation Plan	30	32	62	30	32	30	32	16	16	—	—									
S-3	Roof Plan	30	32	62	30	32	30	32	16	16	—	—									
S-4	Foundation Sections	40	32	72	40	32	40	32	16	16	—	—									
S-5	Foundation Sections	40	32	72	40	32	40	32	40	32	20	16									
S-6	Roof Sections	40	32	72	40	32	40	32	20	16	8	16									
S-7	Roof Sections & Details	40	32	72	40	32	40	32	40	32	16	24									
S-8	Typical Column Sections	40	32	72	40	32	40	32	20	16	8	16									
S-9	Typical Beam Sections	40	32	72	40	32	40	32	32	32	16	24									
S-10	Structural Details	24	32	56	24	32	24	32	24	32	24	32									
S-11	Structural Details	24	32	56	24	32	24	32	24	32	24	32									
	Totals	548	484	1,032	536	468	520	452	406	372	244	292									

A/E — Architect/Engineer
D — Draftsman

Overall Progress = 1 − (hours remaining ÷ budget hours) = ____

5.2 One way to determine budget status is to periodically estimate the man-hours remaining to complete each task.

CALCULATIONS OF ESTIMATED PROGRESS

Task Description	Task Budget ($/Task)	% Complete	Data Base Date: 6/1/83 Estimated Progress Equivalent Progress
A. Develop background data	13,140	× 65	= 8,541
B. Conduct case studies			
1. Select case study sites	2,920	× 100	= 2,920
2. Prepare briefing documents	2,960	× 100	= 2,960
3. Develop data management plan	7,650	× 100	= 7,650
4. Visit case study sites	19,700	× 20	= 3,940
5. Analyze waste samples	17,500	× 0	= 0
C. Estimate disposal costs for case studies			
1. Develop computer cost models	8,060	× 10	= 806
2. Perform preliminary designs	10,860	× 0	= 0
3. Estimate costs	8,820	× 0	= 0
D. Evaluate potential for treatment, recovery, reuse	4,420	× 30	= 1,326
E. Assess cost impacts	5,260	× 0	= 0
F. Evaluate cost impact models	6,240	× 0	= 0
G. Project reporting			
1. Topical reports			
a. background data	8,940	× 10	= 894
b. case study site visits	8,940	× 0	= 0
c. waste sampling and analyses	8,940	× 0	= 0
2. Draft report	18,100	× 0	= 0
3. Final report	7,940	× 0	= 0
H. Project management	13,400	× 25	= 3,350
Totals	$173,790		32,387

Total project progress = $32,387 ÷ $173,790 = 0.186 = 18.6%

5.3 The individual task budgets may be used as weighting factors in order to determine equivalent progress on each task at a given point in time. These values can then be totaled and divided by the project budget to determine total progress on the project.

Even if your accounting department is so efficient that it can report all costs on an up-to-the-minute basis, you may still need to adjust the values that it reports to you. Even the most efficient accounting system can keep track of only the costs it knows.

For example, the bill for airplane tickets probably comes from your travel agent once a month, a few days after the end of the month, which creates a one-month lag between the time you order a ticket and the time the accounting department finds out about it. The same is true for outside consultants. Considerable funds can be spent by outside consultants before their invoices finally get to your accounting department. Therefore, do not accept the record of expenditures provided by your accounting department blindly without questioning its substance.

Determining Overall Schedule and Budget Status. Using the projected expenditure curve (see Chapter 4) as a base, plot the actual project progress and project expenditures on the same graph, as shown in Figure 5.4. The overall schedule status can be determined graphically by measuring the horizontal distance between the projected expenditure curve and the progress curve (distance A in Figure 5.4). The overall budget status can be determined by measuring the vertical distance between the project progress curve and the actual expenditure curve (distance B in Figure 5.4).

A common mistake is to compare the projected expenditures (budgets) with the actual expenditures (costs) in an attempt to determine overall project status. If this comparison is made in the example project (Figure 5.4), note that the actual

COMPUTING OVERALL SCHEDULE AND BUDGET STATUS USING THE IBSM© METHOD

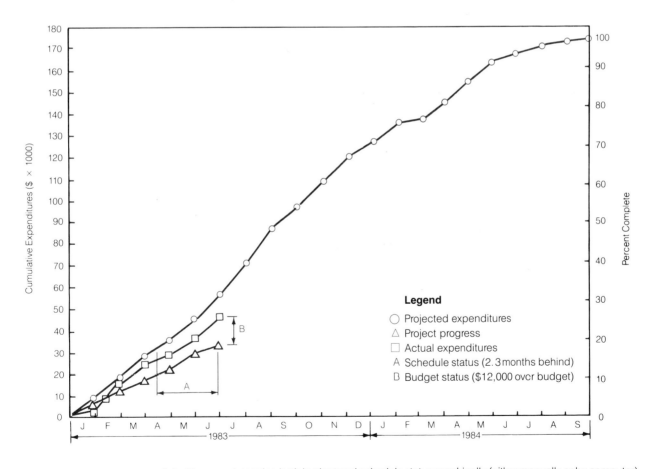

5.4 You may determine both budget and schedule status graphically (either manually or by computer) using the IBSM method.[1]

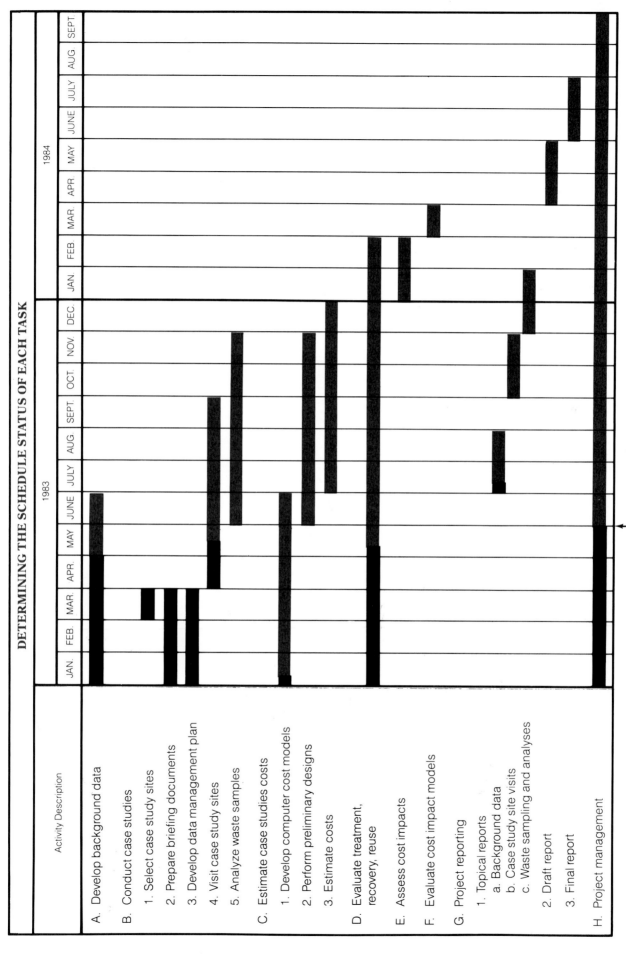

DETERMINING THE SCHEDULE STATUS OF EACH TASK

Activity Description	1983												1984								
	JAN.	FEB.	MAR.	APR.	MAY	JUNE	JULY	AUG	SEPT.	OCT.	NOV.	DEC.	JAN.	FEB.	MAR.	APR.	MAY	JUNE	JULY	AUG	SEPT

A. Develop background data

B. Conduct case studies

 1. Select case study sites

 2. Prepare briefing documents

 3. Develop data management plan

 4. Visit case study sites

 5. Analyze waste samples

C. Estimate case studies costs

 1. Develop computer cost models

 2. Perform preliminary designs

 3. Estimate costs

D. Evaluate treatment, recovery, reuse

E. Assess cost impacts

F. Evaluate cost impact models

G. Project reporting

 1. Topical reports

 a. Background data

 b. Case study site visits

 c. Waste sampling and analyses

 2. Draft report

 3. Final report

H. Project management

Data base date

■ Work completed

▬ Work remaining

5.5 The schedule status of each task may be determined by comparing the progress (as a percent of the total duration) with the data base date. A task is behind schedule if the "work completed" portion of the bar chart does not reach the data base date.

expenditures appear to be less than the projected expenditures. This leads us to the wrong conclusion—that the project is under budget and thus on target, when in reality this is not the case. Comparing projected expenditures with actual expenditures is not a realistic way to determine either budget or schedule status, and may tend to lull the project manager into a false sense of security. Many projects may be so far behind schedule that they appear under budget!

Determining the Schedule Status of Each Task. If the results of this analysis indicate that the project is behind schedule, you need to know which areas are in trouble. By applying the estimated progress percentages to the project schedule, as shown in Figure 5.5, it will become readily apparent which tasks are behind schedule/(Tasks A, B4, B5, C1, C2, and H in Figure 5.5).

While this example uses a simple bar chart, the same analysis can be made using a CPM diagram. As described in Chapter 3, the use of CPM scheduling methods has the advantage of allowing concentration on critical path activities, that is, those which will most impact the ultimate completion date. Remember that while the CPM method defines tasks as either critical or noncritical, this distinction is not nearly so absolute in the real world.

For example, a task on a project may involve sending a team to visit twenty plant sites for one week each, for a total of twenty weeks. A similar task may be to send a team to a single plant site to collect site data for twenty weeks. In the first example, the scheduled time could be shortened by sending two teams to visit ten sites each. In the second example, it is clear that the duration must be twenty weeks regardless of the manpower applied to the task. Even though these two tasks would appear exactly the same on a CPM diagram, the second example is clearly more critical, because additional manpower cannot shorten the task's duration.

Determining the Budget Status of Each Task. Monitoring the budget status of each individual task is not as simple as monitoring the schedule status. Independent cost accounting must be maintained for each task to be monitored. This requires increased paperwork and close monitoring of the project team to ensure that everyone is charging their time and expenses to the proper task code. The project manager must determine on a case-by-case basis whether the additional information is worth the effort it takes to obtain it.

Whenever it is worthwhile to monitor the budget status of individual tasks, do so by comparing expenditures for a given task with progress calculated for the corresponding task (Figure 5.6). Those tasks in which the actual expenditures exceed the progress made are over budget; those in which the progress exceeds the expenditures are under budget.

Monitoring the Status of Small Jobs

Monitoring the budget and schedule status of small projects is difficult because you cannot afford to spend much time doing it. However, these jobs are generally of such short duration that failure to monitor them closely can quickly lead to irreparable schedule and budget problems.

An effective way to monitor small projects is to omit the step of estimating the progress of each task. On a small job, you should be able to estimate the overall progress yourself reasonably accurately since you are probably involved in each task personally.

On smaller projects the project manager must also monitor the project hands-on, in lieu of using the firm's monthly accounting system. This may mean photocopying the time cards of team members and calculating your budget status manually from hours being charged. It also means you may have to perform the actual details and specifications on the project yourself because there is not enough time in the budget for delegating and communicating to others the requirements of the client. Take care when monitoring small jobs to avoid developing manual systems which are more complex and time consuming than systems which already exist. If you cannot obtain information quickly from project data, you may waste chargeable time that you could use more productively doing the work.

DETERMINING THE BUDGET STATUS OF EACH TASK

Data Base Date: 1/1/83

Task Description	TASK BUDGET ($/Task)	Estimated Progress % Complete	Equivalent Progress	Actual Expenditures ($)	Budget Status ($)
A. Develop background data	13,140	× 65	= 8,541	11,487	− 2,946
B. Conduct case studies					
1. Select case study sites	2,920	× 100	= 2,920	4,072	− 1,152
2. Prepare briefing documents	2,960	× 100	= 2,960	2,526	+ 434
3. Develop data management plan	7,650	× 100	= 7,650	6,511	+ 1,139
4. Visit case study sites	19,700	× 20	= 3,940	7,086	− 3,146
5. Analyze waste samples	17,500	× 0	= 0	0	—
C. Estimate disposal costs for case studies					
1. Develop computer cost models	8,060	× 10	= 806	4,256	− 3,450
2. Perform preliminary designs	10,860	× 0	= 0	0	—
3. Estimate costs	8,820	× 0	= 0	0	—
D. Evaluate potential for treatment, recovery, reuse	4,420	× 30	= 1,326	2,625	− 1,299
E. Assess cost impacts	5,260	× 0	= 0	0	—
F. Evaluate cost impact models	6,240	× 0	= 0	0	—
G. Project reporting					
1. Topical reports					
a. Background data	8,940	× 10	= 894	721	+ 173
b. Case study site visits	8,940	× 0	= 0	0	—
c. Waste sampling and analyses	8,940	× 0	= 0	0	—
2. Draft report	18,100	× 0	= 0	0	—
3. Final report	7,940	× 0	= 0	0	—
H. Project management	13,400	× 25	= 3,350	5,169	− 1,819
Totals	$173,790		32,387	$44,453	−$12,066

− Over budget.
+ Under budget.

5.6 Budget status can be determined for each task only if actual costs are monitored for each individual task. The project manager must decide if the value of this information is worth the effort to maintain separate task accounts.

	Week 1	Week 2	Week 3	Week 4
1. Projected progress	$4,000 (25%)	$8,000 (50%)	$12,000 (75%)	$16,000 (100%)
2. Actual progress	20% ($3,200)	55% ($8,800)	65% ($10,400)	100% ($16,000)
3. Actual expenditures	$2,800	$8,100	$12,200	$15,700
4. Schedule status [(2)-(1)]	−5%	+5%	−10%	on schedule
5. Budget status [(2)-(3)]	+$400	+$700	−$1,800	+$300

5.7 Here is an example of how to use the IBSM method to monitor the status of a small project with a $16,000 budget.

Figure 5.7 is a tabulation showing how the IBSM method can be used to monitor the status of a small project with a $16,000 budget.

The negative numbers in this example refer to periods that are behind schedule or budget; the positive numbers denote periods that are ahead of schedule or budget. The schedule status is shown in percentages rather than in weeks as it was in the previous example (Figure 5.4). The schedule status can be converted to weeks by multiplying the percentage by the total project duration. Thus, being 5 percent behind schedule represents 0.8 weeks, or four working days. However, in small projects you do not have to know the schedule status with such precision; here, using a percentage cuts down on calculations and will provide you with enough information.

Analyzing Schedule and Budget Trends

While it is essential to know the budget and schedule status of a project at a given point in time, monitoring trends can be even more revealing. Let us examine the tabulation of project status trends in Figure 5.8. the "progress" column indicates a rather steady increase in the progress of the project—nothing particularly unusual. The "schedule status" column shows that the project got behind schedule almost from the outset and has deteriorated steadily since. This steady deterioration in the schedule status indicates a fundamental problem. Possible explanations are:

Insufficient manpower has been allocated to the project.
Project staff have not been working productively.
Too much time is being spent on details.
Original schedule was unrealistic.
Too many design alternatives are being examined.

The "budget status" column tells a somewhat different story. The project started out well, got into a bit of trouble in February, and then generally stabilized until June, at which time the budget suddenly developed major problems. This trend indicates that something dramatic happened in June. Possible explanations are:

Costs from another project were incorrectly charged to your job.
A major design error was discovered and substantial redesign was required.
The client increased the scope of work.

Careful study of schedule and budget trends can be most informative. However, such data are available only if the progress of each project is monitored on a regular basis. Frequent monitoring also allows you to identify problems early, while there is still time to resolve them without jeopardizing the final completion date or going overbudget.

PROJECT STATUS TRENDS

Project Period	Progress (%)	Schedule Status	Budget Status ($)
January 1983	3.2	0.3 months behind	$ 2,000 under
February 1983	6.7	0.8 months behind	3,000 over
March 1983	9.4	1.1 months behind	8,000 over
April 1983	11.6	1.7 months behind	8,000 over
May 1983	15.8	2.0 months behind	8,500 over
June 1983	18.6	2.3 months behind	12,000 over
July 1983			
August 1983			
September 1983			
October 1983			
November 1983			
December 1983			
January 1984			
February 1984			
March 1984			
April 1984			
May 1984			
June 1984			
July 1984			
August 1984			
September 1984			

5.8 Monitoring project trends over time offers you valuable insight into possible causes of budget or schedule problems.

Overcoming Schedule Problems

It is said that early identification of a problem is 80 percent of the solution. Even if true, this still leaves the other 20 percent to worry about. Following are a few successful ways to overcome schedule problems on a project:

1. Stop evaluating alternative solutions. When you reach a choice between several options, pick one that you know will work and go with it.

2. Get the less experienced people off the project. Senior people are able to get much more done if they do not have to spend time supervising trainees. You will also be able to do more technical work yourself as a result of saving supervisory time.

3. Get permission from principals to postpone noncritical administrative duties until you have survived the crunch. Then spend the extra time on the most critical aspects of the project.

4. Subcontract a portion of the work to another firm. However, this is not the time to subcontract to someone you have not worked with before.

5. Identify the critical activities and concentrate your efforts on them. Also, ask the clients which items are most critical to them and if anything can be allowed to slip without harming the schedule.

6. Work overtime. Everyone works overtime; it usually is the first technique to get back on schedule. But be careful not to consider overtime as a cure-all. One study by a large engineering firm found that nine hours per day is the most efficient workday and that a firm receives only 10 percent productivity from the tenth hour and beyond. If you work overtime, keep productivity high by working Saturday and Sunday instead of working until midnight.

7. Use principals. Putting principals to work "on the boards" can take advantage of valuable expertise from individuals who tend to charge time to your project anyway. Also, an experienced professional may accomplish in one hour what a green technician can do in five.

8. Involve the client. Instead of immediately asking for an extension, suggest five or ten ways in which the client can help you achieve the target date, including use of client staff for certain tasks.

9. Reorganize the drawings. Conduct a planning meeting with consultants, drafting help, a representative from your blueprint company, and your word processing operator to talk about how to produce the required construction documents using fewer sheets and less information on each sheet (especially elaborate details). Also, explore graphic techniques such as photocopying details or entire sections of a drawing. Eliminate hand-lettered notes where possible.

10. Shun excessive perfection. Most design decisions are 90 percent perfect the first time; we then spend whatever time is left making them 5 percent better.

Overcoming Budget Problems

The following are some ways in which you may overcome budget problems and get back on track:

1. Examine the figures. Before making any changes, be sure that you are really overbudget. Check all charges of time and expenses to your project. Ask your financial manager for a current assessment of your overhead charges to be certain that all charges have been made as planned when the project was budgeted.

2. Check to be sure that everything you are doing is required in the scope of work. If something is not, stop work or get additional funding from the client.

3. Examine each task to be sure that only experienced people are working on those activities requiring judgment and only junior people are working on tasks that merely require persistence.

4. Shorten the schedule and work overtime. This will reduce coordination costs by minimizing the number of people working on the project. It will also cut overhead costs because overtime hours do not carry the same burden as regular hours. (This concept is explained more fully in Chapter 11.)

5. Stop evaluating alternative solutions. Go with what you know will work and don't change your mind unless someone can convince you that what you have selected won't work.

6. Renegotiate consultant contracts. If the total budget is in trouble, perhaps aspects of the problems were caused by other consultants. If so, you may be justified in renegotiating their contracts. Also, if some of the consultants' tasks will not be needed, eliminating them may save a project budget.

7. Use temporary help. The firm can save payment of some fringe benefits by using temporary help. At current figures of 20 percent of direct labor, major budget

REQUEST FOR A FEE INCREASE

Dear Carl:

In accordance with our conversations of April 22, 1982, I am writing to provide an update on the subject project budget.

As we have discussed on previous occasions, there have been a number of engineering tasks which we have been requested to perform which were not within the scope of our present purchase order. Some of these items were activities which were not directly related to preparation of plans and specifications for construction. Others were tasks that could not be done by your staff due to a lack of available time. This is particularly true for Bill Jones's activities as a result of his recent promotion.

Table 1 (attached) lists specific tasks not within our original scope which have been requested by you or your staff. This table describes each task, references the date of the correspondence confirming your request, and presents our best estimate of the actual effort required to perform the work. In addition, we have incurred a significant amount of costs due to the developmental nature of this project. Although it is difficult to quantify these additional costs, I think we are all aware of them.

Our latest estimate of engineering costs required to complete the work specified in the purchase order, plus additional requested tasks, is $57,500. as of April 1. The amount of our remaining authorization is $22,200. which is expected to carry us through the month of April. We therefore request an increase of $35,300. in our present authorization. As you know, most of the uncertainties associated with this design are behind us, and we feel sure that no additional increases will be required for the present scope.

We would be glad to furnish you with all back-up material used to arrive at the figures presented in this letter upon your request. If you have any questions regarding these items, please call me and we will be pleased to discuss them with you.

Yours very truly,

J. B. Higgins

J. B. Higgins, P.E.
Project Manager

5.9 Writing a letter requesting a fee increase can be a difficult assignment. Here is an actual letter to show you how to do it effectively. Table 1, referred to in the letter, is shown on the opposite page.

TABLE 1: WORK REQUESTED WHICH WAS NOT WITHIN ORIGINAL SCOPE

Task	Reference	Principal	Man-Hours Engr.	Man-Hours Drafting	Support	Other Direct Costs
1. Verification of existing yard piping outside of waste treatment plant area	10/14/81	8	31	464	30	$900
2. Electrical interconnection diagrams	3/28/82	4	70	40	16	
3. Instrument installation details	3/2/82	6	60	40	20	
4. Review of shop drawings						
a. Miscellaneous iron	4/12/82	—	8	2	—	
b. Sand filters	2/14/82	8	60	40	16	$ 85
c. Carbon columns	3/29/82	18	90	60	30	$240
5. Redesign of carbon transport system	12/10/81	20	100	140	20	$350
6. Redesign required to eliminate virgin carbon tank	12/10/81	—	16	24	6	
7. Take-off of FRP pipe and fittings	3/2/82	—	6	13	1	
8. Redesign of concrete from 4000 to 3000 psi	3/3/82	—	18	12	4	
9. Preparation of specifications for steel carbon columns in addition to FRP columns	1/31/82	—	12	—	4	
10. Redesign of site grading plan to locate basins away from power easement	12/10/81	12	12	20	—	
11. Preparation of electrical elementary wiring diagrams instead of typical ladder diagrams	12/10/81	—	30	30	—	

savings could be made *if* the temporary help is able to produce right away on a project.

8. Be a squeaky wheel. If your project is overbudget, don't hide it. If you inform everyone in the firm that you are in trouble, those (such as principals) who might otherwise charge a random hour to your project, will think twice. If you can save even one hour per week, it may be the difference between profit and loss.

9. If all else fails, ask the client for a budget or fee increase. If the scope or other circumstances have changed, don't be afraid to go back and ask for more. Even if he or she says no, you have at least informed the client that you are closely watching changes. This could discourage the client from calling with nickel-and-dime changes. Also, you may get the added money if your request is legitimate and the client likes the work you are doing. (A good example of an actual letter requesting a fee increase is presented in Figure 5.9.)

Conclusion

This chapter has offered a simple method for determining the project budget and schedule status at various points throughout the project, as well as several specific approaches for overcoming schedule and budget problems, while still meeting the project's objectives.

The next chapter describes some simple techniques of manpower planning on individual projects, as well as for an entire office. The next chapter also presents various ways to resolve short- and long-term manpower shortages.

CHAPTER 6

Manpower Planning and Staffing

1. Why should I be concerned about manpower planning?

2. How can I avoid the trap of overcomplicating my manpower projections?

3. How can I tell if there is a manpower shortage or surplus on my project?

4. How can I tell if the shortage or surplus is temporary or long-term?

5. How should I determine the number and types of individuals that my project will demand?

6. What are the best ways to alleviate a short-term shortage or surplus of manpower?

7. In what ways does manpower planning for small offices (twenty people or less) differ from that for large ones?

8. What can be the real impact of excessive turnover of personnel?

ONE OF THE MOST difficult tasks for managers in design firms is manpower planning. Unlike their counterparts in industry or government (where work loads are generally planned at least a year in advance), managers in consulting firms must contend with changes in workload that can occur almost on a daily basis. Yet in spite of the enormous difficulty of accurate manpower planning, this is a vital activity if the firm is to operate efficiently and profitably.

The Project Manager's Role in Manpower Planning

The responsibility for manpower planning and staffing varies from office to office, depending upon how a particular design firm is organized. This function may be performed by one or more of the project managers in the office or by the manager of operations. In either case, the key input data used to plan manpower requirements must come from the project managers. Furthermore, the results of the office's manpower planning affect the project managers directly because they determine who will work on their projects. The complete project manager must therefore not only be able to plan manpower needs on his or her own projects, but also understand the concepts of manpower planning for the entire office.

The Key to Successful Manpower Planning

The single most commonly observed failure in manpower planning is excessive sophistication and complexity in approach. Given the many demands on the manager's time, manpower planning is often given a low priority, especially if much time is demanded by a complex system. As a result, projections are seldom updated and manpower planning is done by "gut feel." The key to successful manpower planning, therefore, is to select a simple approach and keep projections updated on a regular basis. Leave the sophisticated systems to managers outside the design profession who can forecast workloads accurately over a long period of time.

Proper manpower planning answers four basic questions:

1. Is there a manpower shortage or surplus?

2. Is it temporary or long-term?

3. What kinds of people are needed?

4. How can the shortage be alleviated?

Determining Long-Term Requirements

The simplest form of long-term (more than six months) manpower planning is monitoring the manpower backlog. Dividing the total number of man-hours remaining on all active projects by the total number of man-hours worked by the office staff provides a close approximation of long-term needs. Here is a calculation for ABC Consultants, a fictitious design firm:

Project	Hours Remaining	Employee	Available Hours/Week
A	160	F. Smith	40
B	1,280	J. Hanson	30
C	470	N. Parks	40
D	620	F. Stanford	40
Total	2,530	Total	150

Backlog = (2,530 hours) ÷ (150 hours/week) = 16.9 weeks

While this is a simple calculation, there are a few potential errors to avoid. First, be careful to include only the man-hours that will be spent by people in the office,

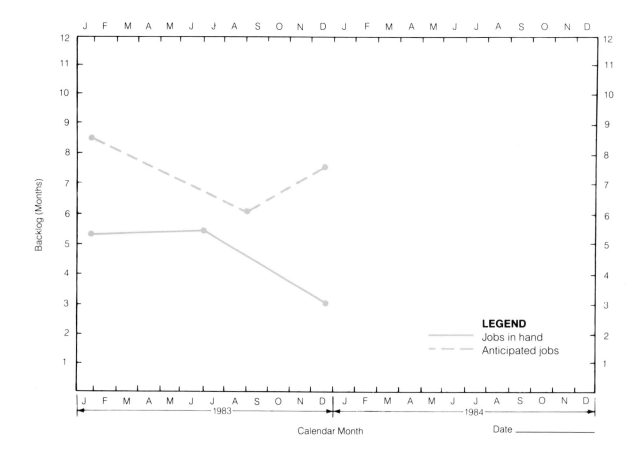

6.1 You may compute total backlog by dividing the man-months of work remaining on all projects by the number of people in the office. Monitoring backlog trends can provide advance notice of manpower surpluses or shortages.

not consultants or people from other offices. Second, always use the estimated hours needed to complete the job, not necessarily the difference between budgeted hours and hours spent to date.

The magnitude of the manpower backlog for most design firms varies from two months to two years. However, the backlog of two firms cannot be readily compared because of numerous factors specific to each firm. *The real benefit of computing backlog, therefore, is obtained when it is done on a regular basis and the results compared with previous data from the same firm.*

A major problem with the use of manpower backlog as a planning tool is that it is based only on jobs actually under contract and is thus somewhat reactive. This problem can be overcome by including prospects that have a 90 percent or higher chance of becoming projects. Data can then be plotted to determine trends in manpower requirements, as the example in Figure 6.1 shows. Note that the actual backlog has been dropping steadily over the past six months. However, if anticipated jobs are included, it appears that the situation has begun to turn around. If the predictions are accurate, this turn-around should be reflected in the actual backlog within the next few months.

This is the kind of advance information needed to shape long-term plans for hiring new employees and/or changing the level of effort to be spent in marketing. Many firms have developed several levels of probability for anticipating new projects as a refinement of this procedure. However, take care not to make plans based on marketing projections of questionable accuracy.

Short- and Medium-Term Planning in Small Offices

In a small (less than twenty-person) office, manpower planning can be done on a personal level. Consider the following procedure:

1. Each project manager identifies the names or types of people required to finish the project (see Figure 6.2).

2. The person with responsibility for office manpower planning computes the demand on each person or type of person in the office. (In the example in Figure 6.3, DSF and REM are projected to be substantially overcommitted for the next few months, while TNS, the junior engineers, draftsmen, and typists, have free time available.)

3. Having projected the overloads and underloads for each person or type of person, a meeting is called among the project managers. The meeting does not end until the workload has been equitably distributed among the available staff.

4. Work assignments are established based upon what was agreed on during the meeting. Revised versions of Figures 6.2 and 6.3 are then prepared and distributed.

5. The process is repeated every month or two, depending on how many new projects have begun.

The above procedure is suitable for short- and medium-term manpower projections in a small office. Combined with a regular computation of the manpower backlog, it provides the manager with enough information to decide on hiring plans.

You may also use the same procedure to plan manpower requirements for a single project. The only difference is that workloads are projected by tasks, rather than by projects.

Short- and Medium-Term Planning in Large Offices

The method shown in Figures 6.2 and 6.3 becomes burdensome for an office of over twenty people. You therefore need a different approach when determining short- and medium-term manpower requirements for larger offices.

The first step is to identify manpower requirements for individual projects. On major projects this can be accomplished with a format similar to the one in Figure 6.4. For small projects, simply divide the total man-hours by the project duration to determine the average manpower required per period.

		Man-Hours Required							
Project	**Person**	MAY	JUNE	JULY	AUG.	SEPT.	OCT.	NOV.	DEC.
Putnam County Jail	DSF	80	80	80					
	Jr. Engr.	20	20	20					
	TNS	60	60	60					
	Drafting			40					
	Typist		32	32					
Cayce Landfill	DSF	40	40	60	60	60			
	Jr. Engr.	20	20	20	20	20			
	TNS	16	16	24	24	16			
	Drafting					20			
	Typist				16	40			
Waycross Renovations	REM	160	160	160	160				
	TNS	8	8	8	8				
	Drafting		16	16	16				
	Typist			16	24				
New Hanover Mall	TNS	24	24	24	24				
	REM	80	40	20	20				
	DSF	80	80	80	80				
	Jr. Engr.	240	240	160	160				
	Drafting			16	24				
	Typist		16	16	32				

<div align="center">INITIAL ESTIMATE OF PROJECT REQUIREMENTS</div>

6.2 In small- to modest-size offices (less than 15 to 20 people), manpower requirements may be projected by matching each project with the people who will perform it.

Project	Person	Month							
		MAY	JUNE	JULY	AUG	SEPT.	OCT	NOV	DEC
INITIAL PROJECTION OF STAFF WORKLOAD									
DSF	Putnam County Jail	80	80	80					
	Cayce Landfill	40	40	60	60	60			
	New Hanover Mall	80	80	80	80	—	—	—	—
	Total man-hours required	200	200	220	140	60	0	0	0
	Man-hours worked	168	168	168	168	168	168	168	168
	Net man-hours available	[32]	[32]	52	28	108	168	168	168
TNS	Putnam County Jail	60	60	60					
	Cayce Landfill	16	16	24	24	16			
	Waycross Renovations	8	8	8	8				
	New Hanover Mall	24	24	24	24	—	—	—	—
	Total man-hours required	108	108	116	56	16	0	0	0
	Man-hours worked	168	168	168	168	168	168	168	168
	Net man-hours available	60	60	52	112	152	168	168	168
REM	Waycross Renovations	160	160	160	160				
	New Hanover Mall	80	40	20	20	—	—	—	—
	Total man-hours required	240	200	180	180	0	0	0	0
	Man-hours worked	168	168	168	168	168	168	168	168
	Net man-hours available	[72]	[32]	[12]	[12]	168	168	168	168
Jr. Engrs	Putnam County Jail	20	20	20					
	Cayce Landfill	20	20	20	20	20			
	New Hanover Mall	240	240	160	160	—	—	—	—
	Total man-hours required	280	280	200	180	20	0	0	0
	Man-hours worked	336	336	336	336	336	336	336	336
	Net man-hours available	56	56	136	156	316	336	336	336

6.3 Staff workloads may be projected by estimating man-hours over a period of months.

Task Description	Total Man-Hours	Monthly Man-Hours	1983												1984								
			J	F	M	A	M	J	J	A	S	O	N	D	J	F	M	A	M	J	J	A	S
A. Develop background data	340	57	57	57	57	57	57	57															
B. Conduct case studies																							
1. Select case study sites	72	72			72																		
2. Prepare briefing documents	100	33	33	33	33																		
3. Develop data mgt. plan	232	77	77	77	77																		
4. Visit case study sites	480	80				80	80	80	80	80	80												
5. Analyze waste samples	500	83						83	83	83	83	83	83										
C. Evaluate case study disposal costs																							
1. Develop computer cost models	268	45	45	45	45	45	45	45															
2. Perform preliminary designs	360	60						60	60	60	60	60	60										
3. Estimate costs	280	47							47	47	47	47	47	47									
D. Evaluate treatment, recovery, reuse	140	10	10	10	10	10	10	10	10	10	10	10	10	10	10	10							
E. Assess cost impacts	132	66													66	66							
F. Evaluate cost impact models	164	164															164						
G. Project reporting																							
1. Topical reports																							
a. Background data	328	164										164	164										
b. Case study site visits	328	164							164	164													
c. Waste sampling and analyses	328	164												164	164								
2. Draft report	700	350																350	350				
3. Final report	188	94																		94	94		
H. Project management	320	15	15	15	15	15	15	15	15	15	15	15	15	15	15	15	15	15	15	15	15	15	15
Total monthly man-hours	5,260		237	237	309	207	207	350	459	459	295	379	379	236	255	91	179	365	365	109	109	15	15
Equivalent full-time people		1.5	1.4	1.4	1.8	1.2	1.2	2.1	2.7	2.7	1.7	2.2	2.2	1.4	1.5	0.5	1.1	2.2	2.2	0.6	0.6	0.1	0.1

6.4 You should make manpower projections for all major projects. Note that the man-hours are allocated to correspond with the schedule for each task.

When the manpower requirements for each project have been determined, an officewide manpower projection can be made using a format similar to the one in Figure 6.5. Note that jobs in hand and anticipated projects are estimated separately. This distinction is important because it allows you to look further into the future, while avoiding excessive optimism.

In a large, multidisciplinary firm, separate forecasts may be needed for each discipline or department. The level of detail varies with the size and diversity of the firm, even when the same basic forecasting system is used. However, you should strive to minimize the number of separate projections to avoid spending too much time computing them.

The results of this workload projection can be used to determine duration of the shortage (or surplus). A plot is made showing the total manpower forecast over an extended period of time (see Figure 6.6). If the workload curve drops sharply, it means that an observed manpower shortage is probably short-term; if the curve decreases gradually, the shortage is probably medium- or long-term. (Note that this curve rarely increases, because the current backlog is being continuously reduced, while new jobs have not yet been "booked.")

Projections for large offices should be made for professional and drafting personnel only. Typists, secretaries, and clerical workers are omitted because their time is inherently more difficult to predict. Because of the disproportionately high percentage of time they spend toward the end of a project, a separate projection should be made for support staff. Figure 6.7 is a form to complete whenever you anticipate a major production effort. Information can then be tabulated on a calendar in a manner similar to Figure 6.8 in order to project workloads for typists, secretaries, graphic artists, and other support staff.

The above approach projects whether there will be a manpower surplus or shortage and its approximate magnitude. However, because all professionals are lumped into the same projection, there is no breakdown of what kinds of people are needed (or are in surplus). This problem can best be solved by peer discussions among the individuals who have the needs—the project managers. They know in detail the manpower deficiencies or surpluses for their jobs.

This communicative approach is far better than pigeon-holing each person into a category and relying on a computer or on one of the principals to match personnel needs with availabilities. Not only does this approach provide more accurate results; it also tends to treat people as individuals, not machines.

Resolving Short-Term Shortages or Surpluses

If there is a temporary increase in workload, various alternative solutions exist to solve the problem without hiring people who will have to be laid off when the workload returns to normal. These include:

overtime
use of temporary employees
joint venturing
use of individuals normally assigned to overhead functions

To make these measures work, lay the groundwork *before* the crisis is at hand. For example, many universities have programs through which students can be hired on a temporary or part-time basis. However, the way to get the best possible help when you need it is to *avoid* these programs. Rather, contact individual professors to find out who are the outstanding students. Then contact these students directly to determine their interest in part-time work when the crunch arrives.

Another approach is to develop a list of retired professionals living in the community. Call upon these individuals when you need experienced help on a short-term basis. One midwestern firm maintains a list of both students and retirees. It hires one retiree with one student to form a mini-team that works together on overload projects. This approach combines the experience of the retiree with the enthusiasm of the student. It also serves as a low-cost way to identify, recruit, and train future full-time employees.

OFFICE-WIDE MANPOWER PROJECTION

Department: Architectural Date 12/18/82

JOB NO.	PROJ. MGR.	PROJECT TITLE	Total Professional Man-days	PROJECTED PROFESSIONAL MAN-DAYS											
				JAN	FEB	MAR	APR	MAY	JUNE	JULY	AUG	SEP	OCT	NOV	DEC
1402	MRH	Canton A&B Assistance	254	94	79	42	30	–	3	–	–	3	–	–	3
1691	RAM	St. Andrews Church Study	32	32	–	–	–	–	–	–	–	–	–	–	–
902	CMM	Williams Brothers Building	931	155	128	96	73	73	73	61	61	54	54	54	49
2006	WGC	Stanton Street Redevelopment	191	73	36	23	30	10	15	4	–	–	–	–	–
1804	WMS	City Hall Const. Inspection	35	23	12	–	–	–	–	–	–	–	–	–	–
2174	EJS	State Capitol Renovation	370	167	96	49	38	10	10	–	–	–	–	–	–
① TOTAL BACKLOG (MAN-DAYS)			1813	544	351	210	171	93	101	65	61	57	54	54	52
	RAM	Warner Hospital Design	1234	162	150	150	150	92	75	105	85	95	60	55	55
	MRH	Southeast Studies	315	95	80	50	40	25	25	–	–	–	–	–	–
	EJS	Air Force Barracks Study	600	–	–	–	–	100	100	100	100	100	100	–	–
② MAN-DAYS ON FUTURE JOBS			2149	257	230	200	190	217	200	205	185	195	160	55	55
③ TOTAL REQUIRED MANPOWER (① + ②)			3962	801	581	410	361	310	301	270	246	252	214	109	107
④ TOTAL AVAILABLE MAN-DAYS			594	594	594	594	594	594	594	594	594	594	594	594	594
⑤ ESTIMATED OVERHEAD AND PROMOTION (MAN-DAYS)			119	119	119	119	119	119	119	119	119	119	119	119	119
NET MANPOWER SURPLUS [③<(④−⑤)]						65	114	165	174	205	229	223	261	366	368
NET MANPOWER DEFICIT [③>(④−⑤)]				326	106										

JOBS IN HAND

ANTICIPATED

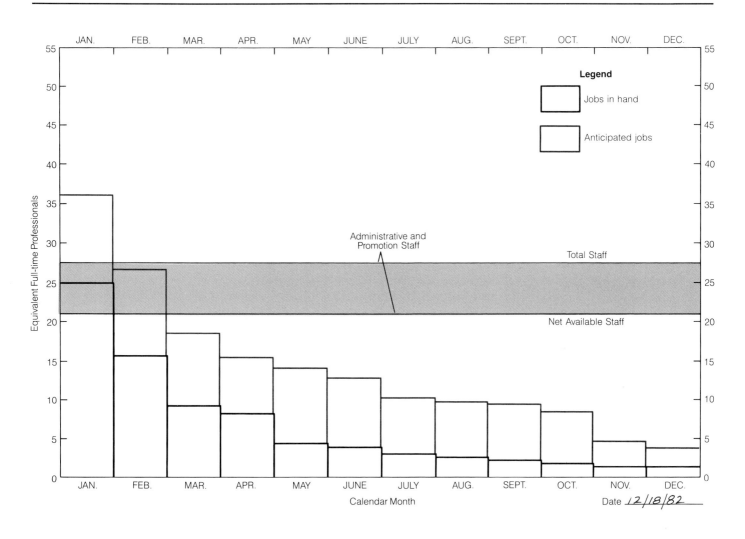

6.6 On officewide manpower forecasts such as this, note that manpower requirements always decline as the backlog is being reduced. This decline must be offset by new sales for the company to operate successfully.

6.5 Using the officewide manpower projections sheet helps you tabulate officewide manpower requirements. Note that jobs in hand are listed separately from anticipated projects to give you a longer term preview of needs.

REPORT/PROPOSAL PRODUCTION REQUEST

Date _8/12/82_

Project _Consolidated Industries Siting Study_ Job # _4794_

Project Mgr. _R. Stalworth_ _____ Dept. Secretary _H. Haney_

Completion Date (2 days before report **must** leave office) _10/4/82_

Client Receipt Date _____

TYPING: Single Space _____ 1½ Space __✓__ Double Space _____

 No. of Typed Pages _120_ Total No. of Copies _16_

 No. of 8½"x11" Tables _20_ No. of Oversized Tables _4_

 Border Paper _✓_ Plain Bond Paper _____ Other _____

GRAPHICS: No. of 8½"x11" Figures _15_ No. of 11"x17" Figures _3_

 Other (explain) _____

PRINTING: Cover: Xerox _____ Offset B/W _____ Offset Color _✓_

 Stamped: Draft _____ Final _____ Confidential _____

 Text: Xerox _____ Offset _✓_ Other _____

 Figures: Xerox _____ Offset B/W _✓_ Offset Color _____

 Binding: GBC _✓_ 3-Ring _____ Perfect _____ Other _____

Remarks/Special Instructions _Print on both sides of paper._

This form is to be completed <u>jointly</u> by the project manager and the department secretary before <u>any</u> work is begun on the report or proposal.

For scheduling purposes the following estimates are applicable: (please note that a more accurate time projection can be made directly interfacing with the various support groups.)

 Word Processing: 4 typed pages per hour
 (tables, proofing & corrections not included)

 Graphics: 2-3 hours per figure (estimate varies with complexity)

 Other Services: Offset Printing – 1-4 weeks (contact Graphics Dept.)

 Special Binding – 2-6 weeks (contact Graphics Dept.)

7/81

6.7 Fill out a form such as this one (for a proposal or report writing project) whenever you anticipate a major production effort. Reproduced courtesy of Engineering-Science, Inc., Atlanta, Georgia.

One of the best approaches to solving both temporary shortages and surpluses is to enter into reciprocal agreements with other consulting firms, preferably firms that do similar work but are not direct competitors. Such arrangements can include joint ventures, subcontracting, and/or temporary transfer of employees. Temporary employee transfers are generally made at a multiplier equal to direct personal expense (salary plus fringe benefits and statutory costs), which is less than the normal overhead charged to outside clients. Include written agreements that the firm to which the employee is being temporarily transferred will not try to hire that employee without permission from the other firm.

Resolving Long-Term Shortages or Surpluses

If you find that the long-term workload justifies hiring more full-time personnel, realize that it takes an average of two months from the time a hiring decision is made until a person is working productively. In the case of disciplines that are in demand, it could take much longer. What is needed is a long-range recruiting and training program. Such a program should answer the following questions:

1. What kinds of people will we probably need over the next few years?

2. What mix of experience levels do we want?

3. Which individuals on our present staff should be groomed for positions of greater responsibility?

4. Where should we recruit additional staff?

5. What criteria should be used to judge potential employees?

6. How can we minimize turnover in our existing staff?

Of the above questions, probably the most important is number 6. To get an idea of the financial impact of staff turnover, consider the example of an above-average-sized firm that just lost one of its better designers to a competitor. What did it cost the firm?

1. Productivity loss. The position went unfilled for two months. The firm lost the employee's profit contribution.

2. Overtime costs. It forced management to work others in the department overtime in order to meet client schedules. Despite the added overtime pay, some of the employees were not receptive to working a lot of overtime, thus causing bad morale.

3. Replacement cost. The firm spent $2,000 running ads in newspapers and trade journals with little response. Finally, it was forced to retain a search firm and pay a fee of $10,500 (30 percent of the first year's salary).

4. Additional training cost. Supervisory time used in orienting the new employee to the firm, projects, and clients.

5. Relocation expenses. A 1981 study by *The Wall Street Journal* indicated the average cost per relocation of a $30,000-per-year white-collar worker was almost $35,000.

In this case, it cost the firm between $50,000 and $65,000 to replace one designer. That's money right off the bottom line. If you multiply that figure by the number of professional people your firm loses each year, the financial impact is enormous.

Setting Priorities

You can sometimes alleviate work overloads by setting priorities and simply delaying work on the lowest priority items. This may be appropriate so long as it is confined to delaying overhead activities, for instance, keeping the office library up to date. However, this practice can lead to major problems if one project is assigned a lower priority than another. Remember that each client considers his or her project to be *number 1 priority*, and will be unhappy if you do not treat it as such!

7-WEEK PRODUCTION SCHEDULE

6.8 A multiweek calendar like this one can help you keep track of deadlines and forecast workloads of support personnel. Reproduced courtesy of Engineering-Science, Inc., Atlanta, Georgia.

In consulting firms, the outstanding manager is the one who can arrange to meet *all* project commitments in spite of obstacles.

Conclusion

This chapter dealt with some simple mathematical approaches to determine whether you have a manpower surplus or shortage and whether it is long- or short-term. It also described a number of ways to overcome both short- and long-term manpower shortages.

The next chapter shows ways to improve supervision of your project team, including such factors as organizing the project team, delegating responsibility, motivating your team, effective communications, dealing effectively with your clients, and how to wrap up a project smartly without going over budget.

CHAPTER 7 Managing Your Project Team

1. How can I attract the best staff members to my project and retain their interest?

2. What criteria should I apply to selecting consultants?

3. What are special concerns to keep in mind when the project is a joint venture?

4. How can I delegate work to others while keeping control over my project?

5. What types of tasks should I delegate?

6. What are the most potent ways of motivating the different personalities on my project team?

7. What are the dos and don'ts of communicating with my team members in writing, verbally, and using "body language"?

8. Why is good listening so important? What are some tips for effective listening?

9. How can I avoid the "we-they" pitfall in dealing with the client?

10. What are the benefits of the "three-alternative rule" when requesting decisions from my client?

11. What are the best ways to shine as a competent project team manager?

12. How can I avoid traps when wrapping up a project?

MANAGING YOUR TEAM during the execution of a project requires that you, the project manager, possess a diverse group of skills, including people management, toughness, empathy, responsibility, the ability to motivate your project team, effective communications, and effective management of conflicts and crises.

Organizing the Project Team

The first step in organizing the project team is to determine what kinds of expertise are required for each activity on the task outline. On design projects this breakdown is usually done by discipline, for example, architectural, electrical, or structural. On study projects, the breakdown is usually more subtle, taking into account factors such as educational background and previous experience on similar projects.

Next, group all activities to be done by each type of person and prepare an organization chart similar to Figure 7.1. Now you have something you can take to the principal-in-charge in order to discuss which individuals should be assigned to the project. Because the best people are always in demand, the trick is to assemble a project team that not only has the ability to do a good job, but also can devote the required time to the project. The following are a few tips:

1. Make people *want* to work on your project. Even busy people always seem to make time for what they want to do.

2. Obtain tentative commitments from key personnel during the proposal stage and involve them in proposal preparation.

3. Remind key people of prior commitments.

4. Don't *demand* that certain key people work on the project; rather, try to convince your principal on the basis of the overall benefits to the office.

5. Keep manpower forecasts current and keep your principal-in-charge apprised of the results.

6. Be understanding of the fact that your principal must make personnel assignments that are best for the entire office, not just for your project.

Selecting Outside Consultants

In many cases, the decision about which consultants to use on a project is made during the proposal effort. At that time, the selection is generally based on what the prime professional believes will be most salable to the client. In other cases, it may be up to the project manager to select a consultant to fill a role in an existing

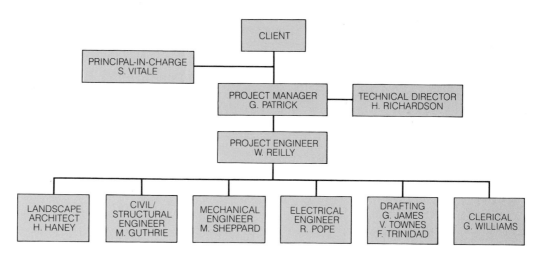

7.1 A project organization chart can be used to identify who should be on your project team and what each person's role should be.

project. In either case, the same considerations should apply. Questions you should ask yourself when selecting consultants should include:

Have I personally worked with them before? If so, what were the results?

How are they generally regarded within my firm? By other consultants?

Have they ever worked for my client before? With what results?

Who are the individuals that will be working on my project? What do I think of them?

What is their track record of meeting commitments?

What logistical problems will I encounter in dealing with them, for instance, distance, differences in accounting procedures, or differences in organizational structure?

How interested are they in developing a long-term relationship beyond this particular project?

Remember, you are responsible for the performance of all your consultants just as much as any other member of your project team. Be sure that anyone you select has the highest level of commitment to meeting your project objectives.

Joint Ventures

The best joint venture is really a prime-associate relationship. That is because an equal partnership (which is what a legal joint venture is) is fraught with management problems, such as who is in charge, how to obtain liability insurance, and so on.

But if you must enter into an actual joint venture, effective management is the key to success. Forestall problems by following these suggestions:

1. Avoid joint ventures with firms who have your same capability. Such firms tend to unconsciously duplicate hours on certain tasks, thus reducing profitability. If your firm is known for design but not for production efficiency, consider joint venture with firms weak in design but good at producing documents. Then, discipline yourself to do *no* production. Selecting a joint venture partner to make up for your firm's deficiencies in certain design disciplines can also be effective.

2. Avoid cost reimbursement contracts with joint venture partners. Instead, establish lump sum fees for portions of the work, and divide the project responsibilities accordingly. If one of the partners goes over budget, it doesn't affect the other.

3. Minimize or eliminate joint venture overhead. Have each partner maintain individual liability insurance, and assign the responsibility for bookkeeping to one of the firms instead of the joint venture.

4. Name one of the principals as the principal-in-charge of the joint venture to be responsible for all financial transactions, such as billing, collecting, and disbursing funds. Require only one signature on joint venture checks to avoid "check signing" meetings. The principal-in-charge should also be the prime contact with the client.

5. Define specifically how changes in scope will be handled and how compensation will be made. Most firms prefer a straight hourly amount billed to the client by each firm without joint venture markup. Thus, whoever does the work gets the total benefit from it. The billing rates for changes should be outlined in advance for the benefit of the client.

6. Meet monthly with your joint venture partner to discuss all aspects of the project. Firms with joint venture problems all cite poor communications as a major factor.

7. When splitting fee amounts with your partner prior to starting the work, always leave a minimum of 10 percent as a contingency in the joint venture account.

8. Try to contract with the client on a lump sum basis so that detailed scope definition becomes mandatory and fee amounts are set. Avoid a percentage-of-construction-cost fee arrangement, which can lead to major disputes over who caused construction costs to go up or down.

9. Pick your partner carefully by checking past joint venture references. A joint venture can be a shotgun wedding or it can be a marvelous success. Your ability to pick a congenial partner before going after a project may make the difference.

Delegating Responsibility

One of the most difficult tasks for project managers is to delegate responsibility *properly*. The two most commonly observed problems are (1) reluctance to delegate work to others and (2) the inability to remain in control of the work once it has been delegated.

Most project managers in design firms begin their careers "on the boards" doing technical work on projects. After several years, the best architects, engineers, and planners are often promoted to the position of project manager, where they are given overall project responsibility. This leads to a tendency for project managers to resist assigning work to others for fear it won't be performed as well as the project manager would do it. The key to overcoming this reluctance is to redefine the standards used to judge performance. Do not expect work to be as good as you would do—it rarely is. Rather, preestablish minimum acceptable levels of performance and be firm that these standards for technical quality, budgets, and schedules are met.

The following is a list of the kinds of tasks that can be delegated:

1. Something you don't have the expertise to do yourself.

2. Technical tasks that someone else can do as well as you.

3. Technical tasks that someone else can do sufficiently well.

4. Project management tasks.

Activities at the top of the list are relatively easy to delegate while the ones toward the bottom become more and more difficult. The pinnacle of successful delegation in a larger firm is to delegate project management tasks to an assistant project manager. Doing so allows you to handle more projects and/or perform other duties (marketing, for example) that will make you more valuable to your firm and advance your professional career. Furthermore, this approach can be used to train young professionals who can then move into project management more rapidly, thus increasing the firm's depth and ability to handle more projects.

Once you decide to delegate a task to someone else, the first step is to define the work clearly. On every task, you should:

1. identify all available information

2. define the completed activity

3. agree on the level of effort (budget) required

4. establish a suitable completion date

5. set up control mechanisms

Especially important is item 2—establishing a detailed specification of what constitutes the completed activity. For example, define completion of a study project using a detailed outline of the final report, possibly including lists of figures and tables. Similarly, a detailed list of drawings and specifications can be used to define completion of a design project. Obviously, these lists will change as the project progresses; however, such tools are invaluable for assuring good communications. They also help in monitoring progress on the project.

Probably your greatest challenge is establishing and use of control mechanisms. You should permit your team to operate with a high degree of freedom, while still

effectively controlling performance. *The most successful project managers spend most of their time controlling work delegated to others.*

The degree of control is a function of the importance of the task and the confidence that the project manager has in the person doing the work. For example, consider the following scenarios that, though similar in scope, require different degrees of control.

Task definition	Control Mechanism
1. Write a letter to the client asking for a fee increase.	Project manager asks person to prepare a draft of the letter for review.
2. Write a conference report to submit to the client.	Project manager asks person to prepare the report and have it typed, leaving the final proofing for the project manager prior to signing the report.
3. Write to a vendor requesting equipment dimension drawings.	Project manager asks person to prepare and mail the letter, routing a copy to the project manager to assure that the letter was sent.

The above examples are only a few of many effective control mechanisms available to you. Others include periodic reviews, identification, and tracking of milestones. One of the best control mechanisms is simply to walk through the office once or twice a day, stopping to see what each member of your project team has been doing. (This is best done at different times so your team will not view it as a routine event.)

Project Name _Springfield City Hall_

Project Number _1794_

Client _City of Springfield_

Project Manager _R. Marlow_

Department _Architecture_

Project Budget _$89,000_

Contract Completion Date _10/19/82_

Task No.	Task Description	Responsibility	Due Date	Man-Hours	Actual Completion Date
A-3	Research building codes	RLM	4/12/82	12	4/11/82
A-3	Research permit requirements	RLM	4/16/82	8	4/20/82
B-4	Evaluate alternative bldg. materials	SKP	5/12/82	24	
C-2	Determine struc. framing system	LMR	5/12/82	40	
D-1	Establish landscaping criteria	SPT	5/20/82	16	

7.2 Use this form to keep track of all activities that have been delegated, along with the agreed-upon completion dates and budgets.

Finally, be sure that everything is written down by both you and the person who will do the work. If you see that the person is not making notes about key points, take notes yourself and then give him or her a copy. Maintain your own documentation of delegated work so you can give it the proper follow-up. A good form for doing this is presented in Figure 7.2.

Motivating Your Team

In professional service firms motivation tends to be self-induced. As project manager, all you can hope to do is create an environment in which your people can achieve their own goals so that they become self-motivated. To do this effectively, you must know what motivates each individual. Maslow established a hierarchy of needs, shown in Figure 7.3. The motivational implications of Maslow's hierarchy are described in Figure 7.4. Realize that different members of your project team may be on different levels in Maslow's hierarchy and will be motivated by different things. For example, a draftsman who has been laid off on three jobs within the past four years will probably be on the "security" level and will be more receptive to hints about job security than technical achievements. On the other hand, senior engineers who have a national reputation in their field will be more motivated by compliments on the excellence of their work.

In dealing with design professionals, the most effective motivator is recognition. Architects and engineers tend to be most productive in an environment where criticism is given in a constructive manner and achievement is recognized and rewarded. Either criticism or praise should be given *as soon as possible* following the performance of the activity. One of the worst approaches is to confine comments about an individual's performance to an annual performance review. When criticism is levied several months after an event, it is likely that the person respon-

MASLOW'S HIERARCHY OF NEEDS

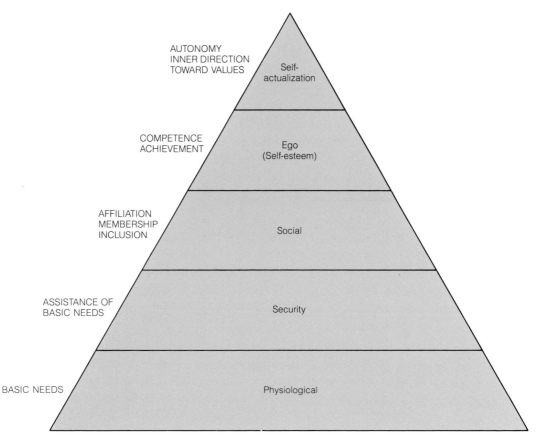

7.3 Maslow's hierarchy of needs states that "a need satisfied no longer motivates." This means that a person will not be motivated by factors below his or her position in the hierarchy.

IMPLICATIONS OF MASLOW'S HIERARCHY*			
Hierarchy Level	**Reward and Punishment**	**Dependency**	**Information Required to Motivate Person**
Self-Actualization	Working toward one's own goals and standards	High degree of autonomy	High degree of knowledge and expertise about persons, goals, values, cognitive needs, and likely barriers to goals
Ego	• Respect • Achievement • General feeling of confidence • Ability to do and know • Respectability	High degree of interdependence self-related to others for psychosocial rewards; identification with and respect from others critical	Substantive, knowledge and responsive around: (1) feelings of competences, belongingness, dependence; (2) desire for control; (3) current existential (here and now) problems
Social	• Acceptance • Warmth • Concern • Rejection • Exclusion • Coldness • Hostility • Indifference	High degree of dependence on others for external material rewards often subject to coercion from others	
Security	Protection from danger, threat, and deprivation		Security, physiological knowledge of state of deprivation and external needs. Adequate subservience and over-compliance is usually overt behavior
Physiological	Food, rest, exercise		

*Abraham H. Maslow, *Motivation and Personality* (New York: Harper & Row Publishers, 1954).

7.4 According to Maslow, a person's position in the hierarchy will determine the kinds of actions that motivate that person the most.

sible was not even aware of the problem and was therefore unable to remedy it. Even if the individual agrees that the criticism was justified, he or she would feel resentful at not having been told earlier.

Recognition comes in many forms. It must be sincere and not viewed as tokenism. If members of your project team do a truly outstanding job, first let them know that you recognize the contribution and appreciate the effort. Do so openly among peers in the office to encourage others to perform as well. Another effective approach is to write a memo to a person's supervisors describing his or her work on the project.

Often overlooked as a motivational factor is the influence of spouses. One of the most common reasons that many professionals leave consulting firms is that their spouses feel the company is taking advantage of the employee. Even if the employee does not feel the same, constant reinforcement by the spouse can eventually lead to dissatisfaction and, ultimately, resignation. A good way to prevent this potential problem is to involve spouses in as many office activities as possible. Company picnics, parties, and other events make the relationship between firm management and employees' spouses more personal and tend to reduce the severity of any criticism. Note that when you ask an employee to work overtime, it is really a request for his or her family to give up time that rightfully belongs to

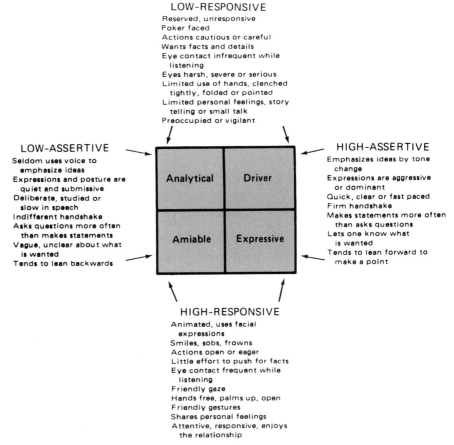

GUIDELINE FOR RECOGNITION
HOW RESPONSIVE IS THE PERSON? HOW ASSERTIVE IS THE PERSON?

LOW-RESPONSIVE
Reserved, unresponsive
Poker faced
Actions cautious or careful
Wants facts and details
Eye contact infrequent while
 listening
Eyes harsh, severe or serious
Limited use of hands, clenched
 tightly, folded or pointed
Limited personal feelings, story
 telling or small talk
Preoccupied or vigilant

LOW-ASSERTIVE
Seldom uses voice to
 emphasize ideas
Expressions and posture are
 quiet and submissive
Deliberate, studied or
 slow in speech
Indifferent handshake
Asks questions more often
 than makes statements
Vague, unclear about what
 is wanted
Tends to lean backwards

Analytical | Driver

Amiable | Expressive

HIGH-ASSERTIVE
Emphasizes ideas by tone
 change
Expressions are aggressive
 or dominant
Quick, clear or fast paced
Firm handshake
Makes statements more often
 than asks questions
Lets one know what
 is wanted
Tends to lean forward to
 make a point

HIGH-RESPONSIVE
Animated, uses facial
 expressions
Smiles, sobs, frowns
Actions open or eager
Little effort to push for facts
Eye contact frequent while
 listening
Friendly gaze
Hands free, palms up, open
Friendly gestures
Shares personal feelings
Attentive, responsive, enjoys
 the relationship

Recognition is most accurate by observing one dimension at a time.

© 1975 WILSON LEARNING CORPORATION

7.5 Everyone on your project team may be classified as one of four basic personality types depending on their assertiveness and responsiveness.

them. This sacrifice can be recognized by sending the spouse a note thanking him or her for giving up the spouse's time.

Contrary to popular belief, studies have shown that money is not a primary motivator for design professionals, with two exceptions. If an employee is being paid below the normal range of salary for a position, that employee will lose motivation and may leave if the situation persists. The second exception is the use of money as a means of recognizing achievement. If only a small percentage of employees receive bonuses, the urge to be included in that group will be a much stronger motivator than the money itself. However, to be most effective, a bonus should be (1) confined to no more than 20 percent of the employees and (2) equal to at least one month's salary.

Identifying and Dealing with Different Behavioral Traits

One excellent method of identifying overall behavioral patterns of various members of your project team is a test devised by Wilson Learning Corporation. It involves the scaled ranking of each individual with respect to their responsiveness and assertiveness. Those that tend to keep to themselves are given a low responsiveness number; the gregarious and group-oriented are given a high responsiveness number. With respect to assertiveness, those individuals that are self-starters are given high numbers; those that tend to seek direction from others are given

low numbers. When a grid is prepared with responsiveness on the x-axis and assertiveness on the y-axis, the personality of each team member can be plotted at the intersection between their rank for assertiveness and responsiveness, as shown in the example in Figure 7.5. It is also useful to rank the client, partner-in-charge, third-party agencies, and anyone else heavily involved in the project and plot their points on the same grid. (There are no good or bad positions on the grid; each quadrant simply represents a different type of personality and style of communicating.)

Those in the northeast quadrant are "drivers," or control-takers. They are highly assertive, but not very responsive. In a crisis, they will attempt to resolve the problem by themselves without outside interference.

Persons in the southeast quadrant are "expressives." Their high level of responsiveness and assertiveness makes them flexible in dealing with a variety of situations. They tend to be good with ideas, but often lack the patience to follow through with the details. In a crisis, they will attempt to involve a number of people in order to achieve a democratic resolution and may spend too much time arriving at a decision.

Those in the southwest quadrant are "amiables," or support-givers. Amiables mix well in groups and tend to do well in marketing situations where social contacts are important. In a crisis, the amiable tends to blame others.

Individuals in the northwest quadrant are "analytics," or data collectors. They tend to be very cautious in making decisions, thorough in dealing with every detail of a problem, and place quality ahead of budgets or schedules. In a crisis, the analytic will usually avoid the problem, leaving it for someone else to resolve.

On a typical project, it may be good to have drivers, expressives, amiables, and analytics all represented on the project team, so the project manager can make best use of each one's style for various tasks. For example, if you need to obtain a permit from a lifelong bureaucrat, this task can best be handled by an amiable, who can establish rapport with the official. Involving a driver in this activity would probably result in animosity and jeopardize the objective of obtaining the permit.

Another example is a task involving development of a complex computer program on which the rest of the project is to be based. This is best accomplished by an analytic who can analyze all the facts and develop and debug the program so that no important aspects are overlooked. In the same task, a driver would probably omit important details, an amiable would waste other peoples' time by trying to get them involved, and an expressive would become bored with the detailed nature of the task.

The project manager's challenge is to (1) recognize the basic personality types of each person involved in the project, (2) make best use of each individual's behavioral traits, and (3) avoid conflicts by minimizing interaction between people of opposite personality types. As project manager you should also identify your own personality type and review how you interact with others.

Dealing with Negative Thinkers. Because most project managers have limited control over the selection of project team members, you often must deal with "negative thinkers" who have been assigned to the team. These individuals are often characterized by the following behavioral traits:

Egotism. Negative thinkers tend to be argumentative and will not hesitate to insult anyone who does not agree with their opinions. The objective of this behavior is for the negative thinker to elevate his or her position by lowering that of others.

Perfectionism. Negative thinkers view the world in absolute terms. Everything is either right or wrong, good or bad. This view requires them to go to extreme lengths to achieve perfection, ignoring the fact that most design decisions are compromises among performance, cost, and schedule.

Procrastination. Managing time effectively conflicts with the negative thinker's

desire for perfection. Every deadline therefore becomes a last minute panic and most of them tend to be missed.

Distraction. Taking off on tangents not only assists negative thinkers in their quest for perfection, it also helps avoid completion of an assignment.

George A. Pogany, a department head at Shell Research Company in Holland, offers the following advice on how negative thinkers operate and how you can harness their competitive spirit and energy.

1. Don't allow yourself to be drawn into arguments about details. Acknowledge minor problems but confine the discussion to overall project objectives.

2. Don't assign negative thinkers to tasks that require simple and quick solutions. They will perform much better where the emphasis is on attention to detail.

3. Recognize that, handled correctly, negative thinkers can be very useful assets. Their attention to detail may often uncover design defects that others have overlooked. Also realize, however, that they are a luxury. You cannot afford to have too many of that kind around.

4. Help to change the negative thinker's style by pointing out the results of actions you feel were deliberately destructive.

Effective Communications with Your Team

People communicate in only three ways: with verbal, written, and body language. Effective communication requires that one form be reinforced with another. For example, speaking is more effective if graphics are used to explain the message. By using written communication (the graphics), you reinforce the verbal communication (the speech). Speech is even more effective if the speaker is animated, using body language for additional reinforcement.

Similarly, written communications (such as letters and memos) should always be reinforced by verbal communications (for example, calling to be sure the memo was received and understood) or by body language (standing in front of the person who is reading the memo, for instance).

Speaking Effectively. Because most communication is verbal, the ability to speak clearly and concisely to both individuals and groups is vital. From a communications point of view, the most important thing is to be sure your message gets through: (1) *reinforce* the verbal message using written communication and/or body language, (2) *repeat* the message several times in different ways, and (3) look for *feedback* to be sure your message is properly received and understood.

When you prepare any kind of speech, organize it into the following four parts:

1. Preview what you are going to say.

2. Explain why it is important for the audience to listen.

3. Deliver the message.

4. Summarize the important points.

This approach builds in several opportunities to repeat your message. While it may seem like overkill, the average person must hear a particular message at least three times before it is retained. The skillful speaker is able to deliver a message several times, each time in a slightly different way, assuring that the message is received without boring the audience.

Another way to ensure effective speaking is to watch for feedback. Following are some effective feedback mechanisms:

1. Taking notes. If people are writing down key ideas, you are probably being understood.

2. Asking questions. If the person isn't asking them, he or she may not be understanding you. Find out by asking the person some probing questions.

3. Body language. Watch for such signs as attentiveness, loss of concentration, or confusion.

Writing More Effectively. Writing memos is a common (though sometimes overused) method of communications. Use the following tips to write more effective memos:

1. Use memos as "ticklers" to make sure others perform important tasks.

2. Eliminate meetings by using memos to communicate easily understood information to a number of people.

3. Do not type memos for internal distribution unless you want them to appear especially authoritative.

4. Color-code your memos by type of memo to provide instant visual communication on the general subject matter of the memo.

Effective letter writing is another fundamental communication skill that is important to the project manager. The most effective letter is only one page long and contains three paragraphs. The first is a brief statement summarizing the subject matter; the second amplifies that description; and the third is a closing that tells the reader what you want done with the information in the letter. Although it is not always possible to write letters in this manner, brevity is an essential component of a well-written letter. Socrates once said, "If I had more time, I would write it shorter."

Another tip for improving the effectiveness of your letters is to use the P.S. to reinforce important messages. A study conducted by *Reader's Digest* revealed that virtually everyone reads the P.S. in a letter. Next time you receive advertising letters, look at the way they use the P.S. to reinforce the sales pitch. In a business letter you can get the same results using the word "remember" in place of P.S.

Using the Telephone Effectively. The telephone has become such a commonly used instrument that people forget how fundamentally unnatural it is as a communications tool. The physical position required to use a standard telephone contorts the body and effectively paralyzes the side on which the receiver is held. More important, using the telephone does not permit the speaker to use body language to reinforce the verbal message. This is why instructions given by telephone never seem to be carried out as well as those delivered in person. Follow these tips to increase your effectiveness on the telephone:

1. Make an agenda for each telephone call before you make the call. When returning calls, the back of the message slip can be used for this.

2. Keep your agenda slips when you call someone who is not in and leave a message for them to return the call. This eliminates the chance of your forgetting topics when the person calls back and also reminds you to call again if the person does not return the call.

3. Always give your telephone number when leaving a message to call back. Even if your business card is in the file, the person will respond faster if he or she does not have to search for the number.

4. Always keep a pencil and note pad handy when making or answering phone calls. This avoids breaking a chain of thought while searching for a pencil and paper.

5. Make your calls in groups. This allows you to gear your mind to the peculiarities of communicating by telephone, and also shortens the length of each call.

6. Reinforce your telephone calls by preceding or following them with written communications. If the message is important, you may wish to call a meeting to provide additional reinforcement.

A good example of the effective use of reinforcement is the use of a telephone call

to a client after an invoice has been sent. The person receiving the call becomes aware that you are interested in prompt payment, even if all you ask is, "Did you receive our invoice?" After you hang up, your invoice will probably end up on top of the "to-be-paid" file, instead of the bottom. More important, if there is a problem, you will have uncovered it through the call, instead of waiting sixty days to send another invoice.

Improving Your Listening Skills. It has been said that the higher one progresses in level of responsibility, the less important it is to speak and the more important it is to listen. George Bernard Shaw once suggested, "Never overlook a good opportunity to keep your mouth shut." A good way to test your listening skills is to give yourself a mental kick every time you begin a sentence with "I think . . ." unless someone has specifically asked your opinion. If you have a list of mental bruises at the end of the day, it is time for you to evaluate how effectively you are listening.

Probably the greatest single impediment to effective listening is the urge to interrupt a speaker to interject your own viewpoint. This not only is rude, but also results in breaking the other person's thought patterns and reducing the effectiveness of the conversation. It is far better to hear the person out, keeping your thoughts to yourself until the person is finished. In addition to allowing the person to express his or her thoughts properly, this approach also gives you a chance to withhold your remarks until you have heard all the facts, thus avoiding rash

TEN KEYS TO EFFECTIVE LISTENING

The Ten Keys	The Bad Listener	The Good Listener
1. Find areas of interest	Tunes out dry subjects	Seizes opportunities; asks, "What's in it for me?"
2. Judge content, not delivery	Tunes out if delivery is poor	Judges content, skips over delivery errors
3. Hold your fire	Tends to enter into argument	Doesn't judge until comprehension is complete
4. Listen for ideas	Listens for facts	Listens for central themes
5. Be flexible	Takes intensive notes using only one system	Takes fewer notes; uses four or five different systems, depending on speaker
6. Work at listening	Shows no energy output; attention is faked	Works hard, exhibits active body state
7. Resist distractions	Distracted easily	Fights or avoids distractions, tolerates bad habits, knows how to concentrate
8. Exercise your mind	Resists difficult material; seeks light, recreational material	Uses heavier material as exercise for the mind
9. Keep your mind open	Reacts to emotional words	Interprets color words; does not get hung up on them
10. Capitalize on the fact that thought is faster than speech	Tends to daydream with slow speakers	Challenges, anticipates, mentally summarizes, weighs the evidence, listens between the lines to tone of voice

7.6 As part of the listening program he operates for the Sperry Corporation, Dr. Lyman K. Steil offers ten basic suggestions. From *Your Personal Listening Profile* by Dr. Lyman K. Steil, Department of Rhetoric, University of Minnesota and Communication Development, Inc., and Sperry Corporation, Copyright © 1980. Reprinted by permission of Dr. Steil and Sperry Corporation.

statements. Reducing the tendency to interrupt is much more difficult than it sounds. It takes constant attention, practice, and concentration.

Research by Dr. Lyman K. Steil, Chairman of the Speech-Communication Division at the University of Minnesota at St. Paul, reveals that we spend over one-third of our waking hours listening. That is 50 percent more than the amount of time we spend talking. However, the average listener retains only one-fourth of a ten-minute message after a forty-eight-hour period. *This means that we are wasting over four hours per day by not listening efficiently!*

Dr. Steil, as part of a listening program he conducts for the Sperry Corporation, has identified ten keys to effective listening. These are listed in Figure 7.6, along with a summary of the attitudes that separate good and bad listeners. Dr. Steil suggests that a good listener will find a selfish reason for listening to the speaker, keeping tuned in for ideas and information he or she can use. He also recommends that a person practicing listening skills should plan to report a conversation to another person later in the day.

Marion E. Haynes, who teaches group dynamics workshops for Shell Oil Company, offers the following suggestions that can improve your listening skills:

> Listen for an overview; that is, don't concentrate on every detail. Too much attention to details can obscure the central meaning.

> Minimize distraction; close the door, turn off the radio, and have your secretary hold phone calls.

> Avoid mental side trips; instead of thinking about what you are doing in the evening, or what you will say when it is your turn to talk, think about what the speaker has been saying.

> Take advantage of the fact that you think faster (600 to 800 words per minute) than a person speaks (100 to 200 words per minute); listen for feelings and emotional catchwords as well as content.

> Summarize what the speaker has been saying and "play back your summary" to him for verification.

> Seek the answers to these three questions: What does the speaker mean? How does the speaker know? What is being left out?

Interpreting "Erasure Words." Consider the following statements made by a member of your project team: "I really would like to work on your project, but I don't have much time available" and "I don't have much time available, but I really would like to work on your project." The message in the first statement is that the person cannot work on your project. The message in the second statement is that, although the person is busy, he or she will somehow find the time to work on your project.

How can these two almost identical statements have such different meanings? The answer can be explained using a concept known as "erasure words." Erasure words are conjunctions such as "but," "however," and "whereas," which divide two contradictory phrases in the same sentence.

In almost every case where this occurs, all the words coming ahead of the erasure word can be erased and the real meaning will be retained. Being alert to erasure words can greatly help you derive the proper message from contradictory statements.

Reading Body Language. An often overlooked method of communicating is through body language. It is one of the best methods of obtaining feedback, because people are generally unaware of the messages they are transmitting through body language; thus there is less opportunity for deception.

Following is a list of common attitudes communicated nonverbally. Being aware of these subtle meanings not only will help you receive information more accurately, it will allow you to reinforce what you say through proper body language to ensure that your messages are received by listeners. This list was provided as part

of a presentation on negotiating by Russell Tirella of Moore, Gardner and Associates at the 1977 Convention of the American Consulting Engineers Council.

Defensiveness	Arms crossed on chest
	Legs over chair arm while seated
	Sitting in armless chair reversed
	Crossing legs
	Fistlike gestures
	Pointing index finger
	Karate chops
Suspicion	Not looking at you
	Arms crossed
	Moving away from you
	Silhouette body toward you
	Sideways glance
	Feet/body pointing toward exit
	Touching/rubbing nose
	Rubbing eyes
	Buttoning coat—drawing away
Readiness	Hands on hips
	Hands on mid-thigh when seated
	Sitting on edge of chair
	Arms spread gripping edge of table/desk
	Moving closer
	Sprinter's position
Cooperation	Sprinter's position
	Open hands
	Sitting on edge of chair
	Hand-to-face gestures
	Unbuttoning coat
	Tilted head
Territorial dominance	Feet on desk
	Feet on chair
	Leaning against/touching object
	Placing object in a desired space
	Elevating oneself
	Cigar smokers
	Hands behind head—leaning back
Nervousness	Clearing throat
	"Whew" sound
	Whistling
	Cigarette smoking
	Picking/pinching flesh

	Fidgeting in chair
	Hands covering mouth while speaking
	Not looking at the other person
	Tugging at pants while seated
	Jingling money in pockets
	Tugging at ear
	Perspiration/wringing of hands
Boredom	Doodling
	Drumming
	Legs crossed—foot kicking
	Head in palm of hand(s)
	Blank stare
	Bored stiff

Managing Your Client

Many project managers fall into the trap of viewing clients as the "they" half of a we-they relationship. This viewpoint ignores the fact that you are both part of the same project team and tends to create needless conflicts. Your ability to deal with clients as members of the project team will to a large extent determine your ability to meet project objectives. This section presents concepts and ideas on how to "manage" your clients more effectively. (These concepts can also be used to improve your relationships with your other bosses, the principals of the firm.)

Dealing with Clients as Individuals. The first step in successfully managing your clients is to find out who they are. This means understanding the role of each member of your client's organization, including:

who makes technical decisions
who is responsible for the schedule and budget
who has the authority to modify the contract
who influences various kinds of decisions

In the case of a small developer, there may be only one person involved with the project. In a large municipality, there may be technical staff, department heads, and elected officials, each of whom has varying levels of authority and involvement in the various aspects of the project. In a major manufacturing firm, both plant and corporate people may be involved. Identify all the participants and each person's role in the project as early as possible.

Once you have established who the client's participants are, find out as much about each individual as you can. On major projects you should personally meet each of the client's representatives in order to know them better and so they can know you better. Whenever possible, you should identify one of these individuals as your primary contact. Most sophisticated clients arrange this by designating their own project manager. However, it is still up to you to know what the limits of the person's authority really are.

Because clients are people, they have personality types, work styles, and behavioral traits. As previously discussed, Maslow's theory states that people are motivated by a hierarchy of needs depending upon where they are placed on a pyramid rating system (see Figures 7.3 and 7.4). Recognize that a particular client may not necessarily be in the same position on Maslow's hierarchy as you. If this is the case, you must modify your methods of dealing with that client in order to be responsive to the client's needs.

An excellent way to determine your compatibility with your client is to rank him or her using the Wilson method described previously in this chapter (Figure 7.5). Then compare the client's rank to your ranking based on input from your peers. If you and your client both fall into the same quadrant, regardless of which quadrant

it is, you will probably have a harmonious relationship because your work styles are similar. Problems are more likely when the two points (yours and your client's) are the furthest apart. These are the cases in which you must modify your normal style to accommodate your client's expectations. In extreme cases, it may even be better for the firm to change project managers in order to improve compatibility.

Peter Drucker, the well-known management consultant, has divided all supervisors into "readers" and "listeners," the same way that people can be divided into right-handers and left-handers. If your client is a reader like Dwight Eisenhower or John Kennedy, don't just call or visit him to talk about a problem or suggestion. Write it up first to make sure you have something for him to read; then you can start to talk. If your client is a listener (someone like Franklin Roosevelt or Harry Truman), don't send a memorandum. Go ahead and talk about it first and then summarize with a memo or letter.

Understanding the Client's View of Your Relationship. There is a gamut of possible relationships between you and your client. One extreme is the "consultant" relationship, in which you (and your firm) are viewed by your client as an integral part of his or her team. The other extreme is the "contractor" relationship, in which your firm has been hired to do a particular job within rigidly defined constraints. The consultant relationship is one in which decisions are made jointly by you and your client. The contractor relationship requires you to make all decisions within your scope of work, but to obtain formal direction for anything outside that scope. Understanding your client's view of this relationship is essential to effectively deal with him or her on a day-to-day basis.

Your relationship with the client may be different depending on the level of involvement desired by the client. For example, you may be working for the chief executive of a corporation on the design of the corporate headquarters, in which case your client will probably wish to participate in making day-to-day project decisions. On the other hand, if your client is the chairman of the board of directors for a small community museum, they may expect you to make design decisions alone, so long as the final product is satisfactory to the community. That's because no single board member is individually accountable for the project.

The nature of your relationship with your client should dictate how you interact with him or her. What may appear to be a cavalier attitude to one client may be interpreted as tight control by another. These differences mean that the successful project manager must sometimes modify his or her own management style to conform to the expectations of the client.

Serve, But Don't Be Servile. Regardless of the kind of relationship that you have with your client, one important ingredient must be present. You must serve without being servile. You cannot act as a "yes man" who goes along with everything the client says, regardless of the consequences.

The General Electric Company, a perennial recipient of *Fortune* magazine's award for the five best-managed firms in the United States, has an interesting way of selecting consultants who are not afraid to disagree with the client. During the interview, a GE employee begins by asking the consultant easy questions for which the "proper" answer is apparent. As the interview proceeds, the GE interviewer asks more difficult questions while still making it obvious what answer is expected. Finally, the interviewer begins asking questions in which the "proper" response is deliberately nonsensical.

The objective of this technique is to determine at what point the consultant develops the courage to disagree with the interviewer. Consultants are then rated according to their ability to provide constructive input, even if it goes against the client's preconceived ideas.

The 3-Alternative Rule. A good way to avoid unnecessary confrontations is to employ the "3-alternative rule," that is, to present three alternatives for any decision, along with your recommendation. If you approach the client with only one recommendation, the client may disagree, leading to a confrontation in which

both parties feel compelled to defend their stated position. Presenting two alternatives is better, but still runs the risk of the client focusing on a different option, one that you did not consider and therefore feel compelled to disagree with. Presenting three alternatives establishes that a variety of options is available and that the best one may be some combination of the three. This method leads to an objective analysis that is not hindered by the need to defend previously established positions.

For example, the 3-alternative rule can be used when the project schedule cannot be met because of various delays. Rather than going to the client with a request for a schedule extension, it would be better to offer the following alternatives:

1. Revise the scope of work, eliminating items to make up lost time and complete the project on schedule.

2. Bring in temporary drafting personnel from your Canadian office, resulting in additional costs and loss of efficiency, which would require a fee increase.

3. Extend the schedule by two weeks.

Depending on the situation, you might then recommend the third alternative as having the least impact on the overall project.

The important thing is to establish three options. Two options are an either-or situation that is only slightly better than the ultimatum that one option becomes. Four options are too many to keep track of and can be confusing.

Hiding Elephants. One of the most damaging things a project manager can do in terms of client relations is to lead the client to believe that the project is in better shape than it really is. If it becomes apparent that meeting the schedule or budget is becoming a problem, you have a professional obligation to inform the client of this condition as soon as possible. In addition, divulging this information allows you to enlist the client's support to solve the problem.

There are those who argue that making such admissions will damage the status of the project manager in the eyes of the client. This is no doubt true, at least temporarily. However, if the problem can be satisfactorily resolved and the project become a success, there will generally be no lasting damage. On the other hand, if the project manager's silence destroys the project objectives, the damage to the project manager's prestige can never be repaired.

Here is a graphic example taken from an actual project, which called for modifications of a group of public works facilities. As a result of numerous factors, it became apparent about halfway through the job that proceeding along the established course would result in exceeding both the budget and the schedule. This fact was explained to the client during a detailed discussion about the causes of the problem. Plans were then made jointly with the client to (1) solve these problems and (2) make up the ground that had been lost. This approach included:

reduction of the number of equipment selection alternatives to be considered before making design decisions

ranking construction priorities so that the most critical items would be built first

performance of certain activities by the client's staff

establishment of a weekly review process to assure that future problems would be quickly identified and solved

As a result the project was finished on time and within budget. Equally important, the client viewed the problems experienced during the early stages as the type of minor difficulties that are encountered in almost all projects. Had the client not been informed about the problem in its early stages, both schedule and budget would have been exceeded and client relations would have almost certainly been dealt a fatal blow.

USING AN AGENDA TO IDENTIFY PLANNING REQUIREMENTS

Agenda Item	Advance Work Required
1. Review project progress	Prepare task outline
	Compute budget status
	Update CPM diagram
2. Select case study sites	Prepare list of alternative sites
	Develop site selection criteria
3. Finalize design criteria	Develop architectural criteria
	Develop mechanical criteria
	Develop structural criteria
	Develop electrical criteria

7.7 Your agenda may be used to help uncover advance work that may need to be done prior to a meeting with your client.

Preparing for Client Meetings. Never go into a meeting with your client unless you have done your homework. A rule of thumb is to spend five to ten minutes of preparation time for each minute of meeting time. However, you need not overdo advance work if you channel your efforts toward accomplishment of the objectives you established for the meeting. The first question to ask yourself is, "In detail, what are my objectives?" Do you want a decision? Do you need advice? Do you want to apprise your client of the project status? Must you warn your client about impending problems? Be sure the objectives of the meeting are clearly communicated to your client and understood by both of you.

The next step is to develop and formulate an agenda that will accomplish your objectives. (Rules for preparing an effective agenda are presented in Chapter 8.) A good agenda can serve as an outline for you to identify advance work that you must do before the meeting. For example, Figure 7.7 presents an agenda with specific "homework assignments" that are required for a meaningful discussion of each item. This approach will direct your efforts toward accomplishing the meeting's objectives without spending too much time on peripheral issues.

Just as important as planning is follow-up after the meeting. Get "action" minutes out quickly, and follow up to be sure that everyone is doing what was promised during that meeting. Once a commitment is made, it is your job to ensure that it is carried out, whether the person making the commitment is a member of your project team, a consultant, or your client.

Developing an Image as a Competent Manager. Today it is not enough to be recognized as a competent architect, engineer, or planner. Clients also expect the managers of their projects to be on top of things at all times. Projecting an *image* as a competent manager requires style as well as substance. The following is a list of things you can do to enhance your image as a competent manager:

1. Keep your files in order so that when your client calls asking for a copy of a misplaced document, you will have it at your fingertips.

2. *Always* arrive at meetings on time and be prepared when you get there.

3. Respond to requests from your client at once. Don't wait for a convenient time, even to respond to what appears to be a trivial request.

4. Be prepared to discuss the project status (technical, budget, and schedule) at any time.

5. Learn to articulate your ideas clearly, both verbal and written.

6. Keep your client informed by routinely sending copies of correspondence, telephone logs, and other important project documentation.

7. Issue progress reports at least once a month, whether your contract requires it or not.

8. Review all invoices before they go out and be prepared to answer any questions your client may have about them.

9. Be sure your office is neat whenever a client comes to visit you, even if you let it revert to its normal condition after the visit.

Managing Crises Effectively

No matter how good a job you have done in planning, organizing, directing, and controlling, there will be times of crisis. Manage these crises effectively by following this five-step procedure:

1. Wait a few minutes—the crisis may disappear.

2. Don't assess blame—it wastes energy and impairs the working relationships required to solve the problem.

3. Carefully define the problem—not just the symptoms, but the causes too.

4. Take positive, authoritative action—a crisis situation demands a level of leadership that can only occur when one person takes charge.

5. When the crisis is over, record the results—keeping a "crisis file" (describing each crisis, actions you took, and results) will help you avoid similar situations in the future or, at least, make them easier to manage.

Wrapping up the Project

One of the most difficult things that the project manager must do is finish the job, get it out the door, and close out the job number. More schedules and budgets are blown during the last 10 percent of the job than at any other time.

How, then, can the project manager overcome this problem? First, recognize the potential pitfalls. These include:

a desire to improve the product continually

fear of failure, which manifests itself in a subconscious desire to avoid completing the work

"burnout" resulting from working too many hard weeks or months (or sometimes years) on the same project

It is almost certain that various members of your project team will suffer these maladies during the final 10 percent of the project.

To overcome these problems, view the wrap-up phase of the project as a separate mini-project with its own scope, schedule, and budget. The objective during the wrap-up phase is to complete the job satisfactorily, within budget and on schedule. This is in contrast with a primary objective during the first 90 percent of the project—to do a technically superior job. Each wrap-up mini-project should consist of the following major tasks:

1. Gather all loose ends.

2. Evaluate all potential changes and determine which ones should be made.

3. Make checklists of all work to be done.

4. Implement activities to be done.

5. Backcheck all work until all changes and corrections have been done properly.

The first task includes final in-house reviews, client reviews, and third-party reviews, as well as any other final activities that are required. As part of this task, the project manager should carefully review the contract and all conference summaries, meeting minutes, and correspondence to verify that commitments have been met.

Another valuable technique for wrapping up design projects is known as the "yellow, red, and green pencil method." One person, often the project manager, takes a clean set of blueline drawings and marks *every* dimension, note, call-out, or other information on each sheet with yellow, red, or green. Yellow indicates that the item has been checked and is all right; red denotes changes to be made; and green represents a question or notation that is not to be put onto the original drawing. (The green pencil avoids embarrassing questions from contractors about comments like, "What does this mean?" which are often mistakenly put onto the drawings by unthinking draftsmen.)

After the project manager has obtained all comments, each suggestion is evaluated to decide if it should be carried out. This decision should be based on the answer to the question, "Will it work if we don't make the change?" Unless the consequences of not making the change are severe, the change should *not* be made. Not changing is difficult for most project managers because it goes against their desire to do top quality work. However, remember that improvements can be made ad infinitum, to any project, but to allow these improvements to destroy the budget and schedule helps neither the client nor your firm.

Having decided which changes are necessary, the project manager should assemble all the necessary activities into a checklist. Each checklist can take the form of a numerical list of items, a marked up set of drawings, a red-lined set of specifications, and/or any other tool that seems appropriate. You must have something that will allow you to follow-up, to ensure that everything is done properly. Once a checklist has been assembled, do not permit any work to be done that is not on the list.

The best approach to making the changes is to *enlist as few people as possible*. Use those on the project team with the most experience. Thus, if four draftsmen worked on a set of electrical drawings, only the most capable should be enlisted to wrap up all the drafting. Everyone else should be told specifically not to charge time to the job.

The last step in wrapping up a project calls for only one thing—tenacity. The project manager must backcheck all work to be sure that everything has been done satisfactorily. This may take three or four reviews, but there are no shortcuts.

Conclusion

This chapter has presented a variety of concepts and procedures that you can use to better manage your project team.

The next chapter deals with ways to improve the management of the most important member of your team—yourself. The procedures discussed in Chapter 8 will allow you to improve the efficiency of your use of time. The ability to use time effectively will let you increase your level of responsibility within the firm and still have enough time for personal interests.

CHAPTER 8

Time Management: The Key to Handling Multiple Projects

1. What are the simplest means for recording the way I use my working time?

2. How can I make the most efficient use of time spent in meetings?

3. What can I do to cut back on the time I need to prepare meeting minutes?

4. How can I increase the efficiency of my telephone conversations?

5. What can I do to defend against unscheduled interruptions from subordinates, superiors, and mail?

6. What are the dos and don'ts of keeping a things-to-do list?

7. Do I spend more time reading than I need to? If so, how can I cut down?

8. How can I squeeze extra time out of my daily schedule?

T IME IS YOUR MOST valuable commodity because it is the only thing that cannot be purchased. Effective time management is important for everyone, but for the project manager who must manage multiple projects simultaneously, it is essential. To manage your time successfully, you must firmly believe that every demand on your time is a request for you to give up the most valuable thing you own. This attitude results in the need to budget time in the same way that you budget money.

Scheduling Your Life

The first step in budgeting your time effectively is to identify how you are presently spending it. Figure 8.1 can be used to schedule all your activities (personal as well as professional) for a one-week period. The object is to identify the major time use categories in your life, such as work, TV, sports, and meals, using brief one- or two-word descriptions in each block of time on Figure 8.1. (Note that some of the blocks represent 30-minute periods while others contain an entire hour.) After compiling this log every day for one or two reasonably representative weeks, tabulate the totals on Figure 8.2. When you have determined how you are presently spending your time, make another copy of Figure 8.2 and identify how you would *like* to spend your time. Then make another copy of Figure 8.1 and identify how you can change your present routine in order to meet your new time budget.

If you are like most project managers, you will find that except for sleep, your single largest time expenditure is for work, whether at the office or home. How well you make use of work time will determine your ability to manage multiple projects effectively, thus increasing your value to the firm and your potential for professional advancement. It is therefore particularly important to schedule your work time, using a work time analysis log. (You can make it easier for yourself to compile such a log if you do it in conjunction with time cards.) After you have done this for one or two weeks, prepare another time summary using Figure 8.2. Then prepare logs of your desired work schedule just as you did for your twenty-four hour daily schedule. Now that you have developed objectives for your new work time budget, you need to set specific strategies for achieving your goals.

Controlling Meetings for Your Benefit

Meetings are the single most time-consuming activity in the workday of most project managers in design firms. Try to minimize your attendance at meetings. The place to start is with meetings in which you are not an active participant. Many supervisors invite everyone they can think of to a meeting because (1) they are afraid that someone might be offended if not invited or (2) they want everyone to hear the discussions. To avoid this syndrome make it known that you generally prefer not to attend informational meetings and would not be offended if you are not invited. You can avoid the tedium of general informational meetings by telling the responsible person that you cannot attend, but would appreciate a copy of the minutes.

Even better than eliminating your attendance at a meeting is the elimination of the meeting itself. Before calling a meeting, consider other ways to reach the same objective, for instance, with memos, telephone calls, or letters. Prepare an agenda. If the agenda doesn't have at least three important items, you probably don't need a meeting.

Consider the weekly Monday morning meeting in which everyone discusses the typing and/or drafting workload for the week. Such meetings often go off on tangents and can take the time of many valuable people for several hours. To avoid this possibility, each project manager should prepare a workload projection for the week and get it to the typing coordinator and/or chief draftsman. Conflicts can then be discussed directly between the typing coordinator (or chief draftsman), accomplishing the objective of scheduling the week's work without wasting time at a long meeting.

Despite your best efforts, a number of meetings will (and probably should) be held. The secret is to cut the time they consume. Below is a list of tips that can help you reduce the time required and make the most of each meeting:

Time of day	Monday	Tuesday	Wednesday	Thursday	Friday	Saturday	Sunday
Your Personal One-Week Time Log							
Morning							
12:00— 1:00							
1:00— 2:00							
2:00— 3:00							
3:00— 4:00							
4:00— 5:00							
5:00— 6:00							
6:00— 7:00							
7:00— 8:00							
8:00— 9:00							
9:00—10:00							
10:00—11:00							
11:00—11:30							
11:30—12:00							
Afternoon							
12:00—12:30							
12:30— 1:00							
1:00— 1:30							
1:30— 2:00							
2:00— 3:00							
3:00— 4:00							
4:00— 4:30							
4:30— 5:00							
5:00— 5:30							
5:30— 6:00							
Evening							
6:00— 6:30							
6:30— 7:00							
7:00— 8:00							
8:00— 9:00							
9:00—10:00							
10:00—11:00							
11:00—12:00							

Comments: _____

8.1 The first step in effective time management is to tabulate how you spend your time.

	Time Summary									
	Daily Time Spent in Hours									
Activity	Mon.	Tue.	Wed.	Thur.	Fri.	Sat.	Sun.	Total	Avg.	% of Total
Totals										100.0

8.2 Use this chart to summarize the data from Figure 8.1, and then compare the results with how you feel you *should* spend your time.

1. *Every* meeting should have an agenda.

2. The agenda should be ranked, with the most important items first. This tends to avoid lengthy discussion on unimportant issues.

3. An amount of time should be allocated to each item on the agenda. This can best be done by indicating the time of day that each agenda item should begin.

4. The names or initials of the individuals involved in each item should be included in the agenda. People whose names are not listed should probably not attend. People whose names appear on only one or two items can be brought in only during discussion of those items.

5. Get the agenda out to all meeting participants at least one day ahead to let them organize their thoughts and prepare material.

6. Indicate the hourly cost of each meeting (based on billing rates) on the agenda.

7. If there are any handouts, get them out *ahead* of time along with the agenda. This improves preparedness and avoids disruptions while everyone at the meeting reads the handouts.

8. Schedule meetings that are 1 to 1½ hours long. This has been found to be the ideal time span for high productivity.

9. Schedule meetings to take place during late morning hours. The participants will be fresh, and protracted discussions will be discouraged by the desire for lunch.

10. Schedule meetings to begin at odd hours, for example, 10:53 A.M. or 4:07 P.M.. People will tend to come on time because the odd time implies punctuality.

11. Start all meetings on time, even if everyone hasn't arrived, and don't repeat things for those who come in late. The latecomers will probably be on time for your next meeting.

12. Have "stand-up meetings." Meetings that are intended to be short can be kept that way by removing all chairs from the room, or telling people not to sit down.

Once a meeting is over, the only tangible product is the meeting summary. As project manager, you should strive to take all minutes personally, especially if the meeting involves the client or others outside your firm. It is said that "whoever takes the minutes controls the meeting." This control may be exerted by interjecting statements like, "Could you repeat that, I didn't get it down" (slowing the pace of discussion) and "What can we conclude?" (terminating the discussion). Moreover, the minutes can be written to reflect *your* point of view. Unless you have grossly misrepresented the facts, most people will not argue about subtle differences and interpretations as they appear in the minutes.

The best way to take meeting minutes is to list only action items, for example, "Electrical contractor will complete wiring by April 28." This avoids long narratives that can obscure the important points. Also, the minutes should be lettered neatly so that they can be copied and distributed *at* the meeting. This allows everyone to review the minutes for accuracy and proceed immediately to implement the action items. The typing and mailing of the official minutes can then be given a low priority, earning gratitude from the secretaries who are constantly bombarded with rush jobs.

Managing the Telephone

The second biggest time waster is the telephone. Furthermore, long distance charges for most consulting firms are substantial. Therefore, you must tightly control use of the telephone.

First, place all your own calls with push-button phones. It usually takes no longer for you to place the call than to tell someone else to do it. Not only does this save time, but also confusion regarding what to do if the desired person is not available. Placing your own calls also avoids the embarrassment of the party

answering the call with a personal greeting, only to find your secretary on the phone. Finally, placing your own calls improves morale. One of the most hated duties of any secretary is placing telephone calls.

Once a call goes through to you, the way you answer the phone can set the tone and length of the conversation. For example, if a potential client calls and you want to engage him or her in a long, friendly conversation, answer the phone with, "Hello, Tom, how are you doing these days?" If, on the other hand, you are taking a call from a vendor with whom you do not wish to spend much time, you can answer by saying, "This is John Doe, what can I do for you?" This is a polite, but effective way of letting the other person know that you are not interested in small talk.

Much time can also be saved by knowing how to end conversations. A good way to get out of a useless phone conversation with a long-winded salesperson is to take over the conversation and hang up while you are in the middle of a sentence. Since no one ever hangs up on *themselves*, the caller will assume you were cut off. In the time it takes to place the call to you again, you can instruct your receptionist to say that you have been called into a meeting and will return the call later.

A more gentle way to accomplish the same thing is to take over the conversation again and say, "Well, that's all I have. Do you have anything else?" This lets the caller know that you are not interested in discussing trivia and usually ends the conversation in short order.

Returning calls properly can also save time and lessen disruption of other activities. Use the back of the phone message slip to list the things you wish to discuss with the person you are calling. (This was discussed earlier as a good idea when you initiate a telephone call.) Save your message slips and return all your calls once or twice a day. Good times for returning calls are late morning and late afternoon. People tend to be in the office during those times, and the approaching lunch hour or end of the day will dampen unnecessary conversation.

Many design firms are finding that their long distance telephone bills are becoming an increasing cost of doing business. This trend is inevitable, but there are things you can do to reduce these costs. First, all long distance calls associated with a specific project should be logged. A sample telephone log is presented as Figure 8.3. When the telephone bill arrives, the receptionist can identify which calls were made on which jobs and add the cost of those calls to the client's invoice. If you are in the Eastern or Central time zone, try to place your calls to the West Coast after 5:00 P.M. when rates are lower. If you are in the Mountain or Pacific time zone, place your calls to the east and midwest before 8:00 A.M. A number of firms have even changed their office hours to enable their staff to take advantage of off-hour long distance rates.

In recent years, a number of communication services have begun to compete with AT&T on long distance services. These competing companies provide substantially lower rates to and from certain cities, using existing touch tone telephone equipment. An excellent comparison of these companies was presented in the March 1981 issue of *Consumer Reports*. An update of that comparison is presented in Figure 8.4.

Controlling Interruptions	Unscheduled interruptions can be a major source of frustration and lost time. The key to avoiding such interruptions is to control your contacts. If you have a client who calls frequently, suggest that you call him or her every day (or every week) at the same time. If the client knows that you will soon be calling, he or she might be more reluctant to interrupt your day with a phone call unless it is for something important. The same approach can be used with supervisors who constantly call you into their office for trivial discussions.

Another common problem is caused by people who stop in your office as they walk by the door. The most obvious way to avoid this problem is to close your door (if you have one). However, this can result in other problems, including losing touch with the rest of the office. A more subtle approach is to arrange the furniture in your office so that you can work facing either toward the door or away from it.

DATE	PERSON CALLED	AFFILIATION	PHONE # plus AREA CODE	TIME OF CALL	JOB #	SPC	ITT	BELL/line
1/24	Mary Haley	3M	762/455-8024	9:20	2592		✓	
1/24	J.K. Owens	LR Industries	404/926-8020	11:15	1386	✓		
1/24	Don Fry	State of NJ	201/462-9951	4:05	1937			70
1/25	Larry Howard	F&P Products	714/828-2623	10:15	2592			71
1/27	Don Fry	State of NJ	201/462-9951	3:00	1937			73
1/27	Art Cummings	EPA	703/762-0047	4:00	1386	✓		
1/28	Mark Cowens	DOE	703/802-4690	10:35	1937		✓	

Name: John Holcomb Office: Minneapolis Week Ending: 1/28/83

8.3 Logging long distance telephone calls allows you to invoice clients for these costs.

COMPARISON OF ALTERNATIVE LONG DISTANCE PHONE SERVICES

Service	Monthly Charge	Minimum Monthly Charge	Initial Set-Up	Percent Savings[1]
Sprint	$10	$25[2]	0	50%
Western Union	$ 5	$40[2]	0	40%
MCI	$10	None[2]	0	30–50%
ITT City Call	$10	None[2]	0	33%

[1]Compared with AT&T direct dial rates
[2]Require touch-tone equipment
For more information, call the following numbers:
Sprint: (415) 692-5600
Western Union: (800) 325-1403 [(800) 392-1516 in Missouri]
MCI: (202) 872-1600
ITT: (800) 221-7267

8.4 Various long distance services are available that can reduce costs in comparison with conventional direct dialing using the AT&T network.

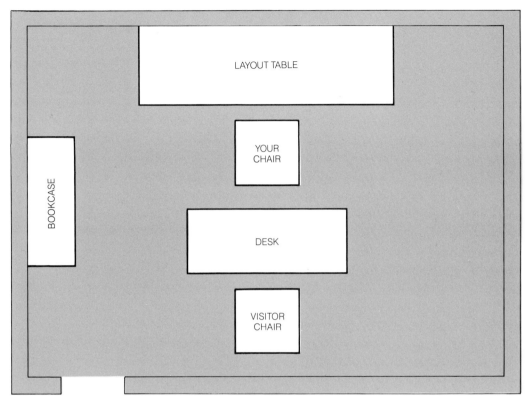

8.5 Your physical environment can affect the way you manage time. Note that this office arrangement allows you to work at the layout table with your back to the door, thereby discouraging interruptions.

(An example of such an arrangement is shown in Figure 8.5.) This lets you either encourage or discourage contact and avoids closeting yourself for long periods of time.

Controlling the Mail

Another major time waster is the mail. People will drop whatever they are doing every time something appears in their in-box. These uncontrolled disruptions can result in a sizable loss of efficiency if internal and external mail are delivered several times a day. This problem can be corrected by delivering the mail only once each day, two hours before quitting time. This practice will:

minimize interruptions

make use of the least productive part of the day (late afternoon) to perform a low-level activity (opening the mail)

keep employees from leaving early (since everyone likes to see their own mail)

encourage staff to plan their next day's work based on what is received

The only exceptions to this practice should be (1) mail sent by express service and (2) checks that should be routed to the accounting department as soon as received.

Scheduling a Daily Quiet Hour

One of the most effective methods for improving time use is the daily "quiet hour" in which no interruptions are permitted. Some project managers come to work an hour before the office officially opens and before the telephone begins to ring. Another approach is to schedule a specific time every day in which the door is closed, a "do not disturb" sign is posted, and the receptionist is instructed to hold calls. Some design firms have gone so far as to schedule a quiet hour for the entire office during which no interruptions are permitted. However, such practices have had mixed results. Regardless of how you schedule your quiet hour, it's probably a

good idea for your receptionist to answer calls by indicating that you are unavailable, rather than telling the caller that you cannot answer the phone because you are on your quiet hour.

Now that you have set aside one hour a day, what is the best use of the time? Answer this question for yourself by listing all your duties under two columns: one marked "urgent," the other marked "important." Under the urgent column, list "short-fuse" activities that must be done to avoid adverse consequences. Examples might include finishing a proposal, preparing for a meeting, or completing a report. The important column should contain long-term activities that are necessary to keep your projects running smoothly and to avoid needless crises. Examples might include manpower planning, organizing projects, updating project schedules, or developing strategies for improving sales.

Devote the daily quiet hour exclusively to the important items, which require a high level of concentration and minimal contact with others. The rest of the day can then be spent on fighting fires.

| **Keeping a Things-To-Do List** | Most project managers have learned by experience that "if it isn't written down, it won't get done." The importance of keeping a to-do list cannot be overemphasized. The following tips can make your things-to-do lists more effective: |

1. Keep your lists on the same size paper. This avoids having all kinds of notes and lists posted all over your office, obscuring the really important tasks.

2. Keep old lists that have been crossed out as a record of what you have done. Indicate the date that each page was begun or completed to find old records.

3. Highlight urgent tasks to be sure they are not overlooked.

One of the best ways to keep a to-do list is to use a 3″ × 5″ spiral notebook. The list of things to do is made on the right side of the book with the date that the page was begun at the top. The left side is used to record telephone numbers, addresses, directions, and other miscellaneous information needed to accomplish the tasks listed on the right side. Figure 8.6 shows an actual to-do list kept in this way. Advantages of this approach are these:

1. Because it is small, you can keep the notebook with you at all times, so you can write things down as you think of them.

2. Old notebooks can be kept chronologically for future reference to past activities, important phone numbers, addresses, and so forth.

3. The notebook is available to review and update during "dead-time" periods.

8.6 A simple and effective method of keeping to-do lists is to use a 3″ x 5″ spiral notebook. Activities are listed on the right side; informational notations are made on the left.

Cutting Your Reading Time

Most design professionals subscribe to several technical journals. In addition, many firms circulate other periodicals to project managers for reading prior to filing in the library. The volume of reading provided by these sources is truly staggering. The project manager seems to have only two options: (1) read all material (feeling guilty about spending too much time); or (2) do not read the material (feeling guilty about not staying informed).

Fortunately, there is a third choice. First, whenever you receive a magazine, look at the table of contents for articles that may be of interest. Then read the first and last paragraph of each article that appeared interesting. This will give you enough information to categorize the article as (1) worth reading, (2) worth keeping for reference, but not worth reading, or (3) not worth keeping.

Those articles that fall into the first category should be cut out (or photocopied if the magazine does not belong to you), stapled, and tossed into your briefcase for reading on an airplane, while waiting for the bus, or during some other period when you have nothing else to do. Articles in the second category should also be cut out or photocopied and then filed in a series of subject files that you have set up based on the topics that are useful to you. Articles in the third category should be thrown out along with the rest of the magazine.

This procedure will not only cut down on your reading time; it will free your bookcase of magazines that collect dust and bend the shelves.

Using "Dead Time" Effectively

"Dead time" is the time that you are away from the office with nothing specific to do. Examples include waiting in airports, staying at hotels, flying on airplanes, and waiting for someone who is late for an appointment. It is usually difficult to predict when dead time will occur or how long it will last. For this reason, it often goes wasted.

The key to using dead time effectively is to be prepared to do something worthwhile when you find yourself with unscheduled time available. Think of your briefcase as a portable office which always contains things that do not have a short-term deadline, but need to be done. These items may include magazines to read (either technical or personal), letters to write, or office paperwork. It is also useful to keep a box of common utensils in your briefcase to help you do these tasks more efficiently. Such utensils might include:

stapler	calculator
scissors	colored pencils and pens
scotch tape	X-acto knife
paper clips	quadrille pad
six-inch ruler	

Each item should be the smallest available in order to fit into a small box or pouch. A business card box works quite well in a normal briefcase.

The Communication/ Time Management Dilemma

This chapter has presented many ideas that can be used to save time. However, a word of caution is in order. There is often a direct contradiction between the goal of good communications and that of proper time management. For example, the regular Monday morning meeting, terrible from a time management viewpoint, may be essential for communications. Many similar examples can also be cited.

Before blindly following anyone's suggestions for improved time management, ask yourself if you are willing to pay the price in reduced communications.

Conclusion

This chapter has described a practical approach to help you see how you presently spend your time and has offered specific suggestions on how you may use your time more effectively.

The next chapter shows how you can take a bigger part in an area that project managers have traditionally avoided—marketing. The chapter also offers several concepts that can help you become a more effective participant in your firm's marketing effort.

Effective Marketing for the Project Manager

1. As a project manager, why should marketing be part of my job?

2. What are the ways in which I can best contribute to the development of my firm's marketing plan?

3. What points should I consider when doing market research for prospective new work?

4. What is my most useful role in the preparation of proposals?

5. How may I best participate during marketing presentations to a client?

6. What are the best ways to use client references to help bring in new work?

7. How can I improve the odds of being selected?

IT HAS BEEN SAID that the design profession consists of only two things: selling work and doing work. While this is an oversimplification, it is true that firms that do well in these areas almost always succeed, while firms that do one or the other poorly often fail. Until now, this book has focused on the project manager's role in doing work. However, the role of selling work is equally important to the success of the firm. Indeed, today the success of a project manager is dependent on his or her marketing abilities, as well as technical and management abilities. The most valuable project manager is one who can bring work into the office and then get it done.

This chapter discusses fundamental marketing concepts and tips on how you can become more active in the marketing effort for your firm.

Roles of the Marketing Function

The five distinct roles in the marketing function are:

1. marketing director

2. marketing coordinator

3. lead finder

4. sales sponsor

5. project manager

In small firms, some or all of these roles are performed by the same individual, whereas in large firms several people may be involved with each role. The distinction is one of function rather than personality.

The role of the marketing director is strategic. He or she is responsible for identifying target markets, setting a course for pursuing these markets, budgeting marketing activities, and preparing and maintaining the firm's marketing plan. In most design firms, the marketing director's role is performed by a principal of the firm.

The role of the marketing coordinator is primarily logistic. Typical responsibilities include preparation of brochures, maintenance of qualifications statements and biographical data, and publication of newsletters and other marketing and public relations items. In some firms the marketing coordinator is also responsible for logistics on proposals and presentations for specific projects.

The lead finder role can be performed by anyone in the firm, from receptionist to general partner. Leads can come from referrals, previous clients, technical conferences, newspaper articles, or "cold calls." Many successful firms strive to broaden the base of potential lead finders by offering recognition and/or rewards to anyone who identifies a lead that eventually becomes a job.

The sales sponsor is the individual who has primary responsibility for organizing and implementing the sales approach once a prospect has been identified. This generally includes contacts with the client and establishing sales strategies.

The final role belongs to the project manager, whose main duties are to supervise production on projects. Marketing responsibilities for the project manager may include:

> researching a client's needs
> preparing the technical aspects of a proposal
> preparing budgets and schedules for the proposal
> describing the firm's approach to the project during an interview

The first three marketing roles are primarily aimed at being included on the "short list" of firms that are considered to be qualified for a particular project. The project manager, along with the sales sponsor, is the individual most responsible for getting the firm selected as the best one to do the job. Today's savvy clients realize that the abilities of the project manager and the rest of the project team are

more important than long lists of similar projects or glib rhetoric from principals.

In today's marketplace, the firm that fields the best project team and convinces the client that they can solve the specific problem is the one that usually wins in a presentation.

The Marketing Plan

As a project manager, you should strive to have a part in the formulation of the marketing plan. The marketing plan is a summary of the firm's marketing goals and approaches to be followed for a specific length of time, usually a year. All good marketing plans should contain the following elements:

listing of services offered
identification of target markets
identification of target clients
specific, measurable marketing goals
approaches to achieving those goals
assignment of individuals responsible for various marketing activities
establishment of budgets for various marketing activities
mechanisms for measuring progress and making midcourse corrections

As project manager you are probably in the best position to identify which of your present clients should be listed as target clients for next year. You may also volunteer to take responsibility for contacting some or all of those clients. You will probably find that taking on this sales responsibility will change the way you handle your existing clients, making you more demanding of technical excellence to enhance your prospects for repeat business. Greater involvement in sales should also force you to think about other work that your clients probably need and that your firm (not necessarily you, yourself) could perform for them.

Once you have gained confidence and demonstrated success in getting additional work from existing clients, you may wish to volunteer to take responsibility for potential new clients with whom you have something in common. For example, if you have done several projects for a division of a large corporation, you might try marketing your firm's services to a different division of the same corporation (always being sure to inform your marketing director). Your previous experience not only gives you a working knowledge of that corporation, it also gives you a credible professional reference from someone within the same organization.

The Sales Forecast

The sales forecast identifies specific prospects that may eventually become jobs. Its primary purpose is to serve as a checklist so that all reasonable prospects are followed until the job is either won or lost. As part of the marketing plan, the sales forecast provides management with a rough idea of the office workload in the coming months, as well as the probability of getting new projects that have been identified. All good sales forecasts have the following elements:

name of client
identification of project
estimate of project size
probability of becoming a sale
responsibility for following up

A typical form used for preparing a sales forecast is presented in Figure 9.1.

It is important that *all* potential revenue be listed on the sales forecast. This includes follow-up work for current clients and scope expansions for existing projects, as well as sales to new clients. Because of your intimate knowledge of existing clients, you as project manager should assume responsibility for any sales to these clients. Be sure that all such prospects are included in the sales forecast and that you follow up on as many of them as is practical.

Marketing Research

One of the cornerstones of a successful marketing program is research, which ranges in scope from the identification of the total size of a potential target market to finding out specific details on a job for which your firm has been short-listed.

Region/Office __Northwest__ Date Prepared __9/28/82__

Client (Name and Location)	Proposal No.	Type of Project	Time Frame (days)				Approximate Fee ($)	% Probability	Sales Responsibility
			30	90	180	Over 180			
Washington State	5612	Siting study	✓				$37,000	25	D. Patton
Weyerheauser	5622	Warehouse design			✓		118,000	50	L. Nathan
City of Portland	5624	Park study				✓	18,000	20	N. Patrick
City of Tacoma	5627	Highway design	✓				136,000	40	L. Nathan
Boeing Aircraft	5641	Maintenance building		✓			86,000	75	D. Patton

9.1 A sales forecast is used to follow up leads on prospective projects.

Once a lead has been identified, the proposed project manager is probably in the best position to research the project. One reason to suggest a particular project manager for a job is his or her knowledge of that type of project. This knowledge, when properly applied, allows the project manager to ask the kinds of questions that will reveal the client's real problems and suggest solutions that would probably be viewed favorably.

Also, early research contact enables the project manager to enter an interview or negotiation with more confidence, already knowing the people involved.

The following are a few tips for improving the quality of research for prospective projects:

1. Don't try too hard to sell your firm's know-how while doing client research. Creating a more relaxed atmosphere will improve your chances of obtaining useful information.

2. Realize that *one* of the client's representatives may not necessarily speak for *all* the client's representatives. Speak with as many representatives and knowledgeable outsiders as possible and try to confirm key information.

3. Don't be afraid to ask sensitive questions such as who your competitors are or how much money the client has budgeted. Clients rarely hold a grudge for your asking, even if they do consider the information confidential and choose not to give it to you.

Preparation of Proposals

One of the primary marketing functions of the project manager in a strong project manager organization is preparation of proposals. In general, good proposals should contain the following elements:

1. Letter of transmittal—a brief (one- to two-page) letter that not only transmits the proposal, but also summarizes the key points.

2. Introduction—establishes the background for the project.

3. Scope of services—describes what services will be performed and the technical approach to be used.

4. Project organization—describes the management structure that is proposed, identifies the roles of key members of the project team, and describes the qualifications of each team member to fulfill his or her role.

5. Project schedule—defines the time frame in which the job will be performed.

6. Project budget—establishes costs and other financial considerations.

7. Qualifications—establishes the firm's credentials and ability to do the work (include only if not previously submitted).

There are numerous ways of organizing a proposal to include the above elements. For a small study, all these may be contained in a single letter; for a major project, these elements may be divided into various sections of the proposal.

The project manager's responsibilities should include, at the least, the preparation of the scope of services and the schedule. He or she should also be directly involved in formulating the project organization and the project budget.

In many firms the entire proposal effort is supervised by the project manager who will most likely manage the job. He or she might prepare a draft of the entire proposal with guidance and review from the principal-in-charge and the sales sponsor. This approach usually results in proposals that are technically sound and appealing to the client. Involvement of the project manager in the proposal effort also raises the level of commitment he or she feels toward the project.

A major problem is that most firms hit on only 20 to 25 percent of the proposals they submit. This means that a project manager must be assigned an average of four to five proposals for each project that he or she performs. Because it is impossible to predict which of the proposals will become projects, the project manager who is responsible for the proposal often will not be able to supervise the job. This problem can be mitigated by a close working relationship among project managers who manage similar types of projects, allowing one project manager to pinch hit for another who cannot perform a job which he or she helped sell.

Repetition: The Marketer's Best Weapon

As designers, we are taught to "say it once, be sure it's right, and don't repeat it!" This is sound advice for preparing contract drawings because it avoids possible conflicts and resulting change orders. This is also good advice for preparing reports because it tends to keep them brief. However, this is a poor practice when writing proposals or making a sales presentation.

It is common knowledge in the advertising field that the number of times a message is repeated affects sales far more than the content of the message. This is borne out by the fact that sales of most consumer goods correlate more closely with total advertising exposure than with the quality of the ads.

The best way to plan a proposal or presentation is first to list what you consider are the key points you wish to make and then look for opportunities to repeat these messages as often as possible and in as many different ways as you can. This will do much to ensure that most of these key points have been received and understood by the individual or committee making the selection.

The Project Manager's Role in Presentations

Perhaps the project manager's most important role in the marketing function is in presentations. By the time your firm gets invited to make a presentation, the firm's qualifications to do the work have already been established (as they have for the other invited firms). At that point, the number one selection criterion is the client's confidence that your project team can solve their problem. This confidence cannot be gained by reading resumes in a proposal; it must be established face to face.

As project manager, one of your roles in the presentation is basically the same as during the performance of the project: to coordinate the efforts of your project team. However, you will probably not have the opportunity to bring the entire project team to the presentation. You must therefore become sufficiently familiar with each team member's role in the project so that you can discuss it even if he or she is not present. If there is an aspect of the project the client feels is especially important, an expert in that specialty should be included in the presentation team to discuss that aspect.

Your other principal role in a presentation is to convince the client that you can deliver the results wanted on time and within budget. A history of on-time, on-budget performance is one of the most important factors that clients consider when selecting design firms. It is not enough just to *say* that you will perform the

job on schedule and within budget. To be convincing, you must describe *specific approaches* for accomplishing these objectives and demonstrate how you have used these approaches successfully on previous, similar projects.

Postselection Reviews with the Client

Because you must learn from both good and bad presentation experiences, you should become involved in postpresentation interviews of potential clients.

Being short-listed for a project is in itself an achievement. It means that you have convinced the client of your qualifications to do the project and of the need for the client to spend more time in further evaluation of your firm. This goodwill should not be wasted, even if another firm is eventually selected. Most clients do not mind talking with the unsuccessful proposers about how the selection process was conducted and why a particular firm was chosen. (It is better not to dwell on questions about why *your* firm wasn't selected.) Clients usually view this discussion as a way of thanking you for going to the expense of proposing on their project.

Often overlooked is the opportunity to do a postselection review meeting on projects for which your firm *was* selected. The information gained from these reviews can be just as valuable as that obtained from a review of an unsuccessful effort. In either case, the questions should include:

what the winning firm did to impress the client
a review of the client's selection procedure
the client's view of your firm's strengths and weaknesses
ways you could have improved your proposal or presentation

The principal benefit from these postselection review meetings is to avoid making the same mistakes in the next proposal or presentation. In one instance—an unsuccessful proposal for a project with a large municipality in the southeast—the postselection review revealed the client's perception that the personnel proposed for the project did not have enough specific experience. A review of the proposal quickly revealed the reason for this opinion. The only biographical data submitted were standard resumes for the project team. These resumes were so general that it was impossible to identify the expertise that really existed. The information from this review led to a restructuring of the way resumes were prepared, so as to stress specific qualifications.

Taking a Positive Approach to Marketing

It is an axiom that successful marketing people are incurable optimists. This is not a coincidence. One of the hardest things to resist is a salesperson who is genuinely enthusiastic about a product and who is personally convinced that you really cannot do without it. The same is true in marketing professional services. Clients want to hire people who are obviously convinced that they can do the best possible job on their projects.

For example, instead of simply telling people what you will do, you might prepare schematic drawings for use during a presentation to illustrate the concept that your firm is proposing for a building. This may seem like free design, but it is not. It is merely a further exploration of the client's real problem.

Another example is to conduct a complete computerized literature search to identify available background data on a difficult technical issue and then include the results of this review in the proposal.

Using Client References Effectively

Unless a prospective client on an upcoming project has first-hand knowledge of you and your firm, the use of professional references is perhaps the best measure of your firm's track record. Although most clients do not check references (often to their later dismay), you should encourage them to do so. The individuals you give as a reference should:

be satisfied with your work on their project

discuss similarities between what you did for them and what you are proposing to do for the prospective client

present the facts in an objective, believable manner

be in a position of authority

The most common mistake that architects and engineers make in giving client references is not to take the time to check with the person before giving his or her name and telephone number to a prospective client. Take the time because:

It is considered common courtesy, which is appreciated and is likely to affect the tone of the recommendation.

You can "prime" a reference as to which aspects of the work you performed are most relevant to the project for which your firm is now being considered.

You may find out something that makes you reconsider giving that person as a client reference.

It is an excellent opportunity to keep in touch with previous clients to find out what additional work they may have in the near future.

"Features" vs. "Benefits"

All sales approaches can be divided into two categories: "features" and "benefits." Features are factors that qualify your firm to do the job. Benefits are the things you can do to solve the client's problems. To prepare before a presentation, you should ask yourself the question, "So what?" with reference to each *feature*. The answer should be a *benefit* to the client. Listed below are commonly used features and benefits.

Feature	Benefit
Number of employees	Ability to do the job without having to hire additional staff will minimize delays.
Location of offices	Proximity to client, review agencies, and job site will speed reviews, approvals, and so forth.
Experience on similar projects	Project team will not waste time or money reinventing the wheel.
Previous design awards	The firm's recognition for high quality will assure that the job will be done properly.
Number of design disciplines	Ability to do the project entirely with in-house staff will improve efficiency, lower design costs, and accelerate schedules.

A firm's features should be stressed when preparing qualifications statements. Once your firm has been short-listed, it is more important to concentrate the sales efforts on the benefits. This can be done by (1) finding out what the client perceives to be the biggest potential problems on the project and (2) determining how you can solve them.

Differentiation: A Way of Improving the Odds

An approach known as "differentiation" may be used whenever you are one of several firms competing for a project and you have no particular edge on your competition. This approach is based on formulating the proposal and presentation in such a way that your firm stands out as being *totally* different from any of your competitors, thus differentiating yourself from the others in the eyes of the client. If there are five firms competing for the job, effective differentiation can increase your theoretical odds from 20 percent (one of five firms) to 50 percent (the client will either love your approach or hate it). Following is an actual example of how a large engineering firm (that we shall call ABC Consultants) secured a project for a major electronics firm in the northeast.

ABC Consultants received a request for a proposal to design the facilities associated with a new manufacturing process. Marketing research revealed the following:

A total of five firms received requests for proposals.

Two of the firms were located near the client's plant, and ABC was located much farther away than any of the other firms.

The billing rate structure for at least two of the other firms was substantially lower than ABC's.

The client had performed only a cursory evaluation of the new process before requesting proposals for the design.

Additional investigations by ABC revealed serious flaws in the client's process evaluation. ABC therefore decided to apply the differentiation principle by proposing *not* to design the facilities, but rather to perform an in-depth process study first. This proposal was backed up by a detailed technical discussion of the flaws in the previous study and how they could affect the manufacturing process. The client was convinced and awarded the project to ABC Consultants, the only firm that contradicted the request for proposals!

A potential pitfall in the differentiation approach is the possibility that the client will like your approach, but select another firm to implement it. This may occur if the client has already decided who will be selected and is merely going through the motions to make the selection appear competitive. Another possibility is that the client may like your idea, but select a less expensive firm to apply it. Finally, some clients solicit proposals as a way of getting free consulting in planning the project, then combine the best features of all proposals, and award it to the firm they wanted in the first place.

These are all subtle traps, which are not easily avoided. The only way to identify these situations is to thoroughly research every aspect of the client, the project, and the selection procedure.

Conclusion

Although much of this chapter may seem foreign to many project managers, as time goes on more managers are finding that power in a firm comes easiest to those who bring in work. The more a project manager can do to be involved in marketing, the greater the chance of upward mobility.

The next chapter deals with another growing area for project managers—contract negotiations. The chapter describes why project managers should be involved in negotiations, what their role should be, and how they may become more effective in the negotiating process.

CHAPTER 10

The Project Manager's Role in Contract Negotiations

1. As a project manager, why should I involve myself in the contract negotiation process?

2. Which of the four possible outcomes of negotiation is best? Which is worst?

3. Who should be represented on my firm's negotiating team?

4. Why should I negotiate *scope* rather than *price*?

5. How can I help the negotiating team reduce the fee without hurting profitability?

6. How can I best help my firm avoid reduced profits (or a loss) due to the U.S. government's 6 percent fee limitation?

7. What can I do when the client's budget is less than our costs?

8. What are the advantages and drawbacks of the four most common types of contract?

9. What are the thirteen rules of successful negotiating?

PROJECT MANAGERS in most design firms have traditionally been left out of the negotiation process. However, their involvement has become more common in recent years for the following reasons:

1. If he or she has been involved in preparing the proposal, the project manager is probably the person who best knows the scope of work and the level of effort required. This knowledge can be invaluable in defending budgets and negotiating potential modifications to the original scope.

2. Being present in the negotiating session provides the project manager with much useful information regarding the client and the project.

3. Involvement in negotiation enables the project manager to make a higher level of commitment to the budget and schedule than if a signed contract is imposed on him or her with instructions to "make it happen."

4. Participation during the negotiations eases "passing the baton" from principals and/or marketing people to the project manager as the focal point for the client.

This chapter presents some basic concepts to make the project manager more effective during the negotiation process.

The Objective of All Good Negotiations

Any negotiation can have one of four possible outcomes:

Firm	Client
Wins	Wins
Wins	Loses
Loses	Wins
Loses	Loses

The ideal outcome is when both you and the client win, that is, each party achieves its primary objectives. This generally occurs when you are able to negotiate a fee that provides your firm with a reasonable profit, while agreeing to a price that is within the client's budget. The win-win philosophy means that you should view the negotiation from the client's perspective, as well as your own, and that you should not take undue advantage of weaknesses in the client's position. Likewise, you should *not* allow the client to take undue advantage of weaknesses in your position. Both sides must leave the negotiating table feeling good about the outcome so as to be able to work together effectively during the project.

One experienced contracting officer in the southeast first asks the design firm to submit a detailed cost breakdown including drawing lists, task outlines, hourly rates, overhead rates, and expenses, all using a standard format developed by the U.S. Army Corps of Engineers. Concurrently, the project is divided into various disciplines and the client's own design specialists make an independent estimate of the level of effort required. When both sets of estimates have been completed, a negotiation meeting is called, and the differences between the two estimates are discussed in depth and resolved. This discussion includes instances where the design firm's estimate is lower, as well as higher, than the client's estimate for the same activity.

The result of this negotiation is an agreement on (1) the *exact* scope of services to be provided and (2) the level of effort that will be required to perform those services. While the negotiation process can be long and arduous, it contributes to a total understanding of what will be required and reduces problems during performance of the project.

Unfortunately, there are cases in which the objectives of the two sides are so far apart that a win-win negotiation is not possible. In these cases, the objective should be to achieve a lose-lose outcome in which neither side is happy with the outcome, but both sides feel that the burden is being shared fairly.

The worst results of a negotiation are win-lose and lose-win. If you negotiate a contract in which you obtain an apparent windfall profit at the expense of the client's basic objectives, the ill will created will likely manifest itself in client relations problems, which may well wipe out anticipated profits and impair chances for future work with that client.

Likewise, your firm's performance on the project will probably suffer if you feel that you were taken advantage of unfairly during the negotiation.

Who Should Negotiate the Contract?

There are no hard and fast rules regarding the number of people who should be involved during the negotiation process. However, the negotiation team should include individuals who:

understand the scope (the project manager)

have made any promises or commitments (marketing staff)

understand the business aspects of the contract (business manager)

understand the legal aspects of the contract (attorney)

can commit the firm to an agreement (principal)

In some cases, a single individual may meet all these criteria. In others, a team of several people may be required.

Whenever possible, negotiate with someone from the client's staff who has the authority to commit the client. This will avoid the problem of negotiating a satisfactory contract, only to have it rejected, and then having to make further concessions to avoid losing the project. In fact, some clients deliberately employ the two-stage negotiation concept to extract the greatest concessions from the consultant.

The two-stage technique works this way. A branch office of a major corporation appoints a preliminary negotiations team to work out hours and dollars related to the proposed scope of work. After working—often for weeks—with such a team, the architects and engineers are told that all is good so long as the agreement is approved by the home office. The faceless home office then comes back with demands for further concessions.

The best way to avoid this problem is to request that the client's negotiating team include the individual(s) who will sign the contract. If this is not possible, be sure that you reserve the same right for postnegotiation review that the client has.

Negotiating Scope Rather Than Price

If you show up at the checkout counter of your local supermarket with $50 worth of groceries and only $40 in your pocket, the clerk will give you a choice of two options—come up with $10 more or put back $10 worth of groceries. You must look long and hard for a checkout clerk who will allow you to take home $50 worth of groceries for $40. Yet, as design professionals, that is precisely how we negotiate many of our contracts. The price goes down immediately at the mere hint that the client thinks it is (1) too high or (2) more than he or she can afford. The cardinal rule of negotiation is, "*Never* reduce your price without receiving some concession in return."

One effective way to gain concessions is to negotiate on scope rather than on price. As project manager, it is *your* job to prepare a list of items that can be deleted from the contract in order to reduce the cost, while still maintaining the integrity of the project. These may include such items as:

limiting the number of design alternatives to be evaluated

using preengineered package systems instead of custom-designed components

requiring the client to contract directly for surveying, soils investigations, or other field work

specifying that some design activities be done by the construction contractor based on performance specifications, with shop drawings submitted for approval

specifying a reduced level of detail for the drawings

requiring the owner to print the final documents

permitting the use of reprographics techniques

A careful analysis of each project will usually reveal many such methods of reducing costs. At the negotiation session, you should be prepared to discuss the cost impact of any possible combination of these measures. To present these properly, you must do your homework *before* negotiations begin.

Getting the Proper Fees

You can justify your fee on any number of alternative bases. The real issue is what your services for this specific project are worth to this client. Consider these approaches:

1. Value. In developer work, fees derived on a per unit or per square foot basis are common. What characteristics will enable you to achieve a fee at the high end of the range? What is truly unique in your organization that would justify an even higher fee? How much real competition is there?

2. Cost Plus Profit. Bureaucratic organizations need data to support decisions. Therefore, you will probably find yourself negotiating on a cost-plus-profit basis. Make sure that the hours presented are high enough to allow an adequate margin of safety, especially in large projects that tend to become more complex than one would assume initially.

3. Selling Time vs. Selling Results. We are in the profession of selling results, not time. Therefore discourage flat hourly or direct personal expense (DPE) multiple contracts other than for front-end studies. Lump sum contracts work with sophisticated clients, who understand that.projects change and who will fund extra work.

Dealing with the 6 Percent Fee Limit

Federal procurement regulations stipulate that no firm shall be compensated for design effort in excess of 6 percent of the construction cost of the project. While some firms have actually lost money following these stipulations, many firms that consistently work with the federal government have learned how to earn a fair profit.

Consider the following steps when negotiating your next federal job:

1. Get a copy of the *Federal Register* (vol. 41, no. 15) for January 22, 1976, page 3293, and read what is and is *not* included within the 6 percent fee limit. Some items *not* included are:

investigative services for feasibility studies, measured drawings for existing facilities, subsurface borings, surveying, program definition for schematic or preliminary plans, and estimates

specialized consulting services not normally found in an architectural, engineering, or planning firm

supervision of construction, review of shop drawings or samples, travel and per diem allowances, presentations, models, renderings, and lab reports

reproduction of contract documents for bidding

2. Define your project scope in minute detail so as to highlight what you consider to be within the 6 percent limit and what you consider to be outside the limit and therefore subject to extra compensation.

3. Find out who did the government's fee and construction estimates and how old they are. Many government estimators will often not include appropriate task/hour figures or adequate inflation factors for construction costs. Also, their estimate could be three or four years old and based on old construction methods and costs.

4. If you don't agree with the government's construction cost estimate, suggest that you do a feasibility study (for extra compensation) to verify the figures and that the actual construction cost estimate (on which your fee will be based) be agreed upon later.

5. Be certain that the government contract includes a provision whereby changes in scope during the work automatically change your fee. Without this, you may construct a $12 million facility and be paid your fee based on an original estimate of $6 million.

6. Be prepared to perform only those services that are specified in your contract. Don't redo programming just because you disagree with it unless you are to be compensated.

Finally, prepare for every part of your negotiation with government negotiators by systematically reviewing each aspect and term of your contract with those who will actually negotiate the deal. Many firms follow these steps and consistently make a fair profit on federal projects. You can do the same.

Negotiating When the Client's Budget Is Less Than Your Costs

No matter how well a scope is defined, there will be some situations in which the client simply cannot (or will not) authorize enough money to cover all your costs, let alone a reasonable profit. In such cases, considerable ingenuity is required to avoid the dilemma of (1) taking the project at a loss or (2) declining to accept the project.

Use a combination of the following tips to overcome this problem.

Saving Interest Costs by Improving Cash Flow. One way to accept a project at an apparent loss is by specifying the proper invoicing procedures in the contract to improve cash flow. One such procedure is to include payment of a substantial retainer by the client upon project initiation. The entire retainer should be held until the final payment.

Another way to improve cash flow is to establish a weekly billing cycle based upon a pre-established billing schedule. For example, if a $130,000 project is scheduled to last thirteen weeks, the contract can specify a billing amount of $10,000 each week. It is also useful to include a clause in the contract *guaranteeing* that interest is paid for late payment.

These approaches can cut the overhead rate substantially by reducing or eliminating the cost of interest to finance project expenditures. It may even be possible to create a positive cash flow, thus actually generating revenue from the earned interest.

Reducing Normal Overhead Costs. Another way to accept a project at an apparent loss is to reduce or eliminate costs that are normally built into your overhead rate. For example, if your firm allocates accounting costs to a general overhead account (as do most design firms), these costs can be reduced for a specific project by obtaining agreement from the client for a simple billing format with no backup documentation of expenses (such as copies of time sheets, phone logs, or receipts). Under this kind of arrangement, the client can still be protected by being allowed to audit invoices on a random basis.

Working Overtime. Another approach is to take the project at a compressed schedule and work overtime. As long as the client agrees to pay for overtime hours at the same rate as regular hours, this can be an effective way to reduce the overhead rate, because overtime hours generally do not carry the same burden as straight-time hours. For example, once the office rent is paid, it costs little more to occupy the space sixteen hours a day than it does for eight hours a day.

Lowering Your Multiplier. If the client feels that your multiplier is too high, it may be possible to lower it by extracting some of the items as direct project costs. For example, professional liability insurance can be obtained on a job-by-job basis, with the premium costs being paid as a reimbursable expense by the client. An-

other example would be to charge all labor and expenses associated with your firm's job cost control and billing system directly to the project. These kinds of measures, while not affecting the bottom-line project costs, can overcome the psychological effect on many clients of paying a high labor multiplier.

Receiving a Percentage of Construction Cost Savings. Finally, if your client simply does not have enough money to cover your costs for a design project, you can offer to take the job at a loss, but include a provision that you will receive a percentage of the savings if the construction cost comes in under the estimate. If the client responds with a request that you also pay a percentage of any construction cost overrun, point out that you have already taken a financial risk by accepting the design contract at a loss.

What Is the Best Form of Contract?	Figure 10.1 presents the major advantages and disadvantages of the most common contract forms for design firms, along with specific recommendations regarding each one. Note that all these forms have advantages and disadvantages. Contracts to avoid are:

lump sum contract for a vague scope of work

guaranteeing to perform a specified scope of work within a not-to-exceed amount on a time-and-expense contract

percentage of construction cost contract for a client who is not used to this form

ANALYSIS OF VARIOUS FORMS OF COMPENSATION

Form of Compensation	Advantages to Your Firm	Disadvantages
Percent of construction cost	Potential for substantial profits	No direct relationship to scope
	Fee increases automatically with inflation	Contributes to client mistrust
		Tight bidding climate may reduce fee
	Easy to invoice	Punishes use of cost reduction methods
	Easy to negotiate	Creates conflict of interest between owner and A/E
	No need for owner to audit invoices	
	A/E benefits from efficiency	
Salary times a multiplier or cost plus fixed fee	Guarantees a profit (assuming no "not-to-exceed" amount is specified)	Limits potential profit
		Salaries no longer confidential
	Fee increases are relatively easy to negotiate	Ignores value of services provided
		Time consuming to invoice
		Client can audit invoices
Standard billing schedule	Salaries, profit remain confidential	Inflation can reduce profits
	Potential for increased profit by using personnel at lower end of labor categories, where appropriate	Causes confusion regarding billing rate
		Client can audit invoices
	Fee increases are easier to negotiate than for lump sum contacts	Clients tend to think rates are too high
Lump sum	Easy to invoice	Scope must be well defined
	Rewards efficiency	Fee increases are difficult to obtain
	Fee is based on value received	
	Audits are unnecessary	

10.1 All forms of compensation have advantages and limitations. In general, it is better to negotiate a contract that rewards *achievement*, not just *effort*.

standard billing schedule in which there is no expiration date for the specified billing rates

Following is a checklist of clauses for a perfect contract:

1. detailed scope of work—no interpretation necessary

2. responsibilities of *both* parties clearly understood

3. monthly progress payments

4. interest penalty guaranteed on overdue payments

5. a fee retainer credited on *last* invoice to client

6. limit on length of construction administration phase

7. for cost reimbursable contracts, specify a fixed overhead rate (as high as justifiable) if the actual overhead rate is expected to decrease; use a postadjusted rate if the actual overhead rate is expected to increase

8. lowest possible retainer—applied to fee (profit) and not to costs

9. effective date of applicable federal regulations spelled out clearly

10. approval of work—who, where, when, how

11. court remedies and who pays legal costs (Watch out for arbitration since it could invalidate your professional liability coverage.)

12. for changes in scope, bilateral agreement and an equitable adjustment in fee

13. in case of termination of contract, opportunity for consultant to explain and rectify circumstances

Note that *all* contractual agreements *must* be in writing. When changes are made, the contract *must* be modified accordingly. Remember that "a verbal agreement isn't worth the paper it's written on."

Also check all new contract forms with your professional liability carrier. He or she is only a phone call away, and it could save you a lot of headaches.

Terms and Conditions. Terms and conditions account for as much as 90 percent of the words in most contracts, but are given only 10 percent of the attention of the negotiations. This can be a dangerous combination if problems arise on the project. The number of variations of specific terms and conditions in design contracts is endless. Be sure your contract expert or insurance company reviews the contract terms and conditions before the signing.

Thirteen Rules for Successful Negotiations	Much has been written on the art of negotiation. The following summary of thirteen of the most important rules for negotiations is based on years of experience of professionals who have negotiated hundreds of design contracts. As a project manager, begin to practice these rules as soon as possible.

1. Never accept the first offer. The opponent probably is willing to make some concessions.

2. Never *give* a concession without *getting* one in return. A concession granted too easily does *not* contribute to the opponent's satisfaction nearly as much as one he or she struggles to obtain.

3. Don't make the first concession. Research shows that losers tend to make the first concessions on major issues.

4. When the opponent makes a concession, don't feel shy or guilty about accepting it. *Take it.*

5. Don't lose track of how many concessions have been made. The overall amount can provide bargaining leverage. *Keep a record.*

6. Before negotiating, draw up a list of every issue. Establish an *aspiration* level, a *minimum acceptable* level, and an *initial* asking price for each issue.

7. Every concession should move the negotiations closer to some goal. Spend concessions wisely.

8. Be careful not to telegraph the concession pattern. Each concession should point to a possible area of settlement. But the other side should *not be certain* where it will be.

9. Don't honor the opponent's high demand by making a counteroffer. Insist on a *reduction* in the initial demand.

10. Don't concede on a quid-pro-quo basis. Concessions do *not* have to be matched in kind. *Negotiating goals:* Exchange little for much, later for now, little issues for bigger issues, and obscure items for clear ones.

11. Don't feel compelled to stick with a *specific* concession. Warn the opponent that all concessions on individual issues are *tentative*, based on reaching a satisfactory *overall agreement*.

12. Try to identify one minor issue on which you will make the *last* concession that will terminate the negotiation. This will allow your client to leave the negotiation in a positive frame of mind.

13. Remember that you will very likely have to work with the people you negotiate with. Don't give them the idea that you are trying to extract that last ounce of advantage.

Conclusion

This chapter has explained why project managers should be involved in the negotiation process and what their role should be. Also included were specific suggestions on how you can improve your negotiating skills.

The next chapter provides an overview of how project management fits into the firm's overall financial management system. The vital ability to "see the big picture" will make you more valuable to your firm and help advance your career.

CHAPTER 11

Financial Management for the Project Manager

1. How will understanding financial management help me manage my projects?

2. What are the two types of overhead rates and how can they help my firm negotiate a profitable contract?

3. How is overhead determined on contracts with the U.S. government?

4. In what circumstances should I consider a low multiplier in pricing a contract?

5. How can I compute profit on projects still in progress, and what are the benefits to my firm of doing so?

6. What is profit center accounting and why is job profitability only one of several factors that determine how much profit my firm makes?

7. What are the relative benefits and drawbacks of cash basis and accrual basis accounting?

8. How much time should be charged to jobs vs. overhead?

9. What is cash flow, why is it important, and how can I control it?

10. To what extent should I become involved in the client invoicing process?

O<small>NE OF THE FOUNDATIONS</small> of the strong project manager organization is that the project manager maintains financial as well as technical responsibility for the project. This means that the accounting staff who prepare job cost reports, invoices, and other reports relating to your project are just as much a part of your project team as the draftsmen who produce the drawings.

Understanding What the Accounting Department Does

No good project manager would think of letting a draftsman prepare a drawing without (1) understanding what the draftsman is doing and (2) checking it to be sure it is correct. Yet that is what often happens with work done by the accounting department. This oversight results in jobs going over budget needlessly and/or in failure to bill the client for all legitimate charges. The total amount of revenue lost can be staggering.

This chapter introduces financial management principles that project managers should understand and shows why they are important. Discuss these concepts with your accounting and financial people and find out exactly how they are applied in your firm.

What Does "Overhead" Really Mean?

One of the concepts most misunderstood by project managers in professional service firms is the overhead. Simply defined, overhead is the sum of all expenses not directly chargeable to clients, including rent, utilities, vehicles, employee benefits, interest on borrowed money, promotional costs, and so on. The *overhead rate* is obtained by dividing the sum of all overhead costs by the sum of all direct labor charged to clients.

This concept can be understood more clearly by examining the books of a hypothetical firm, ABC Consultants, a fifty-person architectural and engineering firm. Figure 11.1 presents a summary of all overhead costs incurred by ABC during fiscal year (FY) 1982. If the billable labor for FY 1982 were $691,486, this overhead could be apportioned as follows:

Total billable direct labor (DL) = $691,486

Direct personnel expenses = $208,022 ÷ $691,486 = 30.1%

General overhead and administrative = $821,320 ÷ $691,486 = 118.8%

Total overhead = 30.1% + 118.8% = 148.9%; say 149%

Multiplier required to offset overhead costs = 1.0 + 1.49 = 2.49 × DL

There is a fundamental difference between the two overhead categories listed above. Direct personnel expenses (DPE) are directly related to the salaries of the staff: if the total salary level increases or decreases, DPE changes proportionately. (In the case of ABC Consultants, it costs the firm $.30 of DPE for every dollar it pays in direct salaries.) On the other hand, the general overhead and administrative expenses (G&A) are relatively constant regardless of what happens to the firm's total salary costs. Although it has become conventional for professional service firms to recover their overhead costs by applying a multiplier to the direct labor billed to jobs, it is important to understand that this relationship is artificial.

In FY 1982 ABC Consultants may have performed some jobs at a multiplier of less than 2.49 and some at a multiplier greater than 2.49. As long as the firm has collected at least $1,720,828 (overhead plus direct labor), it has recovered its costs. Any revenue collected over this amount is profit. The only strict rule about the multiplier is that it should never be less than direct salary plus DPE (1.30 in ABC's case), or ABC would literally be paying the client for the privilege of doing the job!

ANNUAL OVERHEAD SUMMARY FOR ABC CONSULTANTS

Direct Personnel Expenses

Vacation	$ 33,972
Holiday	36,283
Sick leave	11,085
Incentive pay	21,624
Payroll taxes	47,608
Workmen's compensation	12,422
Employees' welfare and insurance	45,028
Subtotal	$208,022

General Overhead and Administrative Expenses

Administration and indirect salaries	$ 144,151
Technical support and proposal salaries	119,852
Employee recruitment and relocation	14,742
Consulting fees	17,074
Operating and office supplies and services	49,214
Postage and freight	7,375
Building rental	77,305
Telephone and utilities	52,445
Maintenance and repairs	8,483
Equipment rental	14,511
Depreciation and amortization	30,629
Insurance general	64,758
Professional dues and subscriptions	6,047
*Advertising	3,621
Travel	18,229
Auto lease and maintenance	26,206
Proposal materials and expenses	55,383
*Entertainment	5,603
Business taxes and licenses	2,781
Legal and accounting	20,853
*Interest	75,621
Sundry	6,437
Subtotal	$ 821,320
Total overhead	$1,029,342

*Not allowable as an overhead expense for U.S. government projects.

11.1 On this annual overhead summary for ABC Consultants, note that these costs may be classified as (1) variable, that is, a function of staff size (first group), or (2) fixed, that is, independent of staff size (second group).

Determining the Proper Multiplier on Direct Labor

Why should a firm raise or lower its multiplier for a particular project? There are two legitimate reasons why the firm might want to *lower* its multiplier. The first is a lack of work in the office. Where there is a clear choice between laying off staff and taking a job at a multiplier less than that required to offset overhead costs (2.49 in ABC's case), it is better financially to take the job as long as the multiplier covers the DPE (1.3 in ABC's case). If staff must be laid off, their DPE is eliminated, but they generate no revenue to help offset G&A expenses. If ABC's staff can be put to work on a project with a multiplier of, say 2.0, then 0.7 of that amount goes toward paying the relatively fixed G&A costs.

In a period of severe work shortages, there is no question that the firm will lose money. The objective is to cut these losses. Intercompany personnel exchanges represent an extreme case of loss-cutting practices. In these cases, it is relatively common for two noncompeting firms to have an agreement to lend staff at a cost equal to direct salary plus DPE.

Another reason for taking a project at a low multiplier is to expand into new markets. An example would be an architectural firm desiring to expand into inte-

rior design. To gain experience and develop its staff in this area, the firm may need to spend more money on selling interior design work than architectural work, thus increasing its overhead for the Interior Design Division. However, because of market pressures, the firm may not be able to charge a multiplier that is high enough to offset these costs. The new division will therefore lose money until it generates enough business for the revenue to offset the overhead costs.

Another example would be a firm that opens a branch office in another city. Initially the overhead costs would probably be too high to be recovered by a multiplier that is competitive with that of other similar firms. It typically requires a staff of five to ten people in order for a new office to generate enough revenue to cover its overhead costs.

Some firms actively pursue low multiplier projects as a way to enter new markets or to secure new clients. This should be done only if enough revenue is collected from other sources to offset relatively fixed overhead costs for the year.

The "Loss Leader" Concept. It is important to distinguish the above examples from the concept of "loss leaders." The loss leader theory is that a small job is taken at a loss in order to secure a larger follow-on job that will make a profit. This concept is most successfully used by retailers such as supermarkets that advertise commonly used items such as coffee and sugar at prices less than the store's cost. Once the customers are drawn into the store, they tend to buy enough other merchandise to offset the loss. However, the loss leader concept is generally unsuccessful when applied by design firms, for the following reasons:

1. What at first appears to be a fine opportunity for follow-on work often results in less work than originally envisioned or none at all.

2. Once a client has become accustomed to a low-cost multiplier, he or she will not want to pay a higher multiplier, especially for a larger job.

3. Clients tend to look unfavorably on firms that intentionally lose money on jobs. Such behavior is considered naive and makes the client question the firm's judgment.

4. If the practice broadens, it results in widespread price reductions that will not permit any of the affected firms to stay in business.

The only factor that limits price is market competition. If a firm is in a highly competitive market, it must keep its multiplier near the level required just to recover costs. On the other hand, a specialized firm that provides unique services can charge a multiplier that is much higher. Red Adair's oilwell firefighting firm charges its clients a multiplier that is far higher than that of any architectural or engineering design firm.

Pricing on U.S. Government Projects

The exception to the pricing policies described above is work for the U.S. government. On federally funded projects, the overhead rate is determined by an audit of the firm's actual overhead for the previous year. This amount is established either as the fixed overhead rate for the entire project or as a "provisional" rate to be used during the project until the audit has been completed for the project period. When the more current audit results are obtained, the fee is adjusted accordingly. This provisional overhead can cause problems if you are not aware of the overhead trends in your firm.

Another unique aspect of doing work for the U.S. government is the "allowable overhead" concept. Expenditures for entertainment, advertising, and interest on borrowed money are *not* allowed as overhead by the government. This results in a different definition of overhead from that used by the firm's internal accounting system. For ABC Consultants, the allowable overhead would be $1,029,342 − ($5,603 + $3,621 + $75,621), or $944,497. This would result in an allowable overhead rate of $944,497 ÷ $691,486, or 137 percent. All U.S. government contracts for the period would therefore be negotiated based on the allowable overhead rate of 137 percent. Depending on the agency and the type of project, the government

will generally permit a multiplier from 1.05 to 1.15 times the sum of direct labor plus allowable overhead. The following is an example of a typical government project that might be negotiated by ABC Consultants on a cost-plus-fixed-fee basis:

Total direct labor	$64,987
Allowable overhead (1.37 × $64,984)	89,032
Other direct costs	11,478
Total allowable costs	$165,497
Fixed fee (0.10 × $165,497)	16,550
Total contract value	$182,047

As shown below, the *actual* profit on the project is *less than half* the fixed fee.

Nonallowable overhead rate = 149% − 137% = 12%
Nonallowable overhead costs = 0.12 × $64,987 = $7,798
Net profit = $16,550 − $7,798 = $8,752
Percent profit = $8,752 ÷ $182,047 = 0.048 = 4.8%

The Financial Impact of Project Budgets and Progress Reports

To manage the design firm effectively, management must be aware of the firm's profitability, not on an annual basis, but on a quarterly or monthly basis. To point up potential problems created if profits are measured only annually, let us examine the profits for ABC Consultants in a typical year (see Figure 11.2).

If profits for ABC Consultants were not computed until each job were closed, management would have to base their estimated profits for the first quarter of 1982 solely on the performance of a single project with a contract value of $52,000, representing *less than 1 percent* of the total value of all active jobs. The estimates would be only slightly more meaningful during the second, third, and fourth quarters (because more jobs were closed during those periods), but would never represent more than 17 percent of total contract values for any quarter during 1982. Even for the year as a whole, the firm's profit calculations would be based on less than 25 percent of the total value of all active jobs. Waiting until the jobs are finished to calculate profit is obviously not a satisfactory way of keeping track of the firm's profitability. Some way must be found to compute the profit on jobs that are still in progress.

One possibility is to prepare a budget at the outset of each project, including an estimated profit for each job. Management could then compute the firm's profits by totaling the estimated profits from each job begun during a given quarter or year. Figure 11.3 presents an example of such computations. Although this method includes the estimated profits on *all* active projects, it does *not* account for differences between the project budget and actual costs of completing each job.

This difference may be found by adjusting estimated profit for each job based on the actual costs at completion, as in Figure 11.4. An analysis similar to this one is commonly used by design firms to compute profits. It can be seen that this approach requires (1) that each project must be budgeted with precise profit objectives and (2) that budgets must be reconciled with actual costs upon completion of the project. Budgeting the project realistically is the project manager's responsibility; reconciling that budget with the actual cost at project completion is the accounting department's function.

However, there is one major problem with the approach illustrated in Figure 11.4; it does not take into account variations between the budgeted profit and the actual profit until the job is completed. This could represent a large amount of money for major, multiyear projects. One way to overcome this problem is for the project manager to estimate the budget status of each project on a regular (usually monthly) basis. This estimate is obtained in one of two ways.

PROJECT COST SUMMARY FOR ABC CONSULTANTS

Active Projects	Start Date	Finish Date	Contract Value ($)	Billings During 1982 ($)	Value of Contracts Completed During 1982				
					1st Quarter	2nd Quarter	3rd Quarter	4th Quarter	1982 Total
A	7/1/79	5/1/84	$864,720	$248,621					
B	6/1/82	4/1/83	48,960	26,892					
C	2/1/82	4/1/82	7,821	7,821		7,821			7,821
D	4/1/81	6/1/83	261,482	84,806					
E	2/1/82	9/1/82	86,478	86,478			86,478		86,478
F	5/1/80	6/1/82	181,026	46,852		181,026			181,026
G	4/1/82	8/1/83	420,982	56,928					
H	3/1/82	6/1/82	1,260	1,260		1,260			1,260
I	8/1/81	3/1/82	52,980	13,826	52,980				52,980
J	6/1/81	4/1/83	1,264,821	624,086					
K	7/1/82	9/1/83	125,090	48,624					
L	11/1/81	4/1/82	3,000	2,640		3,000			3,000
M	4/1/82	5/1/84	306,400	86,481					
N	1/1/80	3/1/83	286,420	91,406					
O	3/1/79	8/1/82	862,490	181,520			862,490		862,490
P	1/1/82	9/1/83	64,700	42,826					
Q	7/1/82	10/1/84	265,850	56,421					
R	8/1/81	6/1/83	475,920	204,715					
S	9/1/81	10/1/82	56,470	42,520				56,470	56,470
Totals			$5,636,870	$1,954,723	$52,980	$193,107	$948,968	$56,470	$1,251,525

11.2 In the tabulation of all projects performed by ABC Consultants during 1982, note that less than 25 percent of the project values were completed during 1982 ($1,251,525 out of $5,636,870).

COMPUTATION OF PROFITS BASED SOLELY ON PROJECT BUDGETS

1	2	3	4	5	6	7				
						Estimated Profits for Projects Begun During 1982				
Active Projects	Start Date	Finish Date	Contract Value ($)	Project Budget	Estimated Profit ($)	1st Quarter	2nd Quarter	3rd Quarter	4th Quarter	1982 Totals
A	7/1/79	5/1/84	$864,720	$ 756,100	$108,620					
B	6/1/82	4/1/83	48,960	40,020	8,940		8,940			8,490
C	2/1/82	4/1/82	7,821	6,250	$ 1,571	1,571				1,571
D	4/1/81	6/1/83	261,482	231,460	30,022					
E	2/1/82	9/1/82	86,478	81,400	5,078	5,078				5,078
F	5/1/80	6/1/82	181,026	152,624	28,402					
G	4/1/82	8/1/83	420,982	391,480	29,502		29,502			29,502
H	3/1/82	6/1/82	1,260	1,000	260	260				260
I	8/1/81	3/1/82	52,980	45,720	7,260					
J	6/1/81	4/1/83	1,264,821	1,172,407	92,414					
K	7/1/82	9/1/83	125,090	113,500	11,590			11,590		11,590
L	11/1/81	4/1/82	3,000	2,500	500					
M	4/1/82	5/1/84	306,400	278,920	27,480		27,480			27,480
N	1/1/80	3/1/83	286,420	252,080	34,340					
O	3/1/79	8/1/82	862,490	774,861	87,629					
P	1/1/82	9/1/83	64,700	58,400	6,300	6,300				6,300
Q	7/1/82	10/1/84	265,850	252,420	13,430			13,430		13,430
R	8/1/81	6/1/83	475,920	412,380	63,540					
S	9/1/81	10/1/82	56,470	50,000	6,470					
Totals			$5,636,870	$5,073,522	$563,348	$13,209	$65,922	$25,020	0	$104,151

11.3 Computation of profits based solely on project budgets includes estimated profits on all active projects, but fails to account for differences between the project budget and the actual costs of completing each job.

11.4 Computation of profits adjusted to reflect actual costs for completed jobs resolves the problem identified in Figure 11.3, but does not consider the impacts of projects that are still in progress.

COMPUTATION OF PROFITS ADJUSTED BASED ON ACTUAL COSTS FOR COMPLETED JOBS

1 Active Projects	2 Start Date	3 Finish Date	4 Contract Value ($)	5 Project Budget ($)	6 Estimated Profit ($)	7 Billings during 1982 ($)	8 Profit Taken on Work Done in 1982 ($)	9 Actual Costs for Jobs Completed in 1982 ($)	10 Adjustments for Jobs Completed in 1982 ($)	11 Adjusted 1982 Profits ($)
A	7/1/79	5/1/84	$864,720	$756,100	$108,620	$248,621	$31,230			$31,230
B	6/1/82	4/1/83	48,960	40,020	8,940	26,892	4,910			4,910
C	2/1/82	4/1/82	7,821	6,250	1,571	7,821	1,571	$6,387	$(137)	1,434
D	4/1/81	6/1/83	261,482	231,460	30,022	84,806	9,737			9,737
E	2/1/82	9/1/82	86,478	81,400	5,078	86,478	5,078	88,526	(7,126)	(2,048)
F	5/1/80	6/1/82	181,026	152,624	28,402	46,852	7,351	174,706	(22,082)	(14,731)
G	4/1/82	8/1/83	420,982	391,480	29,502	56,928	3,989			3,989
H	3/1/82	6/1/82	1,260	1,000	260	1,260	260	1,865	(865)	(605)
I	8/1/81	3/1/82	52,980	45,720	7,260	13,826	1,895	42,726	2,994	4,889
J	6/1/81	4/1/83	1,264,821	1,172,407	92,414	624,086	45,599			45,599
K	7/1/82	9/1/83	125,090	113,500	11,590	48,624	4,505			4,505
L	11/1/81	4/1/82	3,000	2,500	500	2,640	440	1,427	1,073	1,513
M	4/1/82	5/1/84	306,400	278,920	27,480	86,481	7,756			7,756
N	1/1/80	3/1/83	286,420	252,080	34,340	91,406	10,959			10,959
O	3/1/79	8/1/82	862,490	774,861	87,629	181,520	18,442	776,574	(1,713)	16,729
P	1/1/82	9/1/83	64,700	58,400	6,300	42,826	4,170			4,170
Q	7/1/82	10/1/84	265,850	252,420	13,430	56,421	2,850			2,850
R	8/1/81	6/1/83	475,920	412,380	63,540	204,715	27,331			27,331
S	9/1/81	10/1/82	56,470	50,000	6,470	42,520	4,872	38,967	11,033	15,905
Totals			$5,636,870	$5,073,522	$563,348	$1,954,723	$192,945	$1,131,178	($16,823)	$176,122

Calculations Column 6 = column 4 − column 5
Column 8 = column 6 × (column 7 ÷ column 4)
Totals do not necessarily follow calculation formulas.

Column 10 = column 5 − column 9
Column 11 = column 8 + column 10

Note: Parentheses indicate negative values.

The first method compares the project manager's estimate of the overall progress of the project with the actual expenditures through the same period. An example of these calculations is presented below:

$$\text{Contract value} = \$864,720$$

$$\text{Project budget} = \$756,100$$

$$\text{Overall project completion (progress) through 6/1/82} = 48\%$$

$$\text{Total expenditures through 6/1/82} = \$381,607$$

$$\text{Budget status} = 0.48 \ (\$756,100) - \$381,607 = -\$18,679 \ (\text{over budget})$$

$$\text{Projected profit} = (\$864,720 - \$756,100) - \$18,679 = \$89,941$$

The second method of estimating budget status is based on the project manager's estimate of the amount of work remaining, as illustrated in the following example:

$$\text{Contract value} = \$864,720$$

$$\text{Project budget} = \$756,100$$

$$\text{Total expenditures through 6/1/82} = \$381,607$$

$$\text{Manpower required to complete} = 13,000 \text{ hours}$$

$$\text{Average hourly rate (including overhead)} = \$30/\text{hour}$$

$$\text{Direct expenses required to complete project} = \$3,172$$

$$\text{Estimated cost at completion} = \$381,607 + (\$30/\text{hr} \times 13,000 \text{ hrs}) + \$3,172 = \$774,779$$

$$\text{Projected profit} = \$864,720 - \$774,779 = \$89,941$$

With either of the above approaches, profit projections (such as those in Figure 11.5) can be made with much greater confidence during the project.

Profit Center vs. Job Cost Accounting

Thus far we have discussed various accounting procedures for calculating how much money is made or lost on each project. It is important for the project manager to understand that job profitability is only one of several factors that determine how much money the firm makes. It is entirely possible for *every* project to show a profit, while the firm as a whole shows a loss. To understand this anomaly, you must understand the fundamentals of profit center accounting.

A profit center is any group that is formed for the purpose of making a profit. It may be an office, a department, or the firm as a whole. The calculation of profits (or losses) for a given profit center is theoretically quite simple. It is merely the difference between the total amount of money collected (revenue) and the total amount of money spent (expenditures). If revenues exceed expenditures, the difference is the profit. Similarly, if expenditures exceed revenues, the difference is the loss.

Cash Basis vs. Accrual Basis Accounting. In practice, the computation of profits and losses is not nearly so simple. The first consideration is whether the firm does its accounting on a "cash" basis or on an "accrual" basis. Cash basis accounting requires that all revenue be counted when the money (cash or check) is *actually received*. Similarly, expenditures are counted when the money is actually paid out. On an accrual basis, both revenue and expenditures are counted when money is *obligated*. For example, let us assume that ABC Consultants has the following activity on a small project:

COMPUTATION OF JOB PROFITS BASED ON ESTIMATES OF WORK REMAINING FOR EACH PROJECT

1	2	3	4	5	6	7	8	9
Active Projects	Start Date	Finish Date	Contract Value ($)	Project Budget ($)	Expenditures Through 12/31/82 ($)	Cost of Remaining Work ($)	Estimate at Completion (EAC) ($)	Projected Job Profits (Losses) ($)
A	7/1/79	5/1/84	$ 864,720	$ 756,100	$ 567,728	$ 246,098	$ 813,826	$ 50,894
B	6/1/82	4/1/83	48,960	40,020	8,452	36,192	44,644	4,316
C	2/1/82	4/1/82	7,821	6,250	6,387	0	6,387	1,434
D	4/1/81	6/1/83	261,482	231,460	42,725	152,706	195,431	66,051
E	2/1/82	9/1/82	86,478	81,400	88,526	0	88,526	(2,048)
F	5/1/80	6/1/82	181,026	152,624	174,706	0	174,706	6,320
G	4/1/82	8/1/83	420,982	391,480	12,527	392,408	404,935	16,047
H	3/1/82	6/1/82	1,260	1,000	1,865	0	1,865	(605)
I	8/1/81	3/1/82	52,980	45,720	42,726	0	42,726	10,254
J	6/1/81	4/1/83	1,264,821	1,172,407	624,907	658,705	1,283,612	(18,791)
K	7/1/82	9/1/83	125,090	113,500	37,596	73,087	110,683	14,407
L	11/1/81	4/1/82	3,000	2,500	1,427	0	1,427	1,573
M	4/1/82	5/1/84	306,400	278,920	62,402	252,237	314,639	(8,239)
N	1/1/80	3/1/83	286,420	252,080	165,324	87,946	253,270	33,150
O	3/1/79	8/1/82	862,490	774,861	776,574	0	776,574	85,916
P	1/1/82	9/1/83	64,700	58,400	37,929	21,519	59,448	5,252
Q	7/1/82	10/1/84	265,850	252,420	48,796	197,512	246,308	19,542
R	8/1/81	6/1/83	475,920	412,380	278,592	190,464	469,056	6,864
S	9/1/81	10/1/82	56,470	50,000	38,967	0	38,967	17,503
Totals			$5,636,870	$5,073,522	$3,018,156	$2,308,874	$5,327,030	$309,840

Calculations: Column 8 = column 6 + column 7
Column 9 = column 4 − column 8

Note: Parentheses indicate negative values.

11.5 By computing job profits based on estimates of work remaining for each project, you can consider the budget impact of *all* projects.

Labor	
Spend 8 man-hours on project	7/16/82
Turn in time sheet for 8 man-hours	7/18/82
Pay employee for 8 man-hours	7/24/82
Invoice client for 8 man-hours	8/3/82
Receive check from client	9/1/82

Expenses	
Order airplane ticket	7/14/82
Receive bill from airline for ticket	8/5/82
Invoice client for ticket cost	9/2/82
Write check to airline	8/24/82
Receive check from client	9/28/82

If ABC Consultants does its accounting on a cash basis, expenditures and revenues will be entered as follows:

Item	Expenditures	Revenue
Labor	7/24/82	9/1/82
Expenses	8/24/82	9/28/82

On the other hand, the expenditures and revenues may be entered as follows if ABC does its accounting on an accrual basis.

Item	Expenditures	Revenue
Labor	7/18/82	7/18/82
Expenses	8/5/82	8/5/82

Note that in the above example, the accrual method provides management with information much earlier than the cash method does. That is why most design firms use the accrual method of accounting to monitor profits and losses for management purposes. Many firms also compute profit and loss on a cash basis for income tax reporting because it delays payment of taxes on earnings.

The Work-in-Process Concept. For firms employing the accrual method, there is one additional refinement that is often used, the concept of "work-in-process." Work-in-process (WIP) is the work that has been done on a project, but has not yet been invoiced to the client. The following example illustrates how most firms compute revenue for WIP:

Work done in July = 8 hours

Expenses for July = $80

Hourly rate = $14

Overhead rate = 149% (a 2.49 multiplier)

Profit = 10% × (direct labor + overhead)

July WIP = (8 hrs × $14/hr × 2.49 × 1.10) + $80 = $387

The entire amount of $387 is therefore counted as revenue for the month of July.

The Profit/Loss Statement. Figure 11.6 presents a profit/loss statement (also known as an operating statement) for ABC Consultants. Certain adjustments are included, as well as revenues and expenditures, because the accrual accounting method requires assumptions that may not always be accurate. The key assumptions are (1) that all jobs will be done for the budgeted amount and (2) that all invoices will be paid.

The profit/loss computation is further complicated when there are several profit centers and/or cost centers within a given firm. A cost center is a group that provides a necessary service to the firm, but which is not intended to make a profit (for instance, accounting, data processing, and personnel). The major complication arises when expenses incurred by cost centers must be distributed to the various profit centers, or when personnel in one profit center work on a project that has been assigned to a different profit center. Methods of calculating these interoffice transfers differ widely from firm to firm. The only rule about how these transfers are accomplished is that everyone must agree that the method is fair.

Many factors affect the profitability of a given profit center. These can be divided into the following categories:

overhead costs
staff utilization
average multiplier

Controlling overhead costs directly affects profits by reducing the expenditure column on the profit/loss statement. All other things being equal, every dollar spent on overhead reduces profits by one dollar.

PROFIT/LOSS STATEMENT FOR ABC CONSULTANTS
COMPUTED ON AN ACCRUAL ACCOUNTING BASIS

Revenue	Current Month	Year to Date
Billings	$ 44,233	$1,081,228
Adjusted WIP	156,209	156,209
Total revenue	$200,442	$1,237,437
Expenditures		
Wages and salaries	$ 72,768	$ 429,408
Direct personnel expenses	15,274	93,274
Non-labor expenses	77,407	457,602
Consultant/subcontractor invoices	8,404	59,807
Other project expenses	10,500	49,500
Interest on working capital	7,205	42,764
Total expenditures	$191,558	$1,132,355
Adjustments		
Bad debts	[$ 4,624]	[$14,798]
Projects over budget	[12,725]	[37,496]
Projects under budget	6,275	36,504
Supplier credits	829	4,326
Total adjustments	[$10,245]	[$11,464]
Net Profit [Loss] Before Taxes	[$1,361]	$93,618

11.6 In this operating statement for ABC Consultants computed on an accrual accounting basis, certain adjustments are required to correct assumptions made in previous months.

Staff utilization (also called "productivity") is defined as the percentage of man-hours (or salaries) that is charged to jobs under budget. The following example illustrates this concept:

Jobs under budget	98 man-hours
Jobs over budget	12 man-hours
Overhead	4 man-hours
Holiday, vacation, sick leave	10 man-hours
Proposals	16 man-hours
Totals	140 man-hours
Staff utilization = 98 ÷ 140 = 70%	

The desirable range of staff utilization for most design firms is 65 to 75 percent of total hours worked by all staff in the firm. This permits a reasonable amount of time to be spent on legitimate overhead activities and promotion, while keeping profitability as high as possible.

The average multiplier for all projects assigned to a given profit center must be greater than the value of 1 plus the overhead rate if the firm is to make a profit. All other factors being equal, the greater this difference, the more profitable is the profit center.

Conflicts Between Profit Center and Job Cost Accounting. Computing profits or losses on a single project is far simpler than for a profit center. Because of over-simplifications necessary in computing job profits, there may be instances in which a measure that appears to increase job profits may actually result in losses to the profit center. Commonly this occurs when a portion of a project is sub-contracted to a firm with a lower multiplier than the prime consultant has. If the consultant subcontractor is as efficient as the prime professional, this results in greater job profits because of the reduced multiplier on direct labor.

However, if the subcontractor is paid as a reimbursable expense, the firm will not collect its normal multiplier on in-house labor. This will reduce the total revenues to the firm and, assuming a fairly constant overhead base, cut profits. This impact is even greater if the firm has staff on overhead that could be working on the job. In this case, doing the work in-house would not only increase revenues because of the multiplier on in-house labor but would also improve profits by raising productivity and reducing overhead costs.

Conversely, a specific action may harm job profitability, but benefit the prof-itability of the firm. One such case is use of overtime for hourly employees, which increases project costs because overtime wages are 50 percent higher than straight time in most cases. However, this practice may benefit the firm because most of the overhead components are fixed no matter how many hours a given employee works. Thus, total revenues are increased more than overhead costs, resulting in higher profits for the firm.

Therefore, what is best for a given project may not be best for the firm as a whole. Project managers must recognize what is best for the firm, while still meeting their primary responsibility of bringing the job in under budget. Failure to see "the big picture" leads to parochial behavior that may only retard the project manager's own career progress.

The Importance of Cash Flow

Cash flow is the difference between the money that is collected and the money that is spent. A "positive" cash flow occurs when more money is collected than spent; a "negative" cash flow occurs when more money is spent than collected. Many project managers fail to realize (1) the importance of cash flow to their firm's survival and (2) how the project manager can improve cash flow for the firm.

Figure 11.7 presents a simple cash flow analysis for a single project in which the

CASH FLOW ANALYSIS FOR A SINGLE PROJECT GIVEN A CONSTANT WORKLOAD

Monthly Amounts	JAN.	FEB.	MAR.	APR.	MAY	JUNE	JULY	AUG.	SEPT.	OCT.	NOV.	DEC.	JAN.
Expenditures[1]													
Wages and salaries	6.0	6.0	6.0	6.0	6.0	6.0	6.0	6.0	6.0				
Direct personnel expenses	2.0	2.0	2.0	2.0	2.0	2.0	2.0	2.0	2.0				
General overhead	6.0	6.0	6.0	6.0	6.0	6.0	6.0	6.0	6.0				
Subconsultants[2]			2.0	2.0	2.0	2.0	2.0	2.0	2.0	2.0	2.0		
Other job reimbursables[2]			1.0	1.0	1.0	1.0	1.0	1.0	1.0	1.0	1.0		
Total expenditures	14.0	14.0	17.0	17.0	17.0	17.0	17.0	17.0	17.0	3.0	3.0		
Invoice amount													
Wages and salaries	6.0	6.0	6.0	6.0	6.0	6.0	6.0	6.0	6.0				
Direct personnel expenses	2.0	2.0	2.0	2.0	2.0	2.0	2.0	2.0	2.0				
General overhead	6.0	6.0	6.0	6.0	6.0	6.0	6.0	6.0	6.0				
Subconsultants[2]		2.0	2.0	2.0	2.0	2.0	2.0	2.0	2.0	2.0			
Other job reimbursables[2]		1.0	1.0	1.0	1.0	1.0	1.0	1.0	1.0	1.0			
Profit (10%)	1.4	1.7	1.7	1.7	1.7	1.7	1.7	1.7	1.7	0.3			
Total invoice amount	15.4	18.7	18.7	18.7	18.7	18.7	18.7	18.7	18.7	3.3			
Revenue received													
30-day turnaround[3]	0	15.4	18.7	18.7	18.7	18.7	18.7	18.7	18.7	18.7	3.3		
60-day turnaround[3]	0	0	15.4	18.7	18.7	18.7	18.7	18.7	18.7	18.7	18.7	3.3	
90-day turnaround[3]	0	0	0	15.4	18.7	18.7	18.7	18.7	18.7	18.7	18.7	18.7	3.3
Net cash flow[4]													
30-day turnaround[3]	−14.0	+1.4	+1.7	+1.7	+1.7	+1.7	+1.7	+1.7	+1.7	+15.7	+0.3		
60-day turnaround[3]	−14.0	−14.0	−1.6	+1.7	+1.7	+1.7	+1.7	+1.7	+1.7	+15.7	+15.7	+3.3	
90-day turnaround[3]	−14.0	−14.0	−17.0	−1.6	+1.7	+1.7	+1.7	+1.7	+1.7	+15.7	+15.7	+18.7	+3.3
Total cash on hand													
30-day turnaround[3]	−14.0	−12.6	−10.9	−9.2	−7.5	−5.8	−4.1	−2.4	−0.7	+15.0	+15.3		
60-day turnaround[3]	−14.0	−28.0	−29.6	−27.9	−26.2	−24.5	−22.8	−21.1	−19.4	−3.7	+12.0	+15.3	
90-day turnaround[3]	−14.0	−28.0	−45.0	−46.6	−44.9	−43.2	−41.5	−39.8	−38.1	−22.4	−6.7	+12.0	+15.3

1. Assumes that work begins on January 1 and ends on September 30.
2. Assumes 30 days to receive invoice and 30 days for payment.
3. Includes time required to prepare invoice and collect payment.
4. Net cash flow = revenue received − total expenditures.

Note: All amounts are in thousands of dollars.

11.7 In this cash flow analysis for a single project, assuming a constant workload, note the effect of capital turnaround time on cash requirements. For example, a capital turnaround time of 90 days results in a total cash requirement of $46,000 while a 30-day turnaround time requires only $14,000.

CASH FLOW ANALYSIS FOR A FIRM WITH AN INCREASING WORKLOAD[1]

Monthly Amounts	JAN.	FEB.	MAR.	APR.	MAY	JUNE	JULY	AUG.	SEPT.	OCT.	NOV.	DEC.
Expenditures[1]												
Wages and salaries	6.0	6.3	6.6	6.9	7.3	7.7	8.0	8.4	8.9	9.3	9.8	10.3
Direct personnel expenses	2.0	2.1	2.2	2.3	2.4	2.6	2.7	2.8	3.0	3.1	3.3	3.4
General overhead	6.0	6.3	6.6	6.9	7.3	7.7	8.0	8.4	8.9	9.3	9.8	10.3
Subconsultants[2]			2.0	2.1	2.2	2.3	2.4	2.6	2.7	2.8	3.0	3.1
Other job reimbursables[2]			1.0	1.1	1.1	1.2	1.2	1.3	1.3	1.4	1.4	1.5
Total expenditures	14.0	14.7	18.4	19.3	20.3	21.5	22.3	23.5	24.8	25.9	27.3	28.6
Invoice amount												
Wages and salaries	6.0	6.3	6.6	6.9	7.3	7.7	8.0	8.4	8.9	9.3	9.8	10.3
Direct personnel expenses	2.0	2.1	2.2	2.3	2.4	2.6	2.7	2.8	3.0	3.1	3.3	3.4
General overhead	6.0	6.3	6.6	6.9	7.3	7.7	8.0	8.4	8.9	9.3	9.8	10.3
Subconsultants[2]		2.0	2.1	2.2	2.3	2.4	2.6	2.7	2.8	3.0	3.1	3.2
Other job reimbursables[2]		1.0	1.1	1.1	1.2	1.2	1.3	1.3	1.4	1.4	1.5	1.6
Profit (10%)	1.4	1.8	1.9	1.9	2.1	2.2	2.3	2.4	2.5	2.6	2.8	2.9
Total invoice amount	15.4	19.5	20.4	21.3	22.6	23.8	24.9	26.0	27.5	28.7	30.3	31.7
Revenue received												
30-day turnaround[3]	0	15.4	19.5	20.4	21.3	22.6	23.8	24.9	26.0	27.5	28.7	30.3
60-day turnaround[3]	0	0	15.4	19.5	20.4	21.3	22.6	23.8	24.9	26.0	27.5	28.7
90-day turnaround[3]	0	0	0	15.4	19.5	20.4	21.3	22.6	23.8	24.9	26.0	27.5
Net cash flow[4]												
30-day turnaround[3]	−14.0	+0.7	+1.1	+1.1	+1.0	+1.1	+1.5	+1.4	+1.2	+1.6	+1.4	+1.7
60-day turnaround[3]	−14.0	−14.7	−3.0	+0.2	+0.1	−0.2	+0.3	+0.3	+0.1	+0.1	+0.2	+0.1
90-day turnaround[3]	−14.0	−14.7	−18.4	−3.8	−0.8	−1.1	−1.0	−0.9	−1.0	−1.0	−1.3	−1.1
Total cash on hand												
30-day turnaround[3]	−14.0	−13.3	−12.2	−11.1	−10.1	−9.0	−7.5	−6.1	−4.9	−3.3	−1.9	−0.2
60-day turnaround[3]	−14.0	−28.7	−31.7	−31.5	−31.4	−31.6	−31.3	−31.0	−30.9	−30.8	−30.6	−30.5
90-day turnaround[3]	−14.0	−28.7	−47.1	−50.9	−51.7	−52.8	−53.8	−54.7	−55.7	−56.7	−58.0	−59.1

1. Assumes that work begins on January 1 and increases by 5% per month.
2. Assumes 30 days to receive invoice and 30 days for payment.
3. Includes time required to prepare invoice and collect payment.
4. Net cash flow = revenue received − total expenditures.

Note: All amounts are in thousands of dollars.

11.8 In this cash flow analysis for ABC Consultants, assuming an increasing workload, note that the effect of capital turnaround time on cash flow is much greater than that shown in Figure 11.7 for a constant workload. This points out the importance of cash flow in a growing company.

expenditure rates are uniform for the duration of the project. Note that the total cash requirements are as follows, given total turnaround times (time required to prepare invoices and collect payments) of thirty, sixty, and ninety days.

Total Turnaround Time	Total Cash Requirements
30 days	$14,000
60 days	29,600
90 days	46,600

This means that assuming a ninety-day turnaround time, the firm must *borrow* up to $46,600 to finance a project whose total value is $168,300. (Some firms average total turnaround times of even more than ninety days).

Because most consulting firms have limited fixed assets for use as collateral, borrowing large sums of money is difficult. Even if credit is available, the interest paid on these debts can reduce profits substantially. At an annual interest rate of 18 percent and a 90-day turnaround time, the profits on the example project would be reduced by almost $5,000, or *one-third* of the total profit on the project! By comparison, the same interest rate on a thirty-day turnaround time would reduce the job profit by less than $600. This difference is even more dramatic at higher interest rates.

The effects of average invoice turnaround time are far greater on the firm as a whole, especially if the firm is growing. Figure 11.8 presents a cash flow analysis for a firm that begins the year with a workload of approximately $17,000 per month and increases this workload by 5 percent per month.

Note that a thirty-day invoice turnaround time would permit the firm to maintain a positive cash position after the first year, that is, have no need to borrow money. A sixty-day turnaround time would result in the firm's borrowing approximately $30,000 per month indefinitely. A ninety-day turnaround would require the firm to borrow almost $60,000 per month by the end of the first year. What is worse, this amount would increase at an exponential rate until the firm no longer had sufficient credit to continue operating!

Controlling the Invoicing Process	Many project managers wrongly feel that invoicing is strictly an accounting function and that the project manager's participation in it is a needless waste of time. In fact, your involvement in invoicing is not only necessary to check the accounting department, but essential for good client relations. Clients want to have a single person with whom they can discuss *any* aspect of the project—including finances.

Controlling the Invoicing Process

Many project managers wrongly feel that invoicing is strictly an accounting function and that the project manager's participation in it is a needless waste of time. In fact, your involvement in invoicing is not only necessary to check the accounting department, but essential for good client relations. Clients want to have a single person with whom they can discuss *any* aspect of the project—including finances.

In a typical example of how most design professionals have historically neglected invoicing, one employee told the following story of an architect/project manager. One of this man's first assignments was to design a municipal office building. During the design, it became apparent that the site orientation for the building as originally envisioned would not be suitable due to the severe slope on one side of the site. The project manager therefore worked through an entire weekend to prepare a presentation to the client showing how a different orientation would improve access to the building and eliminate a potential safety hazard during the winter.

Despite what the project manager thought was an excellent presentation, the client voted against making the change. The project manager later learned that an invoice had been sent to the client on the day before the presentation. The invoice contained an error, billing the city for $40,000 more than it owed. The poor timing and obvious error in this invoice convinced the client that the architectural firm was proposing the change not to improve the building but to increase its design fees. They therefore distrusted the firm's motives and refused to believe the technically sound design arguments. The building was built as originally envisioned and has since been plagued by the very problems that would have been avoided had the client approved the suggested changes. If the project manager had been in control of the invoicing process, this situation would never have arisen.

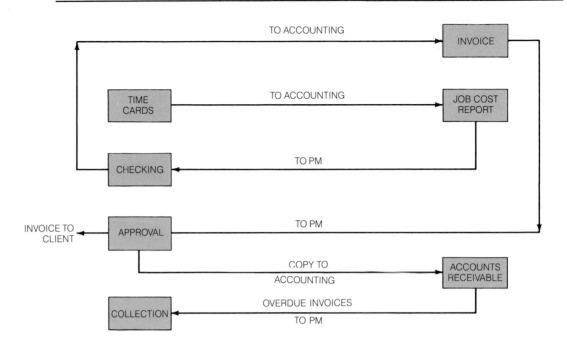

11.9 On this flow diagram for a suggested invoicing process, note that the project manager must expedite processing of *job cost reports* and *invoices* to avoid cash flow problems.

Figure 11.9 presents a flow diagram for an excellent method of controlling the invoicing process. The process begins with the generation of time cards. These data, along with other job-related expenses, are then used by the accounting staff to prepare a job-cost report for the project manager, who reviews it and reports any errors to accounting for correction. Accounting then prepares an invoice that goes to the project manager for review, approval, and mailing to the client, with a copy to accounting to advise them of the date that the invoice was mailed. If the account becomes overdue, accounting advises the project manager, who then does whatever seems best to speed collection.

This process gives the project manager the level of control needed to (1) avoid sending incorrect invoices, (2) assure that the timing of the invoices is appropriate, and (3) cut collection time. The biggest drawback of this method is that it requires fast action by the project manager. The invoice *cannot* be allowed to sit in the in-box while he or she does "more important" things.

For these reasons, each project manager must be aware of the impact that cash flow has on profits and put a high priority on mailing invoices to clients promptly.

Conclusion

The aim of this chapter has been to make project managers familiar with basic financial management principles vital to the success of design firms. If you have trouble understanding some of these concepts, talk to your financial and accounting managers or consultants. You may be surprised how eager they are to help you better understand what they do for the firm.

CONCLUSION

THE DESIGN PROFESSIONAL'S WORLD will continue to become more complex as clients demand more service within smaller fee structures. To the project manager will fall the main task of managing the ever-changing environment of project delivery. Two key trends to watch as we close this century are:

1. The growing diversification of services being provided by most design firms.

2. The coming of total computerization of design practice.

Diversification of Services Provided by Design Firms

The American Institute of Architects defines nearly 200 tasks that can be performed on any design project. Combine that level of complexity with the growth in building code and environmental factors now in force on every project, and it is clear that the project manager's job will become ever more complicated. In the wake of dramatic collapses, public demand for safer facilities—a demand strongly backed by the news media—will add to pressures on the project manager. Clients' insistence that their projects keep up with changing technology and law has in many instances given rise to added specialized consultants, all of whom must be coordinated as part of the design team. These trends will continue into the 1980s and 1990s, and those firms that provide leadership equal to the task will prosper.

Computerization of Design Practice

The entrance of computers into design practice is one of the most crucial changes to come along since design first became a profession. Yet most of today's project managers are not prepared for such sweeping changes. Over the next twenty years, not only will all drawings be done on computer-aided drafting equipment; forecasters also see electronic mail that will transmit images to remote cathode ray tubes (CRTs) at the job site for construction by robots. Rolls of paper drawings will be replaced by lightweight magnetic storage media for computers. Volumes of specifications will be replaced by computer-stored specification banks transmitted electronically among contractor, client, and design professional.

Again, the burden of such drastic changes (let alone the changes already under way in such areas of computer use as project cost and schedule control, design and accounting) will fall largely upon the project manager. Each project manager must learn new skills—to type information into a computer terminal, to interpret complex computer languages, and to motivate operators who are not themselves design professionals. Already some clients are asking design firms to have computer-aided drafting to improve output. The project manager must be capable of handling this massive change.

What to Do Now

Begin your process of improved project management by following these steps:

1. *Start today.* Don't wait until the next problem. Try one of the new time management techniques or a new scheduling method. Discuss your ideas with colleagues.

2. *Improve personal habits.* Your ability to motivate a design team and to communicate and delegate instructions properly is one of your greatest assets.

3. *Try new techniques.* Look at how project managers function in other firms.

4. *Read management journals.* Begin to read management publications such as the *Harvard Business Review* or *The Professional Services Management Journal.* More than 50 percent of a project manager's job calls for management skills never taught in design school. Read about that other 50 percent.

5. *Discuss management with your peers.* Develop checklists and standard operating procedures for each aspect of a project that is done on a repeat basis. Don't wait for management to do it.

The Right Attitude

Finally, develop an attitude about project management. Make decisions and give instructions as if you were a principal acting on the project. For many design firms, the strong project manager may be the key to survival.

SELECTED BIBLIOGRAPHY

Management

Burstein, David. "Cost and Schedule Control as a Project Management Tool," *Public Works*, May 1979.

———. "Project Management in Small Firms," *Professional Services Management Journal*, February 1980.

———. "The Art of Managing Principals," *Professional Services Management Journal*, September 1980.

Coxe, Weld. *Managing Architectural and Engineering Practice*. New York: Wiley-Interscience, 1980.

Current Techniques in Architectural Practice. Washington, D.C.: American Institute of Architects, 1976.

Daugbjerg, Ray J. "Is There a Better Way to Make Engineering Decisions?" *Chemical Engineering*, Oct. 5, 1981, p. 139.

Dibner, David R. *Joint Ventures for Architects and Engineers*. Washington, D.C.: American Institute of Architects, 1972.

Drucker, Peter F. *Management: Tasks, Responsibilities, Practices*. New York: Harper & Row, 1974.

———. "How to Manage Your Boss," *Management Review*, May 1977, p. 8.

Gabarro, John T., and Kotter, John P. "Managing Your Boss," *Harvard Business Review*, January-February 1980.

Henning, Margaret, and Jardim, Anne. *The Managerial Woman*. New York: Pocket Books, 1976.

Hersey, Paul, and Blanchard, Kenneth H. *Management of Organizational Behavior: Utilizing Human Resources*. Englewood Cliffs, N.J.: Prentice-Hall, 1969.

Hough, Michael R. "The Increasing Strength of the Project Manager," *A.I.A. Journal*, October 1976, p. 62.

Korbert, Norman. *The Aggressive Management Style*. Englewood Cliffs, N.J.: Prentice-Hall, Inc., 1982.

Korda, Michael. *Power: How to Get It, How to Use It*. New York: Ballantine Books, 1975.

Lakein, Alan. *How to Get Control of Your Time and Your Life*. New York: Signet Books, 1974.

MacKenzie, R. Alec. *The Time Trap*. New York: American Management Assn., Inc., 1972.

Oncken, William, and Wass, Donald L. "Management Time: Who's Got the Monkey?" *Harvard Business Review*, November-December 1974.

Pogany, G.A. "A Positive Approach to the Negative Thinker," *Chemical Engineering*, July 27, 1981, p. 83.

Rosenbaum, Bernard L. "Improving Communication for Better Job Performance," *Chemical Engineering*, Oct. 5, 1981, p. 139.

Stasiowski, Frank. "Training Project Managers," *Professional Services Management Journal*, August 1979.

Thompson, Donald E. "Moving Up . . . Are You Willing to Pay the Price?" *Consulting Engineer*, April 1982, p. 16.

Winston, Stefanie. *Getting Organized: The Easy Way to Put Your Life in Order*. New York: W.W. Norton & Co., 1978.

Marketing

American Consulting Engineers Council. "The Brochure on Brochures."

———. "For Immediate Release."

Burden, Ernest. *Visual Presentation: A Practical Manual for Architects and Engineers*. New York: McGraw-Hill, 1977.

Coxe, Weld. *Marketing Architectural and Engineering Services*. New York: Litton Educational Publishing Company, 1979.

Gunning, Robert. *How to Take the Fog out of Writing*. Chicago: Dartnell Corp., 1964.

Jay, Anthony. *The New Oratory*. New York: American Management Assn., Inc.

Jones, Gerre. *How to Market Professional Design Services*. New York: McGraw-Hill, 1973.

———. *Public Relations for the Design Professional*. New York: McGraw-Hill, 1980.

Kliment, Stephen, A. *Creative Communications for a Successful Design Practice*. New York: Whitney Library of Design, 1977.

Kotler, Phillip, and Connor, Richard A. "Marketing Professional Services," *Journal of Marketing*, January 1977.

Levitt, Theodore. *Innovation in Marketing*. New York: McGraw-Hill, 1962.

Strunk, William, and White, E.B. *The Elements of Style*, New York: Macmillan Paperbacks, 1962.

Travers, David. *Preparing Design Office Brochures: A Handbook*. Santa Monica, Calif.: Arts & Architecture Press, 1978.

Wilson, Aubrey. *The Marketing of Professional Services*. McGraw-Hill Ltd. (U.D.), 1972.

Wittreich, Warren. "How to Buy/Sell Professional Services," *Harvard Business Review*, March-April 1966.

Financial Management

Compensation Guidelines for Architectural and Engineering Services. 2d ed. Washington D.C.: American Institute of Architects, 1977.

Eyerman, Thomas J. "Financial Management: Concepts and Techniques for the Architect," Skidmore Owings & Merrill, 1973.

Foote, Rosslyn F. *Running an Office for Fun and Profit: Business Techniques for Small Design Firms*. Dowden Hutchinson & Ross/McGraw-Hill, 1978.

Mattox, Robert F. *Financial Management for Architects*. Washington D.C.: American Institute of Architects, 1981.

"Overhead Survey," *Professional Services Management Journal, 1980*.

Siegel, Harry, C.P.A., with Siegel, Alan, Esq. *A Guide to Business Principles and Practices for Interior Designers*. Rev. ed. New York: Whitney Library of Design, 1982.

Standardized Accounting. Washington D.C.: American Institute of Architects, 1978.

Newsletters

A/E Marketing Journal, MRH Associates, P.O. Box 11316, Newington CT 06111.

A/E Systems Report, MRH Associates, P.O. Box 11318, Newington, CT 06111.

Professional Marketing Report. Gerre Jones Associates, P.O. Box 32387, Washington, D.C. 20007.

PSMJ (Professional Services Management Journal), P.O. Box 11316, Newington, CT 06111.

Resource, Professional Development Resources, Inc., Suite 9, 1000 Connecticut Avenue, N.W., Washington, D.C. 20036.

SMPS News (Society for Marketing Professional Services), 1437 Powhatan, Alexandria, VA 22314.

INDEX